Outdoor

Photographer of the Year

PORTFOLIO II

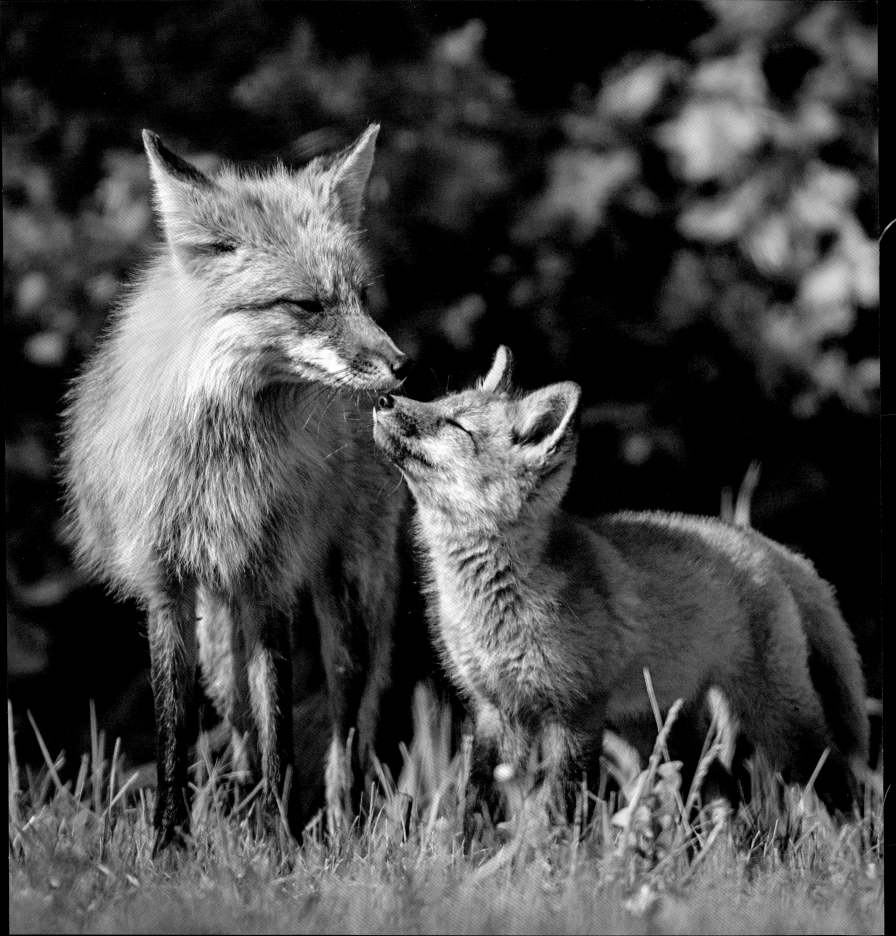

Outdoor
Photographer of the Year

PORTFOLIO II

AMMONITE
PRESS

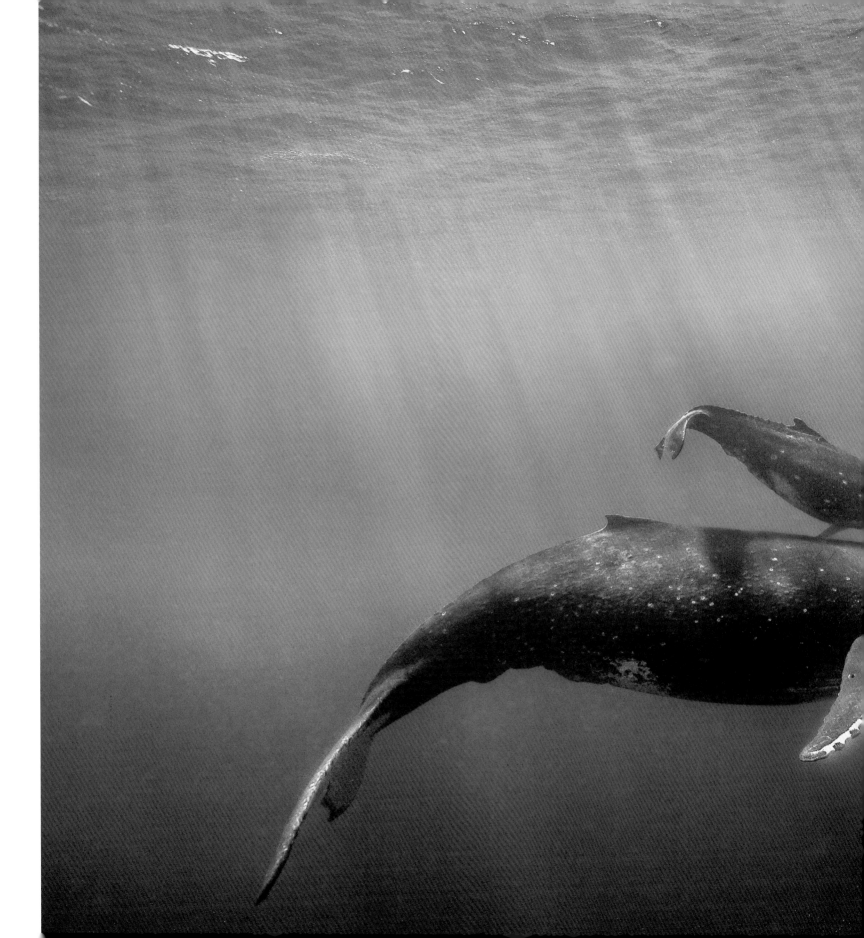

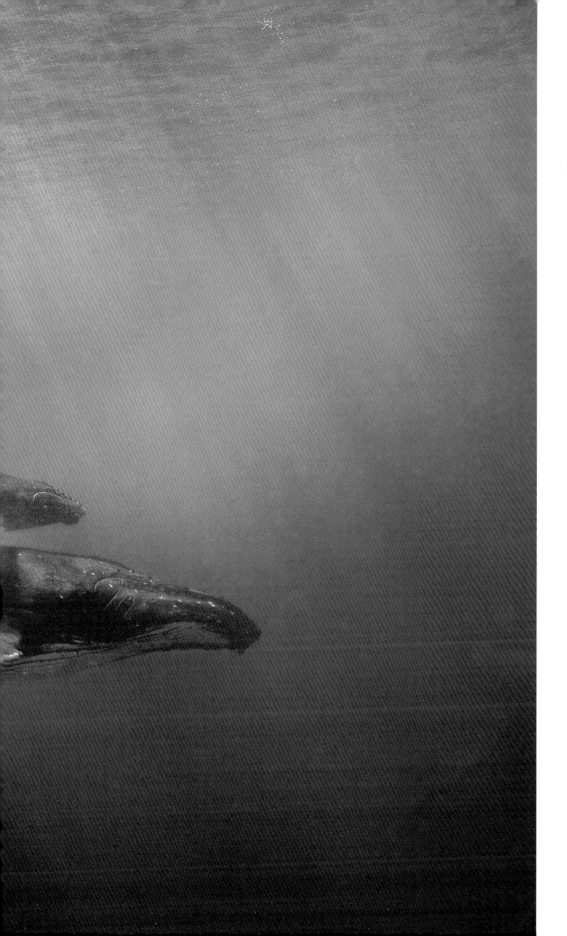

CONTENTS

First published 2017 by Ammonite Press
An imprint of Guild of Master Craftsman Publications Ltd
Castle Place, 166 High Street, Lewes, East Sussex,
BN7 1XU, United Kingdom

ISBN 978-1-78145-304-9

Consultant Editor: Steve Watkins
Publisher: Jason Hook
Designer: Jo Chapman

Colour reproduction by GMC Reprographics
Printed in Turkey

Back cover photographs: (Clockwise from top left)
Aneurin Phillips, Yingting Shih, Nick Robertson-Brown,
Sandi Bertoncelj

Isabella Tabacchi (Italy)

Front cover: **Seiser Alm plateau, South Tirol, Italy.**
I went to Seiser Alm in July to take some shots of
the Milky Way. After taking a panoramic image
of the Milky Way, the moon rose to the left of
Langkofel peak and illuminated the valley, which
was full of fog, and I took another panoramic.
The moonlight washed out the Milky Way, so
I then merged the two panoramic images to show
the complete scene.

*Nikon D810 with Nikkor 14-24mm f/2.8 G AF-S ED lens at
24mm, ISO 3200, 13sec at f/2.8 for the stars; Nikkor 50mm f/1.8
G AF-S lens, ISO 1000, 6sec at f/8 for the rest of the landscape;
Manfrotto tripod*

isabellatabacchi.com

Jacques-André Dupont (Canada)

Title page: **Montréal, Canada.** I was lucky enough
to find a fox family very near the city, on the south
shore of Montréal. I spent several days witnessing
the diverse behaviour of this mother fox with her
three young cubs, which included lots of playing,
hunting and great loving manifestations between
the little ones and the mother.

*Canon EOS 1D MkIV with Canon EF 600mm f/4 L IS lens,
ISO 640, 1/3200sec at f/4, monopod*

jadupontphoto.com

Justin Bruhn (Australia)

Contents page: **Vava'u, Kingdom of Tonga.** After
a morning of heartwarming close encounters with
humpback whales, I had the opportunity to capture
this image of a humpback whale calf reconnecting
with her mother after a brief play on the surface.
I waited until there was complete synchronicity in
movement between mother and calf before I pressed
the shutter release and was rewarded with this
beautiful image.

*Canon EOS 5D MkIII with Canon EF 16–35mm f/2.8 lens
at 16mm, ISO 320, 1/250sec at f/8, Nauticam housing*

pureunderwaterimaging.com

INTRODUCTION

Now in its sixth year, Outdoor Photographer of the Year is one of the most prestigious photography competitions in this genre in the world. It offers a breathtaking look at our planet and the life and adventures to be found on it.

Much of the common perception of our world is formed or heavily influenced by the imagery we see in books, magazines, online and on television. Thanks to the numerous improvements in imaging technology and the growing number of people who are out there pushing the creative and technical boundaries of how the planet can be shown, the standard of photographs and films emerging from this genre has never been higher or more inspirational.

Whether you are into landscape, wildlife, nature, underwater, travel or adventure photography, the opportunities to create extraordinary images are there for all of us to enjoy and explore. We are privileged to see a broad cross-section of this imagery each month as we produce *Outdoor Photography* magazine, and through our annual Outdoor Photographer of the Year competition we aim to surface the most talented photographers around the globe.

There were more than 17,000 photographs entered into the competition this year from over 50 countries, including the UK, USA, Canada, Australia, China, Japan, South Africa, Norway, Sweden, Germany, the Netherlands and Italy, to name just a handful. It attracted entries from professional and amateur photographers alike.

For this year's competition, we once again teamed up with Fjällräven, the premium Swedish outdoor gear manufacturer, to offer a prize that money can't buy. The overall winner is off to the

Arctic on assignment to photograph the Fjällräven Polar dog sled expedition. Fjällräven Polar is the adventure of a lifetime, giving 'ordinary' people the chance to experience how amazing life in a winter environment can be. It aims to show that anyone can enjoy the Arctic on an expedition, as long as they have the right knowledge and equipment – both of which are supplied by Fjällräven. An approximately 300km-long adventure from Norway to Sweden, it crosses the arctic tundra through some of the most beautiful and inspiring terrain in the world.

The overall winner was announced live at The Photography Show at the National Exhibition Centre in Birmingham, United Kingdom, where all the winning images were seen by tens of thousands of people over the course of the event.

A successful photography competition relies heavily on the quality of its judges, and we have had a superbly talented and experienced judging panel in place for some years now. We welcomed two new judges this year too, Julian Calverley and Fergus Kennedy. You can read more about them overleaf, but I'd like to take this opportunity to extend our gratitude for the passion, diligence and expertise they bring to the process. It was another exceptionally tough year due to the extremely high quantity of wonderful images among the entries. We hope you enjoy looking through them as much as we did selecting them.

Steve Watkins – Editor, Outdoor Photography

SPONSOR AND PRIZES

In 1960, Åke Nordin founded Fjällräven in his basement in the Swedish town of Örnsköldsvik. From its very first innovative framed backpacks and lightweight outdoor jackets, Fjällräven has stayed true to its original mission of making it easier for more people to enjoy and stay comfortable in the great outdoors. Backed by its impressive heritage, the company has continued to grow and develop and its clothing and equipment is now popular with outdoor enthusiasts around the world.

All Fjällräven products are characterised by their functional, durable and timeless designs, and the company is best known for its adaptable G-1000 fabric. A hardwearing blend of polyester and cotton, the fabric is incredibly practical for life outdoors and can even be adapted with Fjällräven's natural Greenland Wax to suit the conditions. Passionate about protecting the environment that inspires it, Fjällräven is always looking for new ways to reduce its environmental impact; from its PFC-free Eco-Shell fabric to its highly ethical and fully traceable down-sourcing programme.

Overall winner prize

Selected from the adult cateogry winners, the overall winner of Outdoor Photographer of the Year wins an exclusive assignment in the Arctic to capture all the action and drama of the Fjällräven Polar dog sled expedition. Fjällräven Polar is the adventure of a lifetime, giving 'ordinary' people the chance to discover how amazing outdoor life is in the winter. It aims to demonstrate that anyone can experience the Arctic on an expedition, as long as they have the right knowledge and equipment. It is an approximately 300km-long winter adventure across the arctic tundra from Signaldalen in northern Norway to the forests surrounding Jukkasjärvi in Swedish Lapland. The participants drive their own dog sled throughout the journey, and are responsible for setting up their own camping equipment, along with caring for the dogs. Find out more about Fjällräven Polar at polar.fjallraven.com.

Category winner prize

Each category winner receives a Fjällräven Kånken No.2 Black Edition backpack plus £200 from *Outdoor Photography* magazine.

For more information go to fjallraven.co.uk

Steve Watkins
Judging Chair

Steve Watkins is the editor of *Outdoor Photography* magazine and has been a professional photographer and author for over 19 years. His work has taken him to over 60 countries and to every continent. He is the photographer and author of three bestselling BBC books in the 'Unforgettable Things to do...' series. Among his other editorial clients are the *Telegraph*, *Times*, *USA Today*, *Wanderlust*, AA Publishing and *Geographical*.
stevewatkins.com

Julian Calverley

Julian Calverley is a landscape and advertising photographer. At home both in the studio and on location, shooting people, landscape, automotive and lifestyle, his cinematic style, mixed with a resourceful and passionate nature, has gained him a trusted reputation with clients worldwide. Increased demand for his landscape work has spurred Julian on to make them available as editioned large format archival pigment prints. He has featured in *Lürzer's Archive 200 Best Ad Photographers Worldwide* for the last 8 years.
juliancalverley.com

Pete Bridgwood

Pete Bridgwood is a fine art landscape photographer and writer. He is fascinated by the creative foundations of landscape photography and passionate about exploring the emotional elements of the art. He is the creator and curator of the national biennial landscape photography exhibition Masters of Vision, held at Southwell Minster Cathedral in Nottinghamshire. He is a Fuji X-Photographer and a Manfrotto Ambassador.
petebridgwood.com

THE JUDGES

Brought together for their superb knowledge and critical insight into imagery from all the genres within outdoor photography, the judging panel, along with the Fjällräven UK CEO, ensures the selection process is rigorous.

Fergus Kennedy

Fergus Kennedy is an experienced photographer and filmmaker. Originally a marine biologist, he loves exploring the underwater world, camera in hand. More recently he has been getting heavily into drone photography and video work and is currently writing a book on the subject. His work has been highly commended in Wildlife Photographer of the Year and his clients include BBC, ITV, Canon, Toyota, Nissan, *National Geographic Arabia* and World Wild Fund for Nature.

ferguskennedy.com

David Baker

David Baker has been a photographer since 2005, showcasing his work on his long-standing photoblog. He is a member of Landscape Collective UK, a group of 14 photographers. David is a regular exhibitor both in a sole and collaborative capacity. He exhibited at the 2016 Royal Academy Summer Exhibition. He has published two books, *Sea Fever*, by Triplekite, and *Ridge Trees*, by Kozu Books. David was the overall winner of Outdoor Photographer of the Year in 2012.

milouvision.com

Andy Luck

Andy Luck is an award-winning wildlife short programme producer, and also an environmental photojournalist with a passion for cameras and photography. He worked for the BBC for over 20 years, and now runs his own photography, filming and production company. His work has been widely published, and he is a regular contributor to *Outdoor Photography* magazine.

wildopeneye.com

Pete Webb

As one of Europe's leading and most sought after adventure sports photographers, Pete Webb's style has emerged from surf and mountain sports. He shoots the sport, the people, the places and the clothing. With more than 25 years of working with the best athletes in challenging places and the ability to tell a story in pictures his work is used by the most discerning of clients.

petewebb.com

Andrew Parkinson

Andrew Parkinson is a professional wildlife photographer who lives on the fringes of Derbyshire's Peak District, England. Though he has travelled widely, his greatest passion is for the wildlife and wild places of Britain. He has worked on assignment for *National Geographic* and regularly contributes to *BBC Wildlife* magazine and *Outdoor Photography*, and has also been published in the *New York Times*, the *Guardian* and the *Telegraph*.

andrewparkinson.com

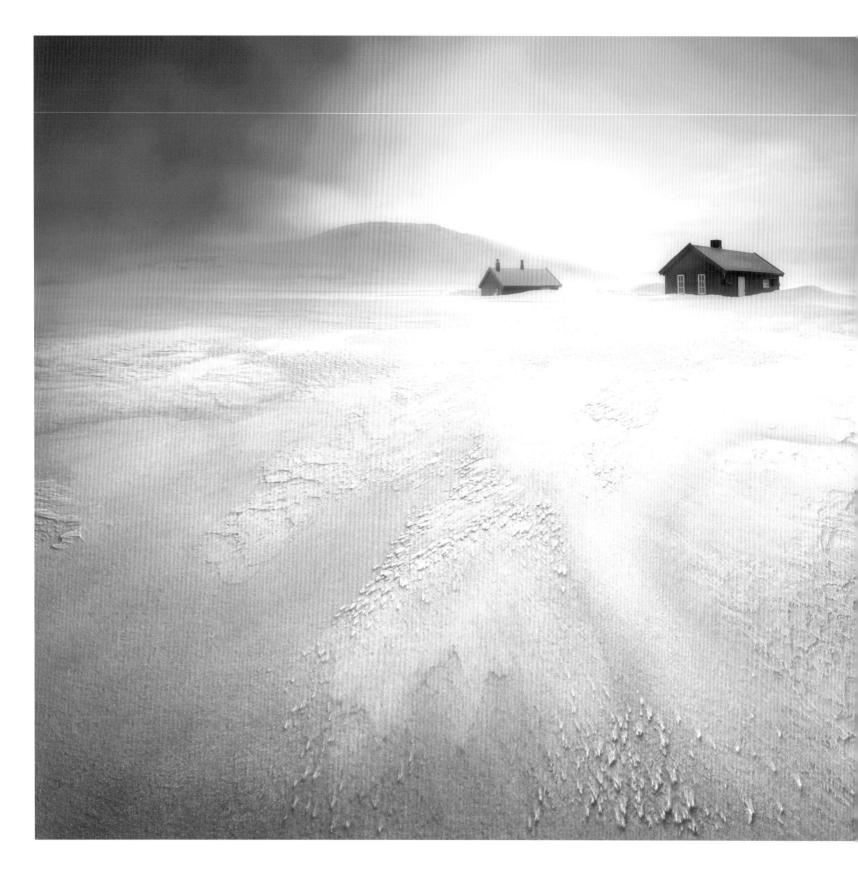

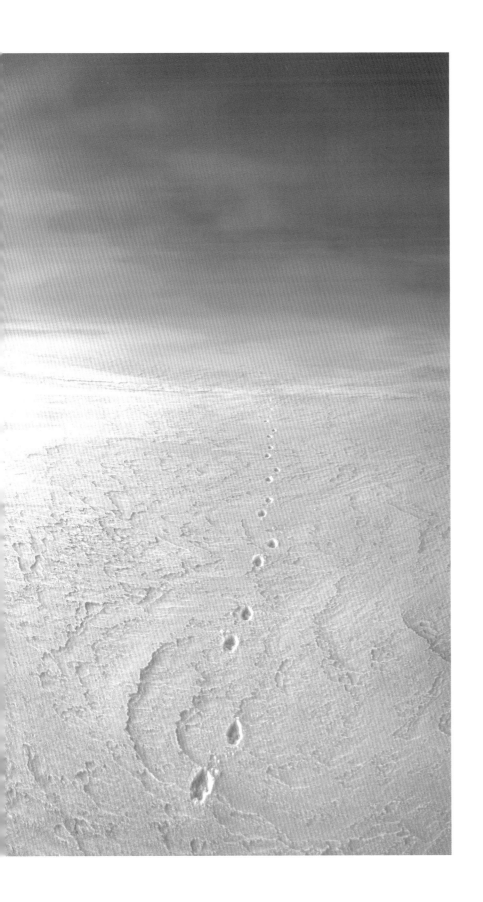

OUTDOOR
PHOTOGRAPHER
OF THE YEAR

OVERALL WINNER

Stian Nesoy (Norway)

Hardangervidda National Park, Norway. After days of frigid snowstorms, a break in the weather revealed an otherworldly landscape near these hunters' cabins. The little footprints were left behind by a lone arctic fox during its relentless search for food in this barren wilderness. After scouting this frozen scene before sunrise, I discovered a spot with a snowdrift leading into the light. The placement of the hill to the left and the tracks made for a balanced image. The image is captured in a wide panoramic format to convey the vastness of the surroundings. I captured the image just before the sun broke the horizon, making for a softly lit scene that helps the textures come alive.

Canon EOS 5D MkII with Canon 17-40mm f/4 L lens at 17mm, ISO 100, 1/50sec at f/16, tripod. This is a panorama stitched from a series of vertical shots

stian.photo

AT THE WATER'S EDGE

Lakes, rivers, waterfalls and the coast make for some of the most appealing
outdoor photography subjects. We wanted to see inspiring images of them
either in their wider environment or more intimate views.

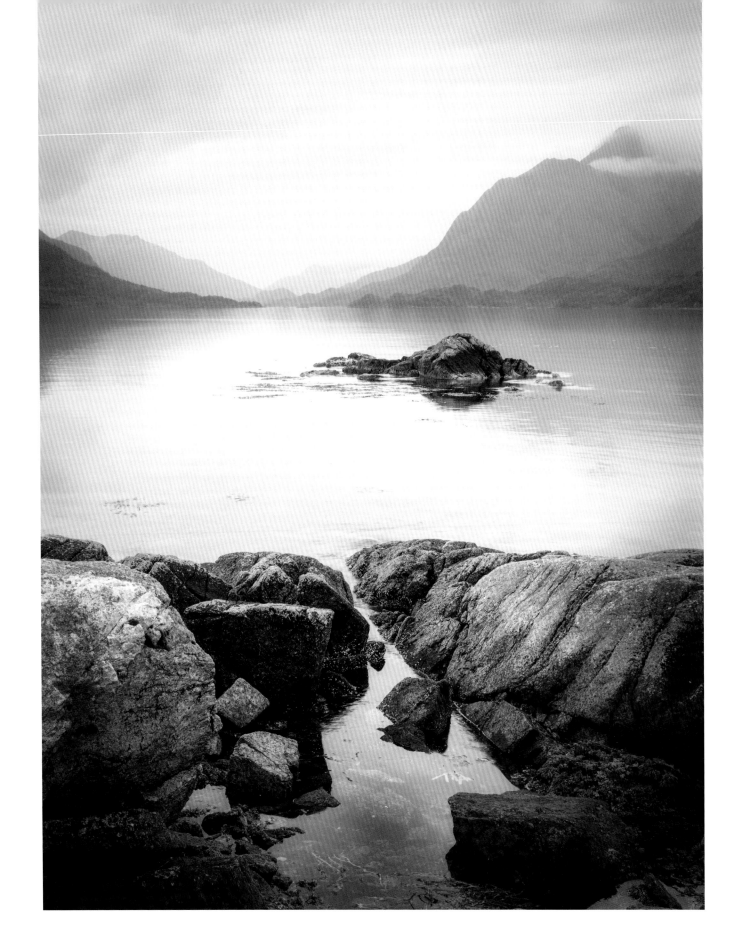

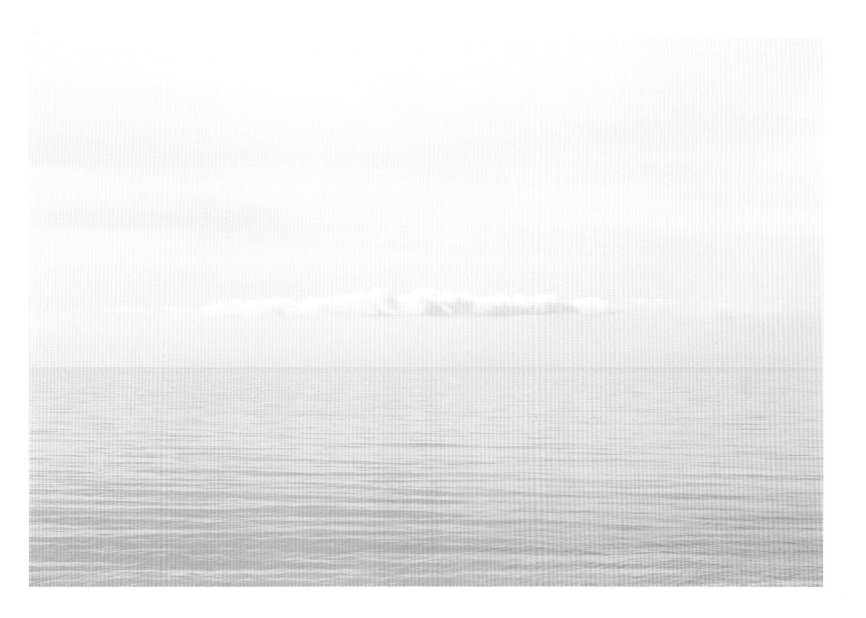

AT THE WATER'S EDGE – WINNER

Pete Hyde (UK)

Left: **Gavlfjorden, Holm, Langøya, Norway**. Having driven several miles up a minor road, we came to the small harbour at Holm. After a short walk, we were presented with this wonderful view up a small side-branch of Gavlfjorden. The soft, misty light and the calmness of the water were perfect for conveying the peace and tranquillity we were privileged to enjoy.

Sony ILCE-7R with Canon EF 24-105mm f/4 L lens at 32mm (attached via Metabones adapter ring), ISO 100, 1/2sec at f/16, tripod

flickr.com/photos/39281598@N04

Richard Thomas (UK)

Mudeford, Dorset, England. This image was taken the morning after a 'blue moon'. The sea was flat, with a calmness the like of which I've not seen before on the coast. A cloud developed over the Isle of Wight and I watched and waited until it made its way to open water before taking this minimalist photograph.

Canon EOS 5D MkIII with Canon 24-105mm f/4 L lens at 105mm, ISO 200, 1/2000sec at f/8, handheld

richardthomas.photography

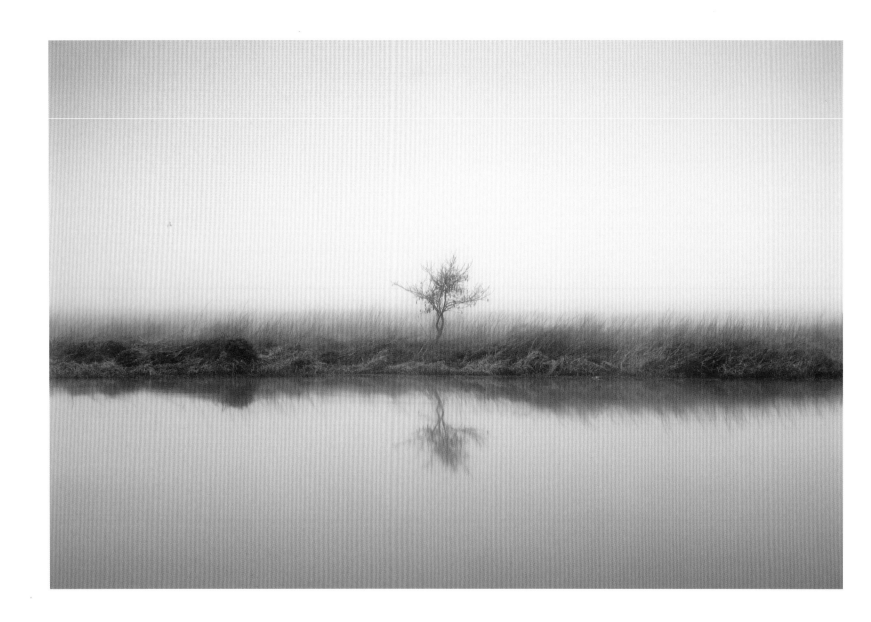

Craig Denford (UK)

River Wey, Ripley, England. The chance of fog will always get me out of bed early, and this was one of those days. A thick fog reduced visibility to a few metres and it was perfectly still and quiet – save for the crows. When I came across this lone tree, isolated from the background by the conditions, it perfectly embodied the feeling of peaceful solitude.

Canon EOS 7D MkII with Canon 24-105mm L lens at 24mm, ISO 100, 5sec at f/16, 0.9 ND grad, tripod, cable release

craigdenfordphotography.co.uk

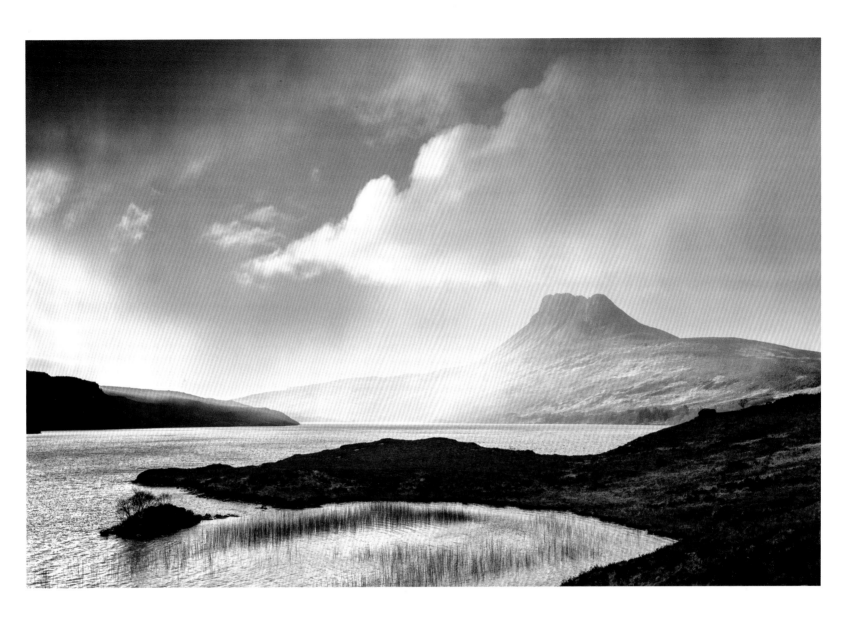

Jackie Matear (UK)

Stac Pollaidh, Loch Lurgainn, Inverpolly, Scotland.
The late afternoon light was lovely when I arrived
at Loch Lurgainn. Gusting winds soon signalled the
arrival of the next storm, and dark clouds began to
roll in. There was a brief burst of sunlight on Stac
Pollaidh before hail and heavy rain blew across the
loch and the view disappeared completely. A short
time later, the sky cleared and sunshine returned.

*Canon EOS 5D MkII with Canon 17-40mm lens at 35mm, ISO
100, 1/20sec at f11, 0.6 ND soft grad, 0.3 ND hard grad, tripod*

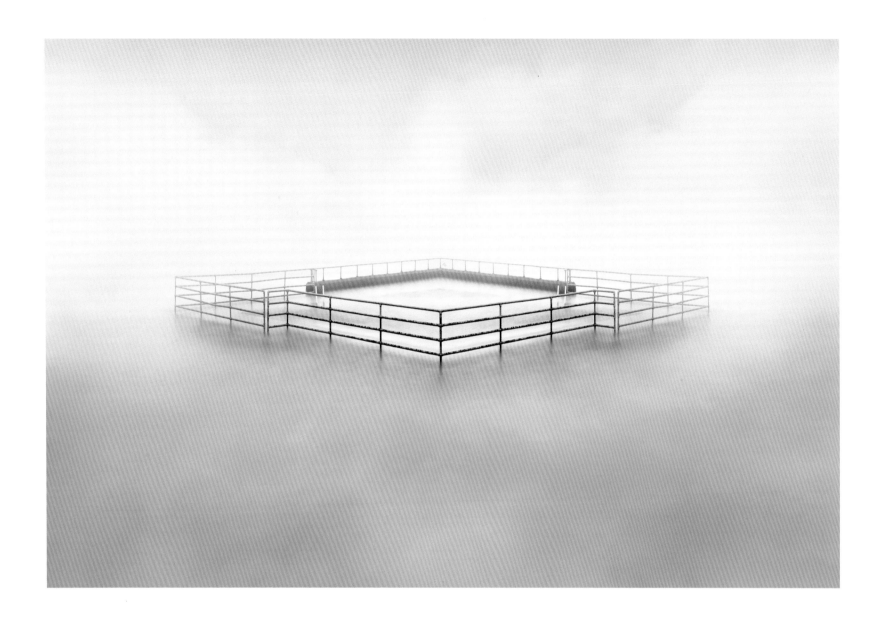

Neil Burnell (UK)

Shoalstone sea pool, Brixham, Devon, England. I'd had this idea for a misty minimalistic shot at Shoalstone sea pool for quite some time. I wanted to mirror image a section of the pool to give it a totally different appearance. I set up my camera with a 35mm lens and framed the corner section of the pool. The long exposure created a surreal feel to the shot. In post-processing I then mirrored the section of the pool, split-toned the image green/blue and faded out the horizon.

Nikon D810 with Nikon 35mm f/1.8 lens, ISO 100, 77sec at f/14, Formatt Hitech 10-stop Firecrest, Manfrotto tripod

neilburnell.com

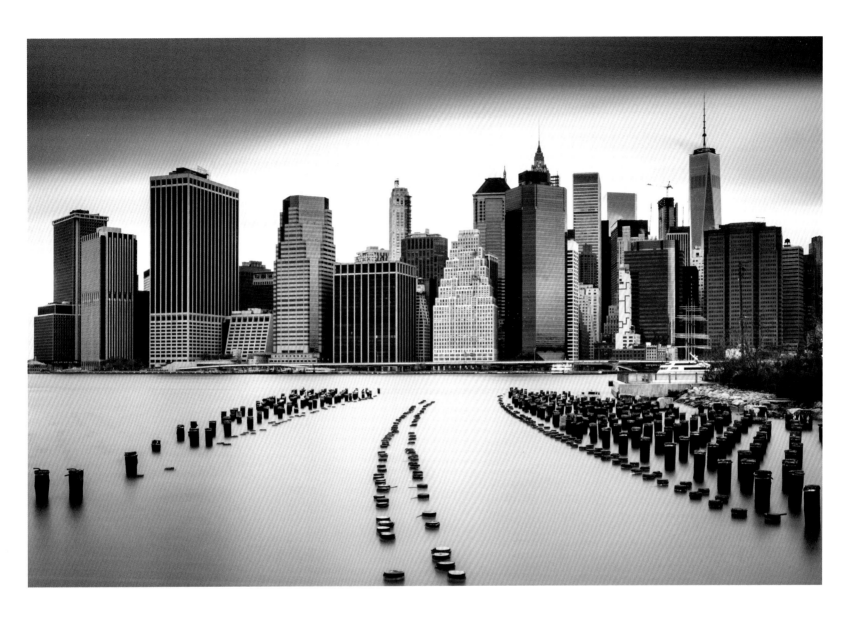

Robert Bolton (UK)

Brooklyn looking towards Manhattan, New York, USA. I was working in New York and had some free time one afternoon. The conditions were fairly overcast and I had in mind a monochrome, long exposure shot from Brooklyn Bridge Park, as I had taken a night shot of the Manhattan skyline from the same location on a previous visit. I knew the wooden foundations of former warehouses made for an interesting foreground, so framed the shot while perched precariously on a stone breakwater.

Fuji X-E1 with Fuji 18-55mm lens at 26mm, ISO 200, 125sec at f/22, Lee Big Stopper, Lee 0.9 ND grad, tripod

capturedlandscape.co.uk

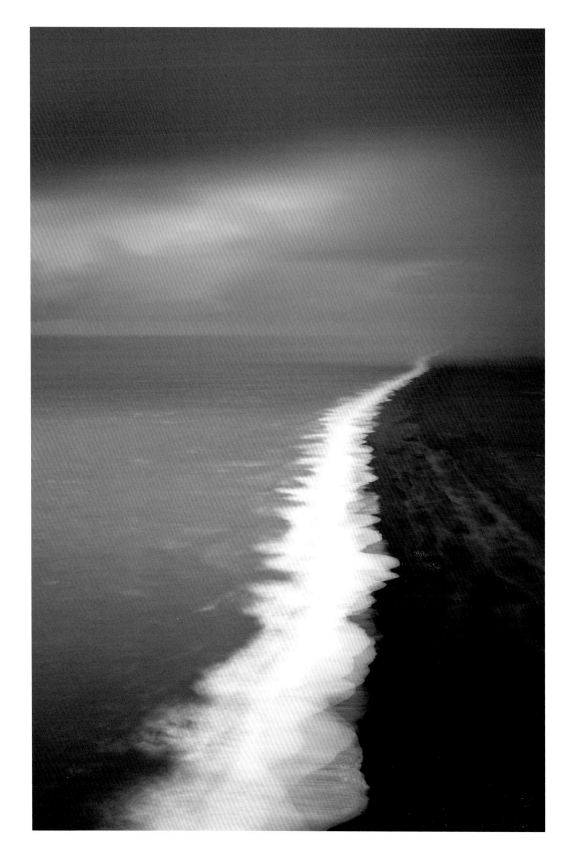

Rachael Talibart (UK)

Dyrhólaey, Iceland. I liked this view looking west from the top of the Dyrhólaey peninsula because of the contrast between the white surf and the velvety, black sand. I also noticed the way passing showers obscured the horizon, making it seem as if the line of surf disappeared into the distance. I decided to use a long exposure to simplify the texture in the breaking waves and emphasise the contrast that had attracted me to the scene in the first place.

Canon EOS 5DS R with Canon EF 24-70mm f/4 L IS USM lens at 44mm, ISO 100, 30sec at f/16, Lee Little Stopper, tripod

rachaeltalibart.com

Rachael Talibart (UK)

Seven Sisters, East Sussex, England. I visit East Sussex almost every week and have photographed the cliffs in all moods, from savage to serene. On this very still spring afternoon I used a long exposure to simplify the textures and emphasise the peaceful atmosphere. The temptation was to shoot wide to include the entire first cliff, but choosing a long focal length allowed me to make the far cliff and lighthouse more significant, and thus, paradoxically, created more depth.

Canon EOS 5DS R with Canon EF 70-200mm f/2.8 L IS II USM lens at 200mm, ISO 100, 30sec at f/13, Lee Big Stopper, tripod

rachaeltalibart.com

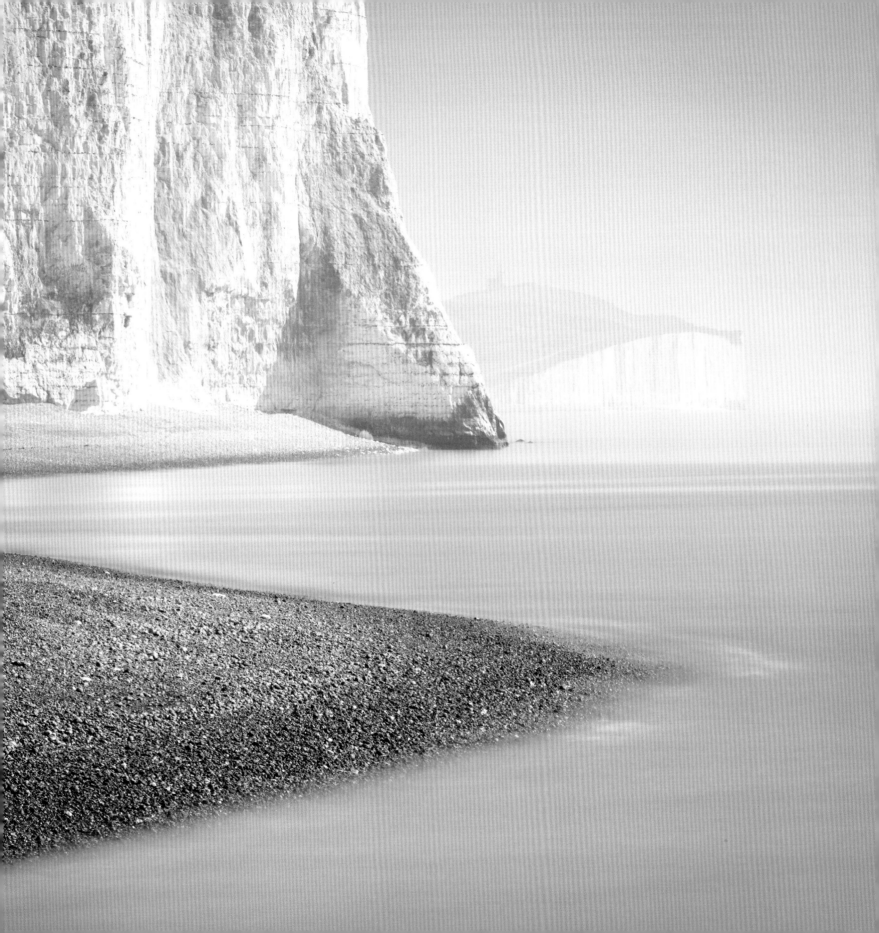

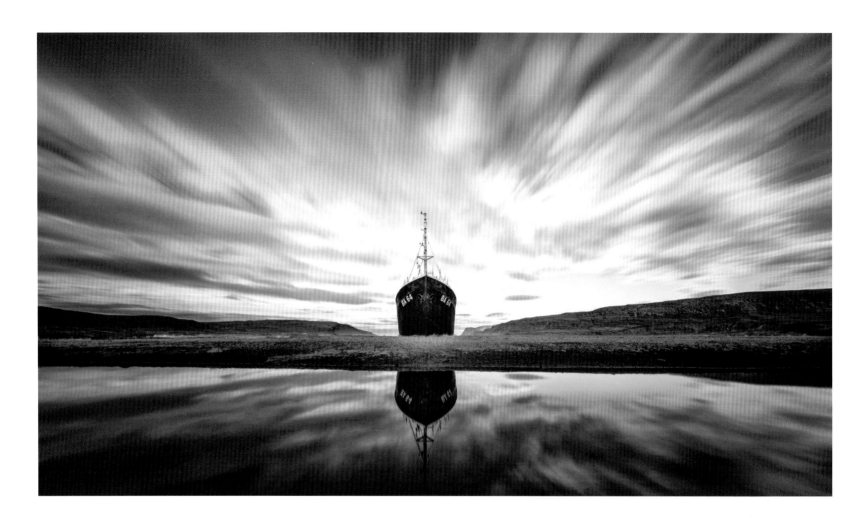

Jóhannes Frank (Iceland)

Patreksfjörður, Iceland. Garðar BA 64 is an old whaling and fishing boat that was built in 1912, the same year Titanic sank. It has served many owners and was a very successful fishing ship in Iceland. In 1981 the last owner decided it would be best to put the ship on this shore instead of sinking it, as is often done with old boats. This created a perfect photo opportunity. I lived in this fjord many years ago, and now when I visit I usually try to take images of this boat, with mixed results. On this visit I was wondering if the small river running in front of the boat would be bigger than usual. It was, and gave me an opportunity to try a shot I had wanted to take for a while.

Nikon D750 with Nikon 14-24mm lens at 14mm, ISO 100, 119sec at f/22, 10-stop Lee filter, tripod

johannesfrank.com

Stephen King (Hong Kong)

River delta, south Iceland. An aerial image shot from a helicopter over a stunning river delta in the south of Iceland. The river is fed by glacial meltwater, which winds its way over lava fields and lava sand and into the ocean. We were fortunate to fly on a brilliantly sunny day, which enhanced the colours of the minerals picked up by the meltwater. The scene was like a giant painted canvas.

Canon EOS 5D MkIII with EF 24-70mm f/2.8 L II USM lens at 70mm, ISO 400, 1/2500sec at f/2.8, polariser

stephenking.photo

William Eades (Australia)

Following page: **Port Macquarie, New South Wales, Australia**. The size of this storm was immense, stretching 500km inland and producing winds of up to 80mph. It caused havoc in Melbourne first with 20,000 power outages, and then commenced its 18-hour mission up the coast of east Australia. After causing the evacuation of beaches across Sydney, the front reached our small town by nightfall, where a friend and I were waiting to intercept it.

Nikon D810 with Nikkor 16-35mm f/4 lens at 35mm, ISO 1250, 20sec at f/4, Gitzo tripod

willeades.com.au

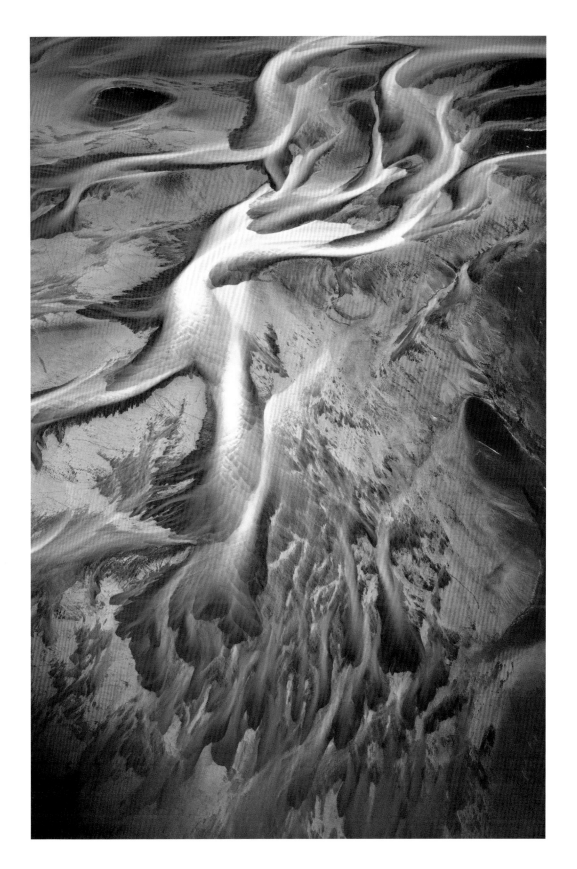

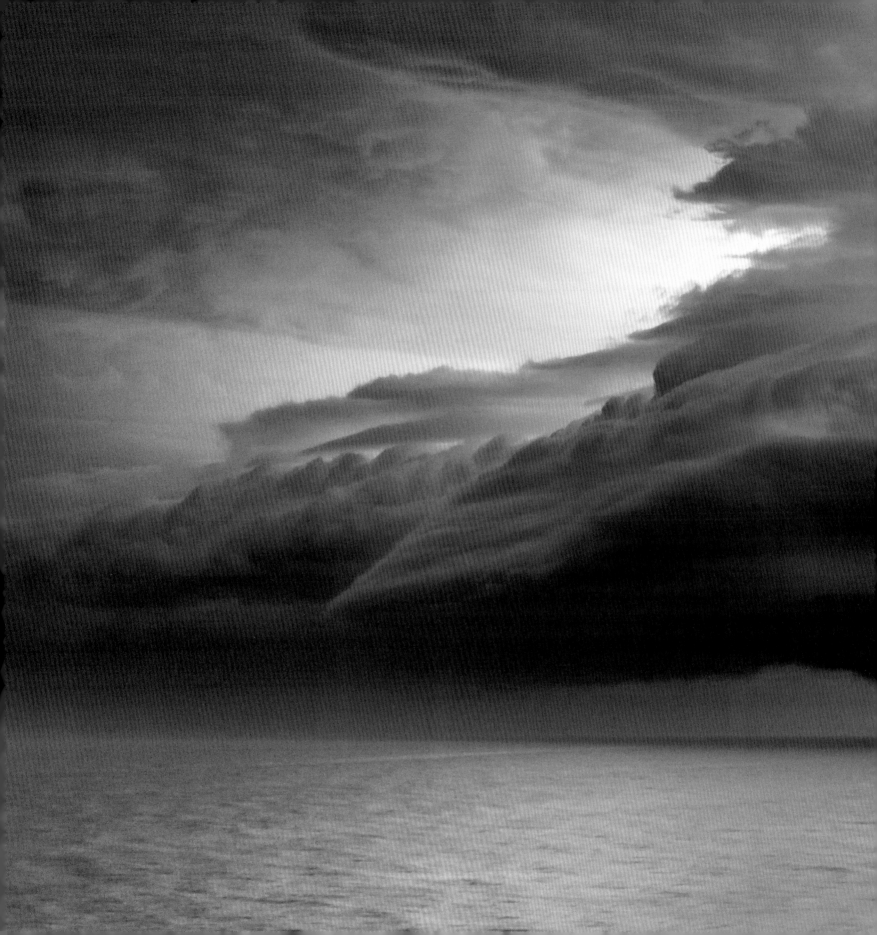

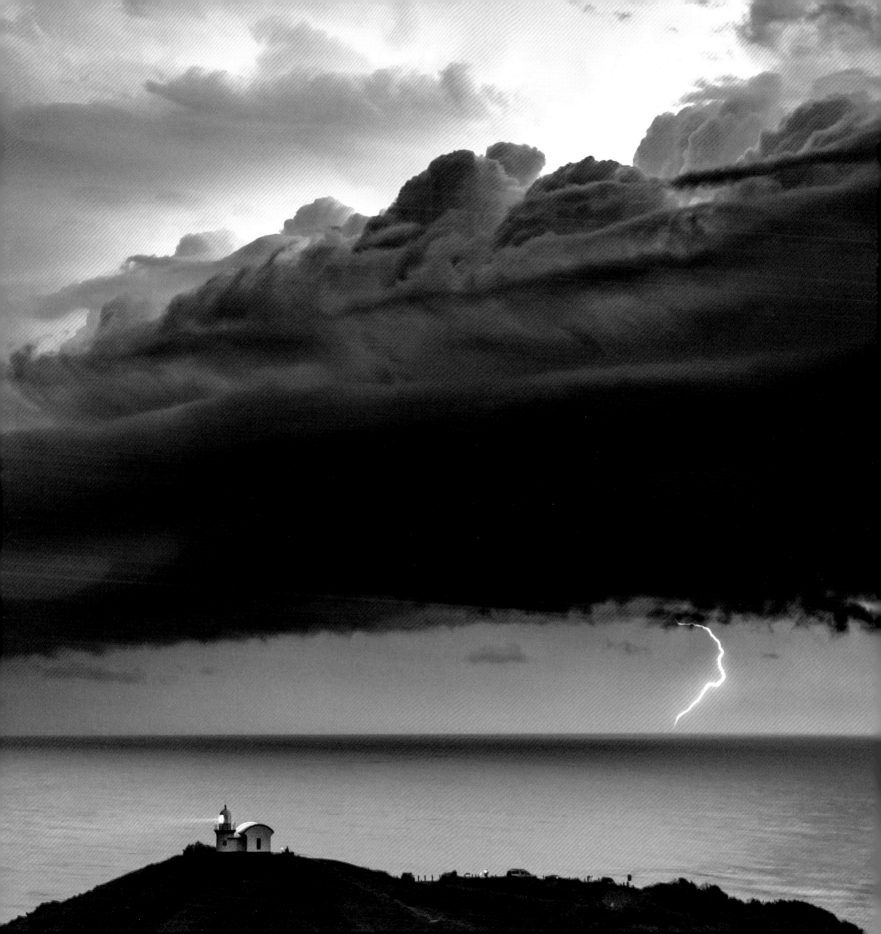

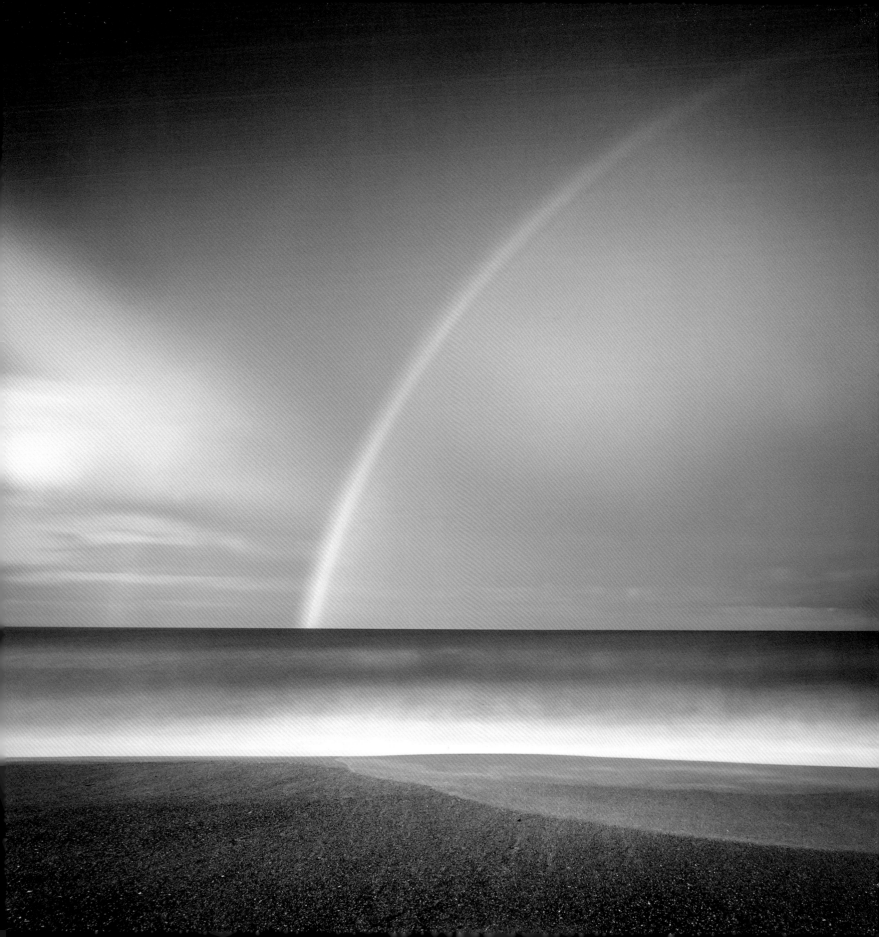

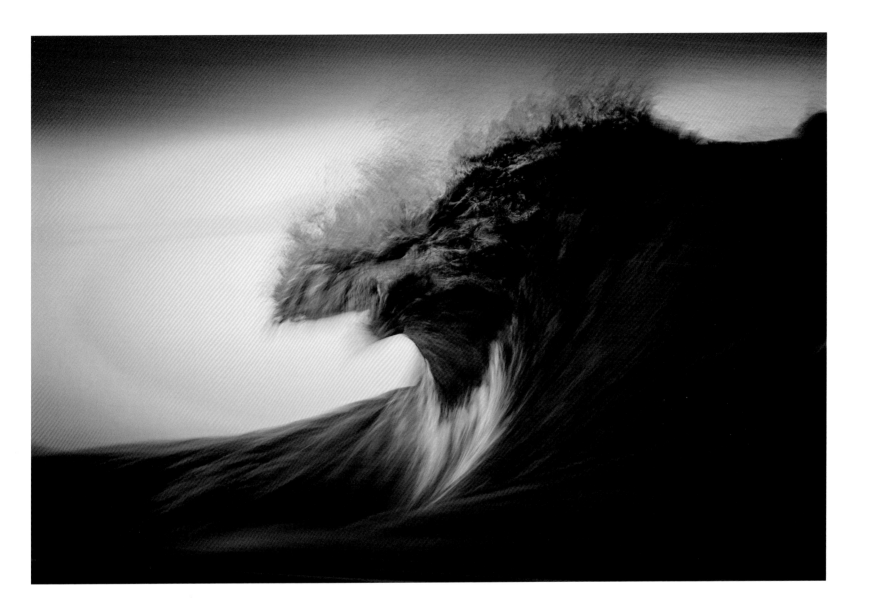

Tom Lowe (UK)

Left: **Blyth Beach, Northumberland, England**.
This was one of those 'right place, right time' shots.
As I parked my car at Blyth beach I noticed an
extremely vibrant rainbow appearing out over
the North Sea. I grabbed my gear and quickly ran
down to the water's edge to set up. This was the only
exposure I managed before the rainbow faded away
and the heavens opened, soaking my camera and me.

*Canon EOS 6D with Canon EF 17-40mm f/4 L USM lens
at 21mm, ISO 50, 52sec at f/16, Hoya Pro ND1000, tripod*

f22digital.com

Warren Keelan (Australia)

New South Wales, Australia. I really enjoy the challenge of jumping from the
rocks into dark ocean water and then waiting for the sun to rise over the horizon,
bringing life to the surface of the sea. This image was captured handheld while
swimming under an eerie sunrise. Treading water in this liquid energy while
trying to compose a shot is difficult, and makes this image all the more personally
rewarding – I tend to miss a lot to achieve something worth keeping.

*Canon EOS 5D MkIII with Canon 70-200mm IS II f/2.8 lens at 200mm, ISO 320, 1/20sec at f/10,
Aquatech underwater housing, handheld*

warrenkeelan.com

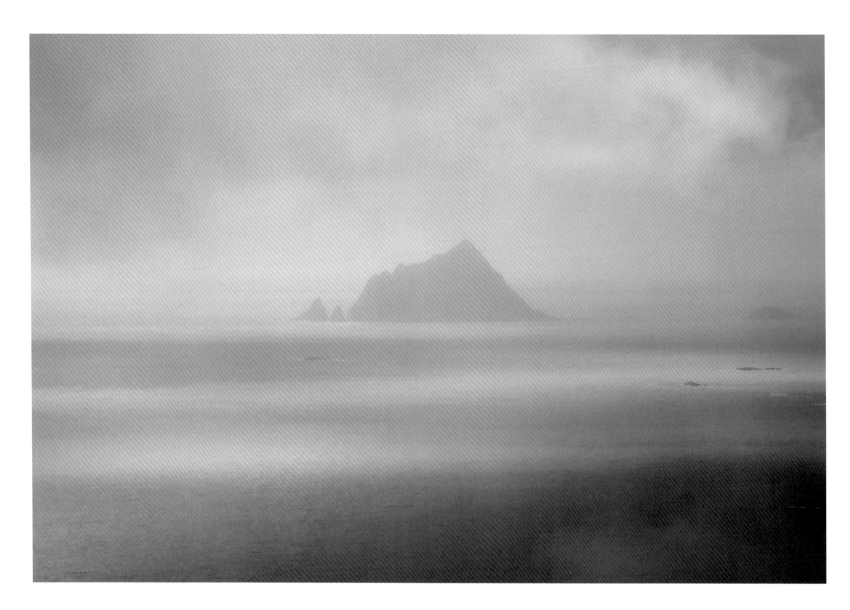

David Wrangborg (Norway)

Tromtinden, Troms, Norway. I love arctic light but I'm especially fond of its interaction with the ocean; this marriage between water and light at times has a watercolour look. Usually the display is more impressive when viewed from a high angle, so when I hike up the peaks along the coast I always carry a telephoto lens and tripod. These allow me to single out a small portion of the scene and to use longer exposure times to accentuate the painterly look.

Pentax K-3 II with Pentax-DA 55-300mm f/4-5.8 ED lens at 230mm, ISO 100, 0.3sec at f/14, polariser, tripod

wrangborg.se

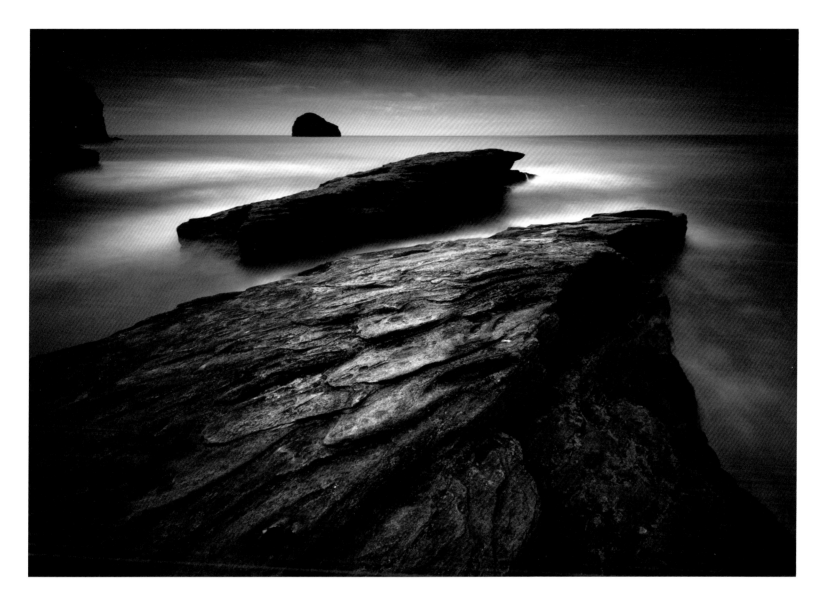

Dominic Byrne (UK)

Trebarwith Strand, Cornwall, England. When
I saw the scene I knew this would be a black & white
image, and I wanted to capture the texture of the
rocks contrasted against the sea. In order to do this
I had to use a long exposure to sufficiently 'flatten'
the sea but I also wanted to keep enough information
visible to show the moodiness of the scene.

*Nikon Df with 16-35mm lens at 16mm, ISO 200, 44sec at f/16,
10-stop filter, tripod*

dominicbyrne.com

Sarah Rose (UK)

Following page (left): **Loch Ard, Stirling, Scotland**.
This particular morning the weather conditions
looked favourable for a good sunrise, so I left home
at 3am to ensure I arrived in plenty of time. After
I had taken some photographs at my planned sunrise
location, I walked around the loch and spotted this
little fishing boat in the water. Just as I got into
position the sun broke through the clouds, which
created a few minutes of beautiful light.

*Canon EOS 5D MkIII with Canon 24-105mm lens at 24mm,
ISO 100, 0.8sec at f/16, polariser, 0.3 ND grad, tripod*

sarahrosephotography.co.uk

Louis Murphy (UK)

Following page (right): **Rothwell, Lincolnshire
Wolds, Lincolnshire, England**. I visited this location
after working a night shift. Mist was forecast and
I suspected there would be a chance of some lovely,
soft light. The tree-covered island in the middle of
the pond caught my attention, coupled with the tree
on the far bank and reflections. I set up with my
tripod and feet in the water in order to remove
distracting foreground grasses.

*Canon EOS 6D with Canon 24-105mm f/4 L lens at 24mm,
ISO 50, 1sec at f/16, polariser, tripod*

flickr.com/photos/louismurphy

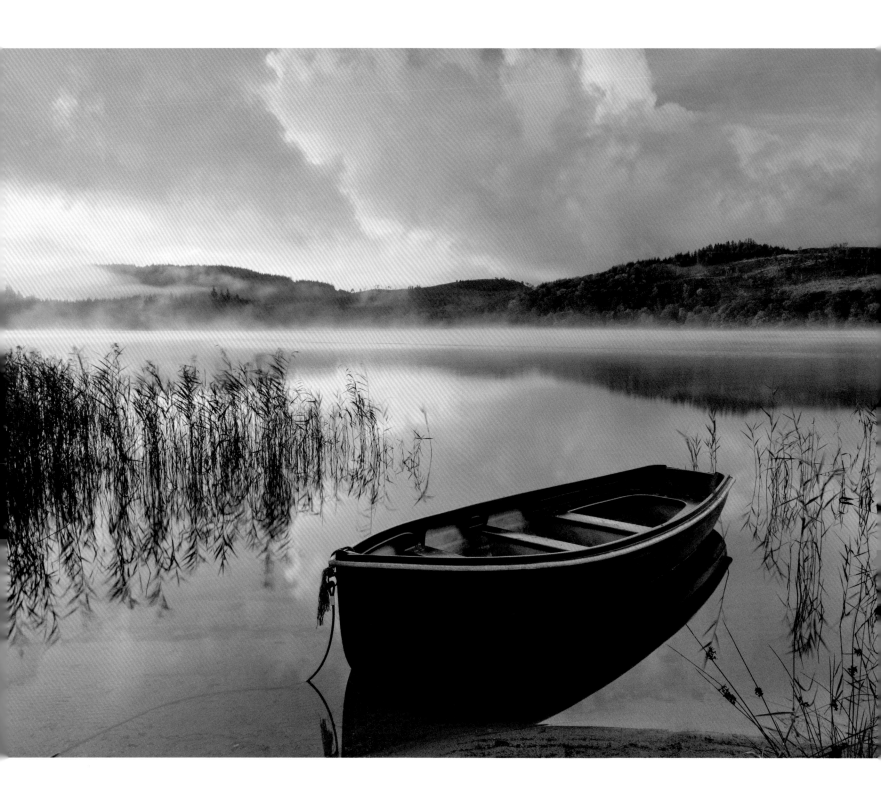

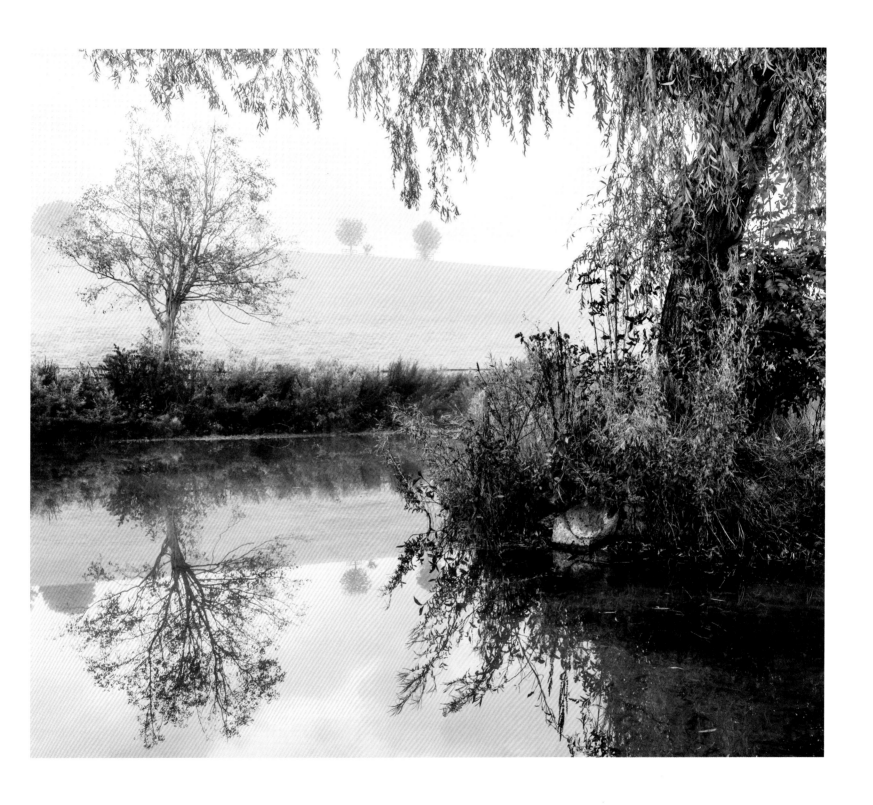

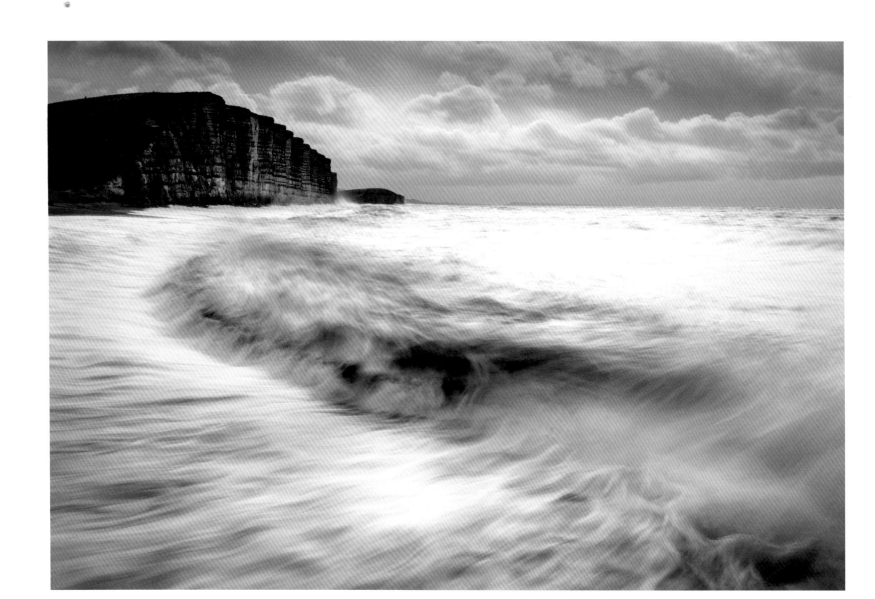

Paul Mitchell (UK)

West Bay, Dorset, England. West Bay in Dorset is one of the most dramatic sections of the famous Jurassic Coast. On the day I visited, it was bitterly cold with a heavy swell out at sea. I quickly decided that an exposure time of approximately half a second would introduce a slight softening of the breaking surf while retaining shape and form.

Nikon D810 with Nikkor 24-70mm lens at 35mm, ISO 64, 0.3sec at f/22, Lee 0.6 ND grad, Gitzo tripod

paulmitchellphotography.co.uk

Stuart McGlennon (UK)

Whitehaven, Cumbria, England. I'd known the south shore at Whitehaven harbour was a potential location for some time but hadn't got round to shooting there. This shot was taken on my first visit, which was simply a recce for possible places to try some astrophotography. When I got home and viewed the files, I was pleasantly surprised at the results. I'll definitely be returning there.

Nikon D610 with 16-35mm f/4 lens at 17mm, ISO 50, 30sec at f/9, 10-stop ND, polariser, Manfrotto tripod

flickr.com/photos/lensdistrict

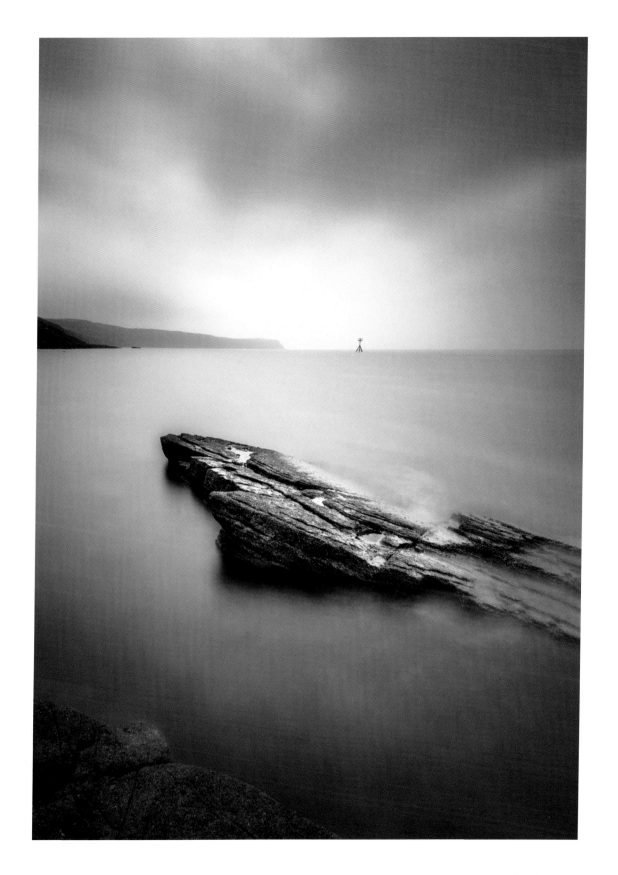

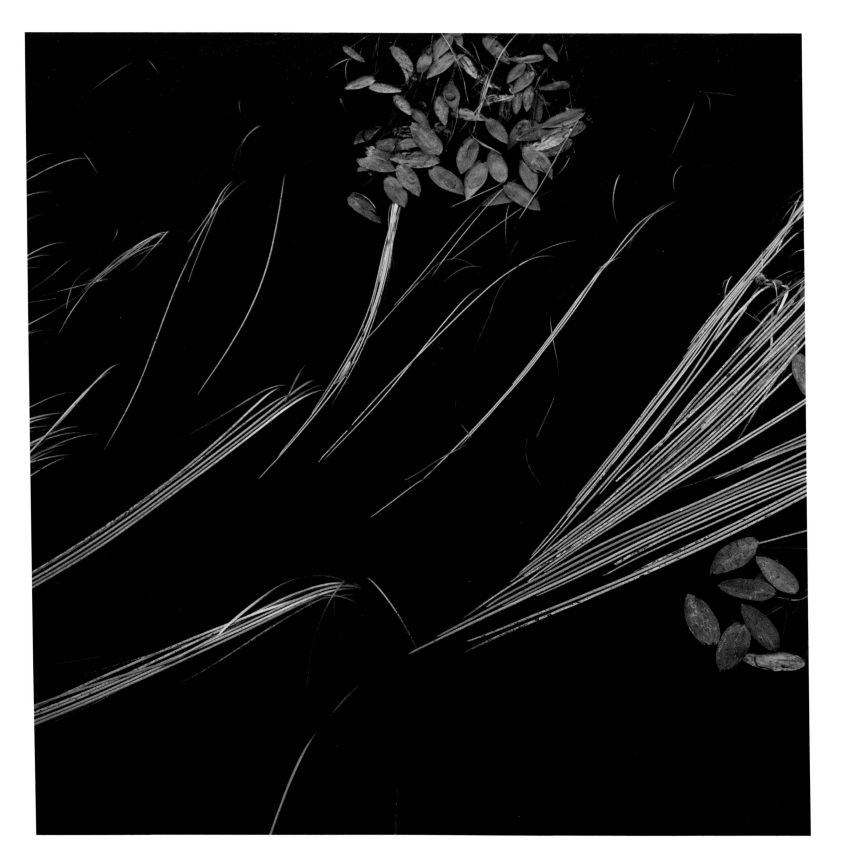

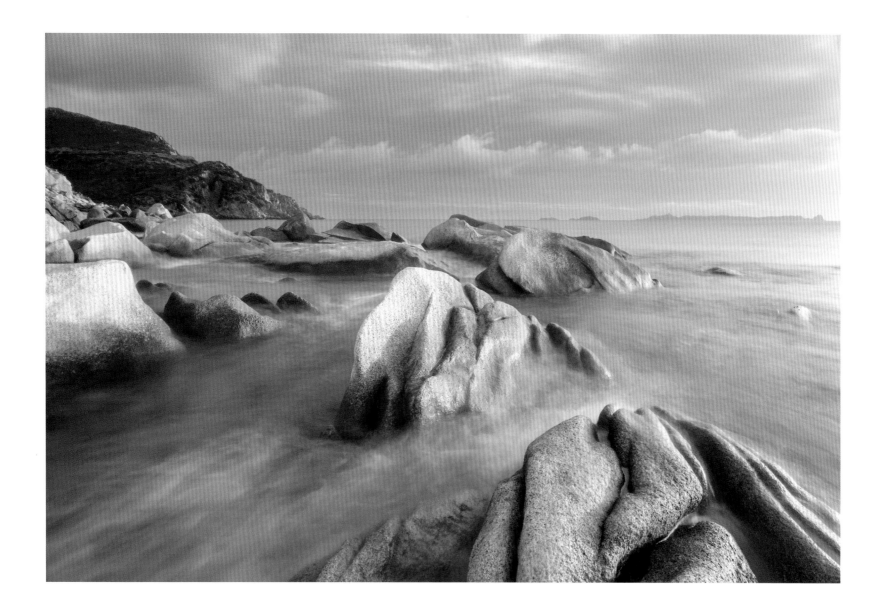

Lizzie Shepherd (UK)

Previous page (left): **Golden Road, Isle of Harris, Scotland**. The Isle of Harris is home to countless lochans, many of which can be found alongside Golden Road. The patterns created by a variety of water-loving plants often evoke oriental art and calligraphy. Here I wanted to emphasise the lovely shapes of nature, with the dark, peaty water providing the perfect foil for this living art arrangement. I had to lean over the water to get the required angle of view.

Fuji X-T10 with Fuji 18-55mm lens at 28mm, ISO 400, 1/40sec at f/6.4, handheld

lizzieshepherd.com

Melanie Collie (UK)

Previous page (right): **Porthcadjack Cove, Portreath, Cornwall, England**. I grew up by the sea before a move for work drew me inland, but it was inevitable I would return to the coast, to the patterns of time and tide. I embraced the creative constraints of having no car and a broken Canon EOS 6D camera and, armed with my smartphone, went to the local coastline to look for interesting coves. I tried to capture the stillness and calm that is hidden half the time in the ebb and flow at the water's edge.

Apple iPhone 6s with 4.15mm lens at 4.2mm, ISO 50, 1/35sec at f/2.2, handheld

melcollie.co.uk

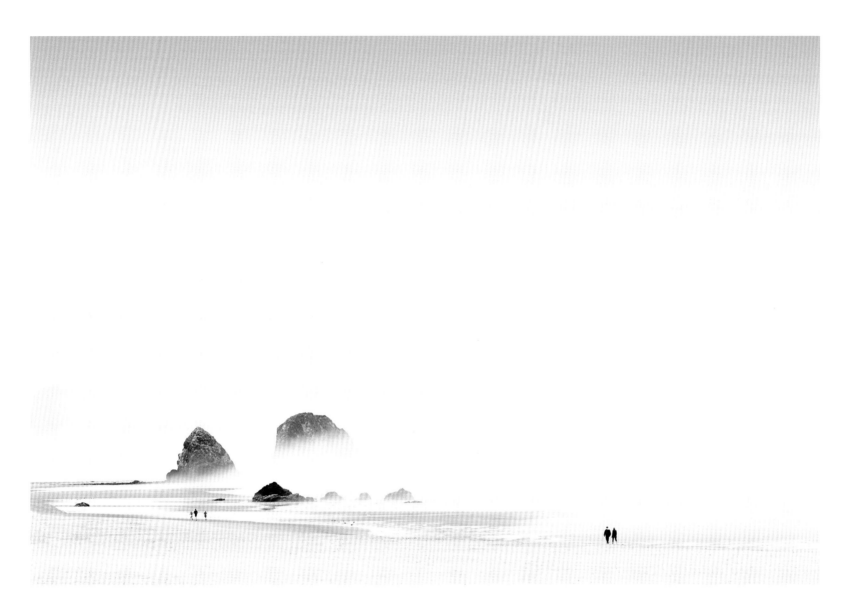

Perdita Petzl (Austria)

Opposite page: **Villasimius, Sardinia, Italy**. This photo was taken shortly after sunrise. The light had changed from incredible pink to yellow and golden and reflected beautifully on the wet stones in the foreground. After a few minutes the sun had disappeared behind the clouds and the show was over.

Canon EOS 5D MkIII with Canon EF 17-40mm f/4 L USM lens at 20mm, ISO 50, 3sec at f/13, tripod, remote release

500px.com/p_petzl

Lisa Mardell (UK)

Cannon Beach, Oregon, USA. It was a misty early morning in August on beautiful Cannon Beach in Oregon, with low cloud swirling around the sea stacks. I composed the image to include five people who were walking along the shore to show the scale of the sea stacks, which seemed immense to the eye when up close to them but it was quite difficult to portray the size with a camera.

Canon EOS 5D MkIII with 70-200mm f/2.8 IS lens at 115mm, ISO 400, 1/160sec at f/8, tripod

photographybylisamardell.co.uk

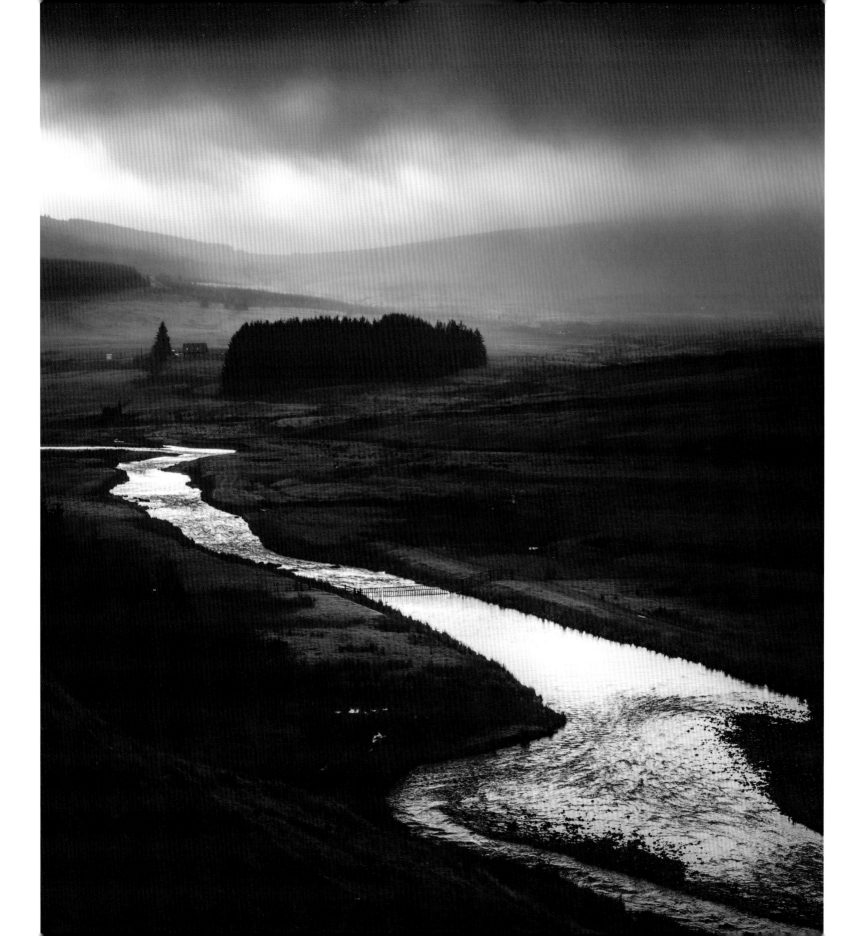

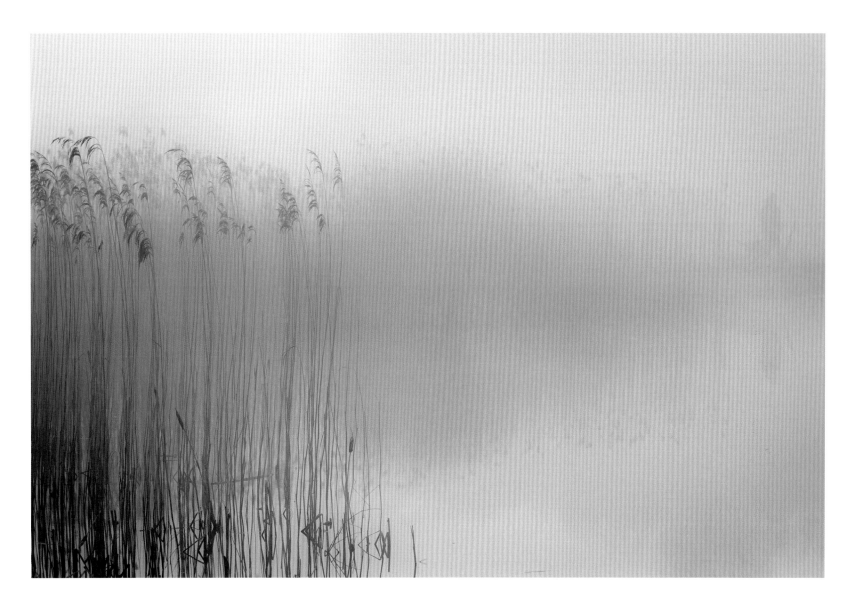

Dylan Nardini (UK)

Wintercleugh, South Lanarkshire, Scotland. Early winter storms were passing through very quickly, and I was drawn to a sudden burst of diffused light along the hills of Clydesdale. Daer Water flows down to form the beginning of the river Clyde, and was ideal for leading the eye to the large copse and small settlement on the hill, silhouetted by the dramatic low light.

Nikon D810 with Sigma 70-200mm f/2.8 lens at 70mm, ISO 100, 1/125sec at f/11, handheld

dylannardini.com

Steve Palmer (UK)

Black Lake, Lindow Common, Cheshire, England. Early one cold and damp February morning, I was at a local lake photographing the reeds and fog when I saw a dog walker making his way round the lake. I waited until he came round again and took the photograph just as he was leaving the frame. The final image was split-toned to enhance the feeling of the damp cold that the walker and I felt that morning.

Pentax K-5 II with Pentax DFA 100mm f/2.8 WR lens, ISO 400, 1/250sec at f/4.5, handheld

stevepalmer.photography

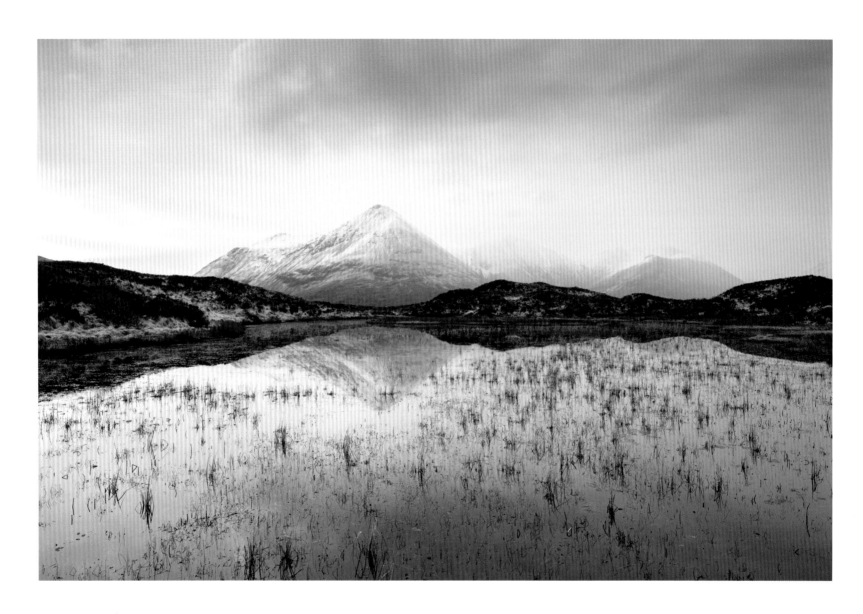

Nick Hanson (UK)

Glamaig, Sligachan, Isle of Skye, Scotland. There was no wind on this particular morning, and there was fresh snow on Glamaig and the Red Cuillin, so I headed to this loch before sunrise in the hope of photographing a reflection with some nice colour in the sky. To begin with, the colour was all to my left, but around 10 minutes before sunrise some lovely colours appeared in the sky above the Red Cuillin, bringing the final touches to my composition.

Canon EOS 5D MkII with Canon EF 16-35mm f/4 L IS lens at 25mm, ISO 100, 0.5sec at f/11, Lee 0.6 ND soft grad, Gitzo tripod

nickhanson.co.uk

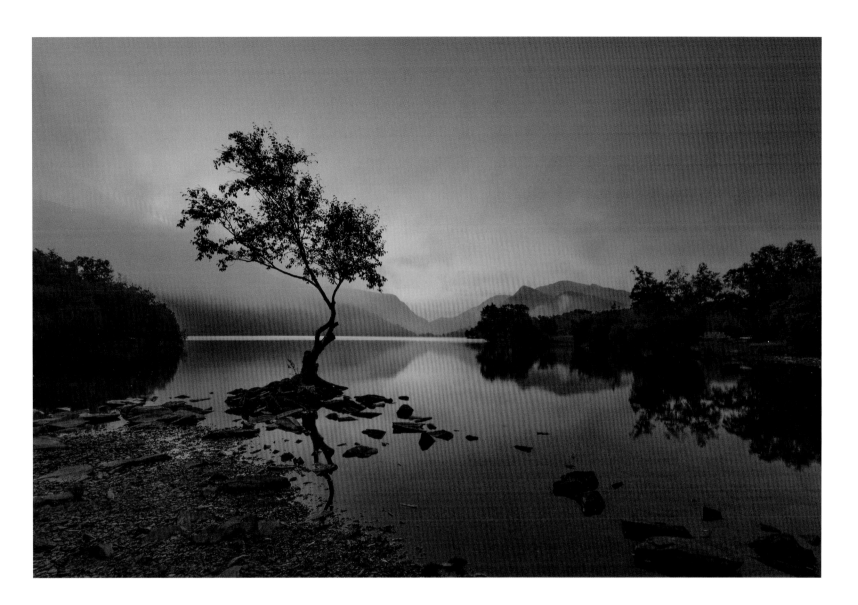

Steve Cole (UK)

Llyn Padarn, Gwynedd, Wales. I love photographing lone trees and I really wanted to photograph the iconic one at Llyn Padarn, with the mountains of Snowdonia as a stunning backdrop. I visited at dawn and was lucky to be treated to some early autumn mist as well as lovely dawn colours. I had to rethink the composition a little due to the low level of the water, and I used the rocks that are normally hidden under the water to lead the eye to the tree.

Nikon D7000 with Sigma 10-20mm f/4-5.6 lens at 10mm, ISO 100, 0.5sec at f/10, SRB 0.6 ND grad, Vanguard Alta 283 tripod

stevecolelandscapephotographer.com

WILDLIFE INSIGHT

There has never been a better time to be a wildlife photographer.
We were looking for compelling compositions showing the
spirit and behaviour of wildlife around the planet.

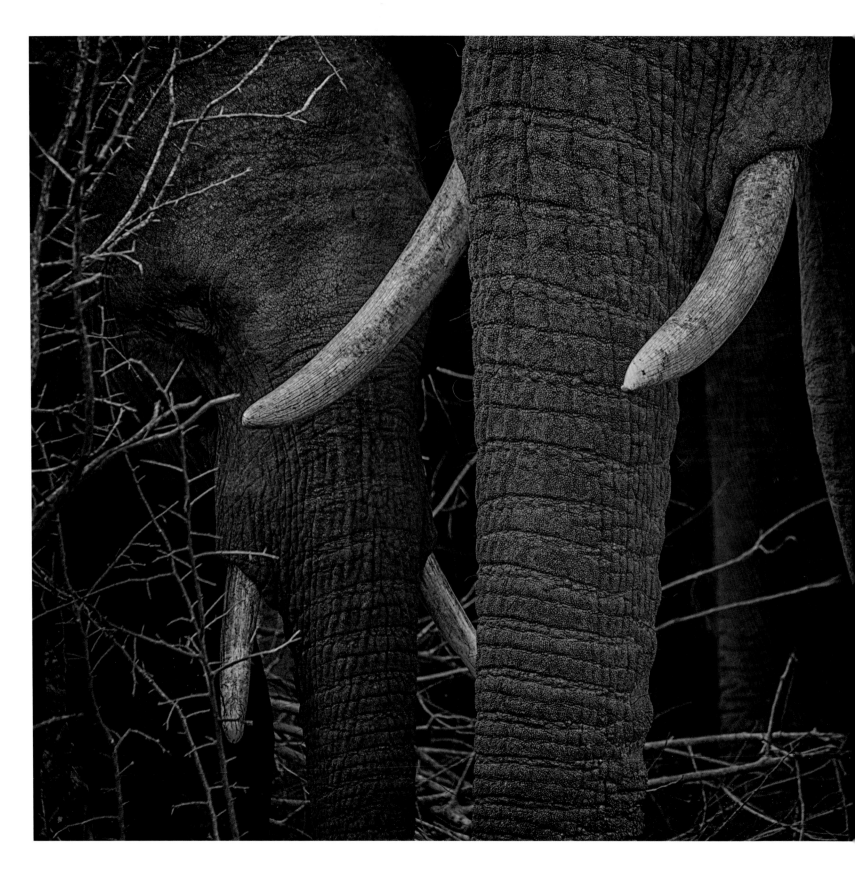

Alice van Kempen (Netherlands)

Lower Sabie, Kruger National Park, South Africa. In Africa, poachers slaughter an elephant every 15 minutes to supply the demand for ivory – that's 96 beautiful creatures a day. In 2016, as of the middle of September, there had been 36 elephants killed by poachers in the Kruger National Park alone – the highest number since 1982. With this in mind, I wanted to create a photograph to reflect the situation the elephants are in. I chose to capture the sad look of one of the elephants; a dark image that lets you focus on the tusks.

Nikon D800 with Sigma 50-500mm f/4.5-6.3 lens at 500mm, ISO 449, 1/125sec at f/10, beanbag

facebook.com/alicevankempenphotography

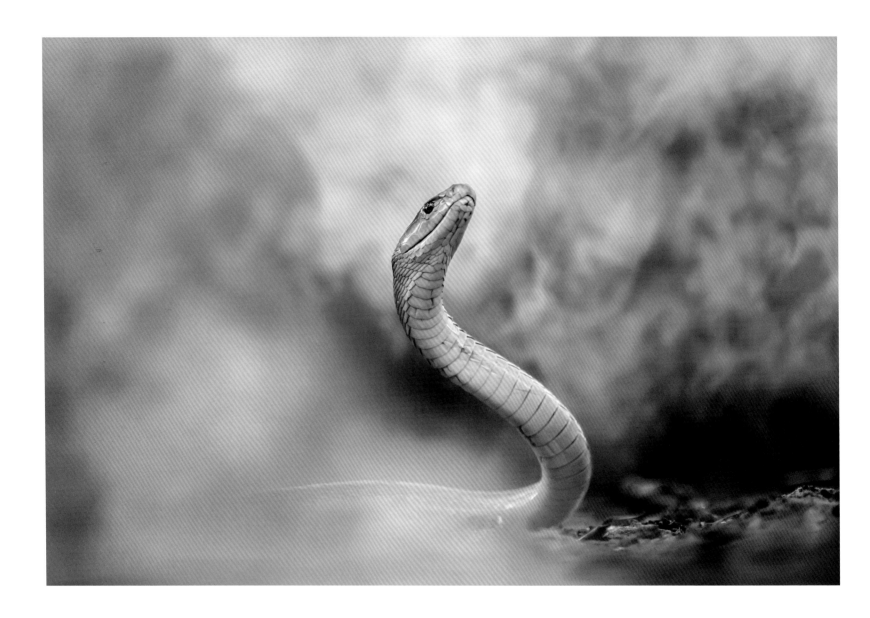

José Fragozo (Kenya/South Africa)

Ballito, Kwazulu-Natal, South Africa. Kwazulu-Natal is well known for its black mambas; especially in the Ballito area where human population expansion and encroachment on this reptile's habitat has caused increased human interaction with this species. I have joined conservationists Neville Wolmarans and Helen Bauermeister on several rescue missions to save black mambas. They are briefly submitted to data capturing and then released shortly after in an appropriate and safe habitat. This photo was taken during one of the missions.

Canon EOS 1DX with Canon 70-200mm IS II lens at 200mm, ISO 1000, 1/750sec at f/2.8

facebook.com/people/Jose-Fragozo/100008325378654

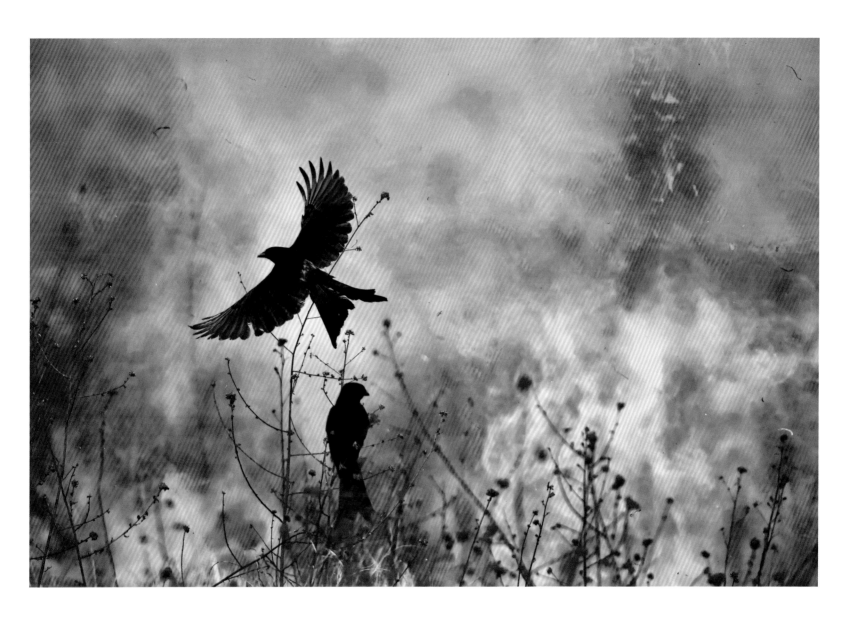

Kallol Mukherjee (India)

Singur, Hooghly, West Bengal, India. At the end of every winter, grassland farmers burn the grass and reeds to clean the land in preparation for the next crop. When the fire spreads across the land, it destroys the habitat of many birds and insects. As the fire progresses, most of the birds fly for shelter and small insects start fleeing the heat, but the black drongo birds act differently. This brave species capitalises on the moment by eating insects flying in the flames – the black drongos remind me of the legend of the phoenix.

Nikon D810 with 300mm f/4 lens and 1.4x teleconverter, ISO 2200, 1/4000sec at f/7.1, handheld

facebook.com/kallolmukherjee.photography

David Lloyd (UK)

Lake Nakuru, Kenya. The trees alone were good enough by themselves as photography subjects but there was a leopard on one of the boughs. It was repositioning itself now and again, but I needed something more to make it special. I waited, but the light was fading. At the moment the leopard sat and yawned, I captured what I'd hoped for. This image was taken in two parts and stitched together, as the light on the trees on the left side of the scene needed to be part of the picture. I then stitched an image of the left half of the woodland's sun's rays to recreate the scene as it was.

Nikon D800E with 400mm f/2.8 lens, ISO 900, 1/500sec at f/4, beanbag

davidlloyd.net

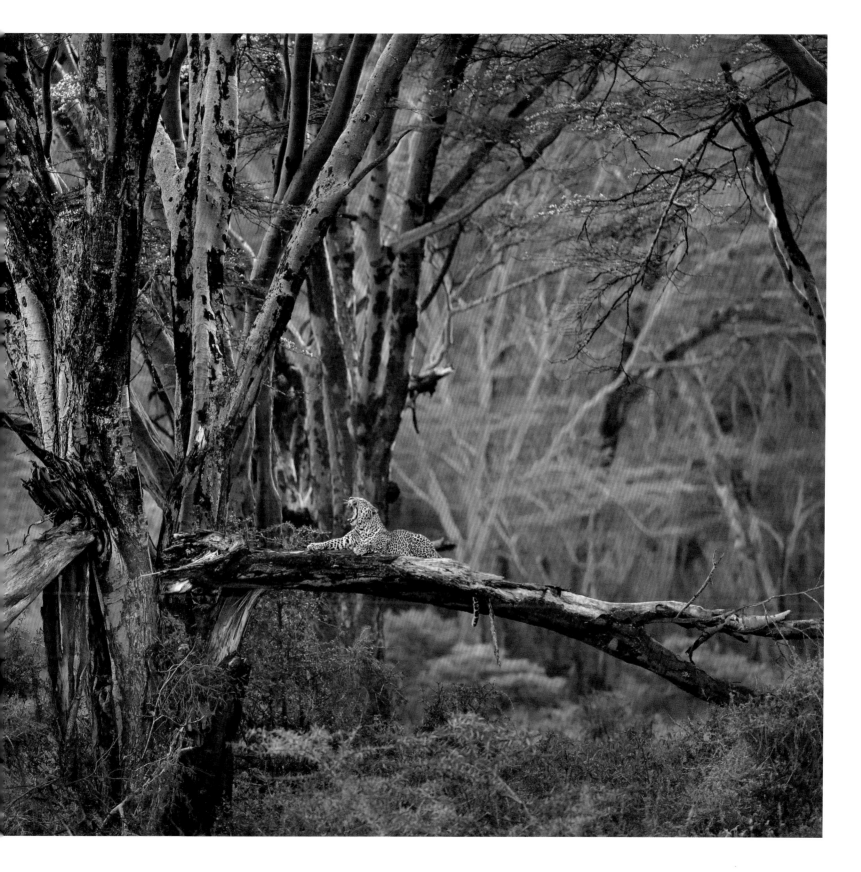

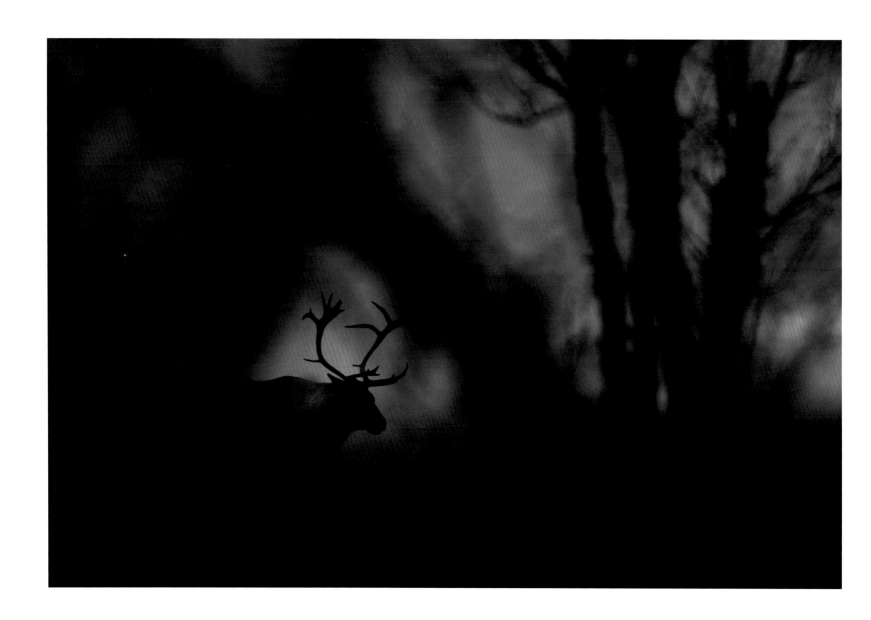

Floris Smeets (Norway)

Forollhogna National Park, Hedmark, Norway. In autumn I spent several days in the mountains in order to photograph wild reindeer during the rut. One day I found about 1,300 wild reindeer, split up into several herds, scattered over the side of a mountain; it was an amazing sight. I sneaked into a dense birch forest and waited for the animals to come to me. One large stag stood hidden behind the birches, and I found a small opening between the branches to take the photograph through.

Canon EOS 1D MkIV with Canon 500mm f/4 Mk1 lens, ISO 640, 1/4000sec at f/4, handheld

florissmeets.com

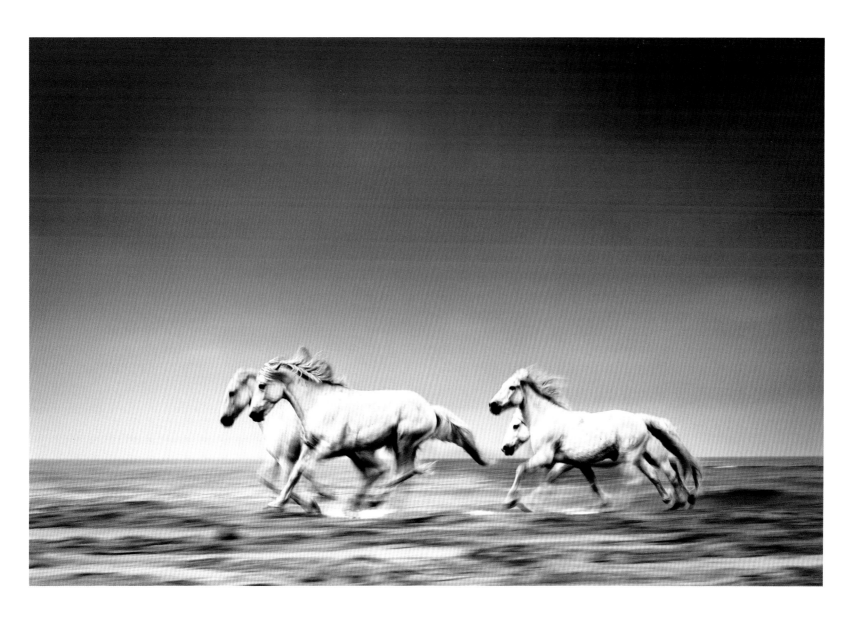

Tom Way (UK)

Camargue, France. The Camargue offers the perfect setting to produce simple
and evocative imagery. I was looking to take an image to show the speed, power
and grace of the famous white horses against the backdrop of the Mediterranean
Sea. By panning with the horses, I was able to create a visual effect of thundering
hooves through the surf.

Canon EOS 1DX with Canon 70-200mm lens at 70mm, ISO 500, 1/25sec at f/20

tomwayphotography.co.uk

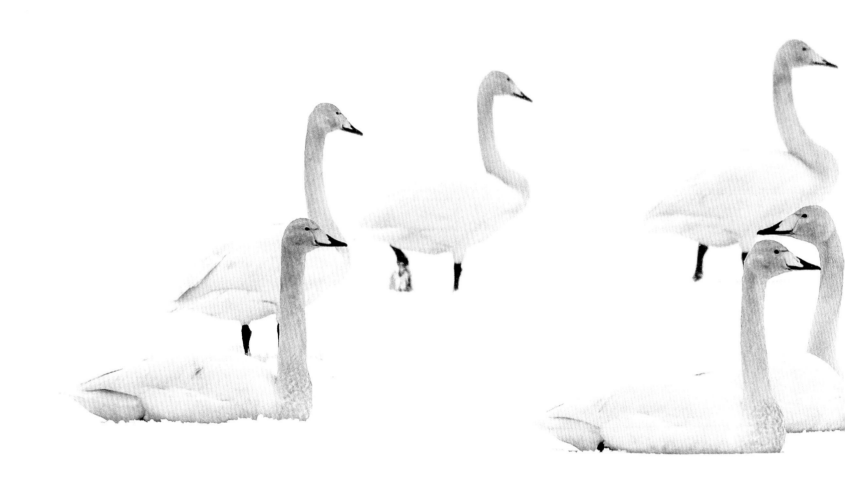

Niklas Virsén (Sweden)

Tinnerö Eklandskap, Östergötland, Sweden. One of the small lakes in Tinnerö Eklandskap freezes in the wintertime. When snow falls it creates this white, icy floor. I wanted to capture a graphic image where the swans were isolated from the background. I'd thought about the end format of the image before taking the shot, and felt that this tight and wide 1:3 format crop would work best.

Nikon D810 with Nikon 300mm f/4 E PF ED VR lens and Nikon TC-14E III 1.4x teleconverter at 420mm, ISO 1600, 1/500sec at f/8, handheld

lkpgbild.se

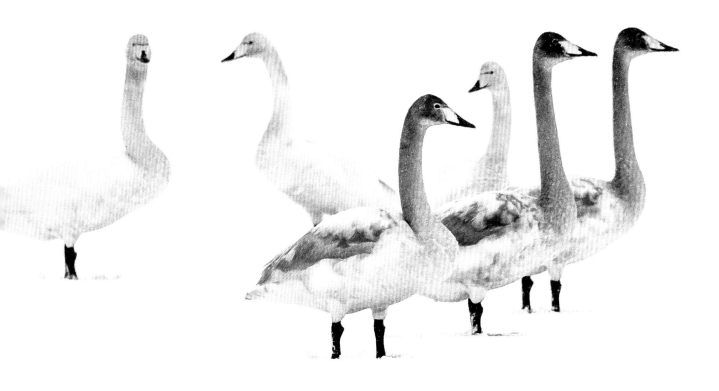

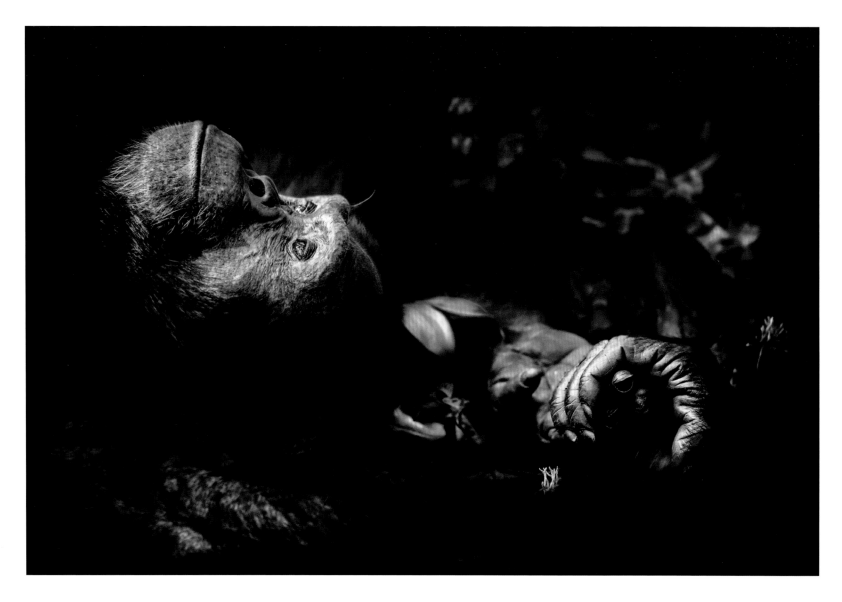

Peter Delaney (South Africa)

Kibale Forest National Park, Uganda. After many hours trekking in the Kibale rainforest, we came across chimpanzees in the canopy. A few of the adult chimpanzees descended from the trees to the forest floor. This male was trying to get the attention of a female in a tree above him. He tried many poses and calls to get her attention but all to no avail, so he just rested on his back with hands behind his head.

Fujifilm X-T1 with 40-150mm f/2.8 lens, ISO 3200, 1/75sec at f/2.8, handheld

peterdelaneyphotography.com

Peter Delaney (South Africa)

Etosha National Park, Namibia. It had been the same routine for weeks. The 'Godfather' – a 4m tall African elephant weighing over 4 tonnes – and his two shadow bulls arrived early afternoon and commandeered this waterhole. It was the only water for 20km and the elephants had travelled far to drink there; they were not going to give way or tolerate any other animal drinking there at the same time. A multitude of animals – springbok, zebra, ostrich, giraffe and even lion – had waited hours for the elephants to depart so that they could quench their thirst. From a photographer's point of view it was like manna from heaven, as there were attempted lion kills and sporadic jostles between herd males vying for dominance. I had visualised a shot of the elephants taking a dust bath, and had spotted them feeding from a camel thorn tree away from their usual place. I anticipated their route, and waited. The 'Godfather' raised his trunk filled with red Kalahari dust.

Nikon D3 with 200-400mm f/4 lens (focal length not recorded), ISO 400, 1/1000sec at f/8, photographed from the driving seat of my 4x4 using a Wimberley Gimbal head mounted on a door bracket

peterdelaneyphotography.com

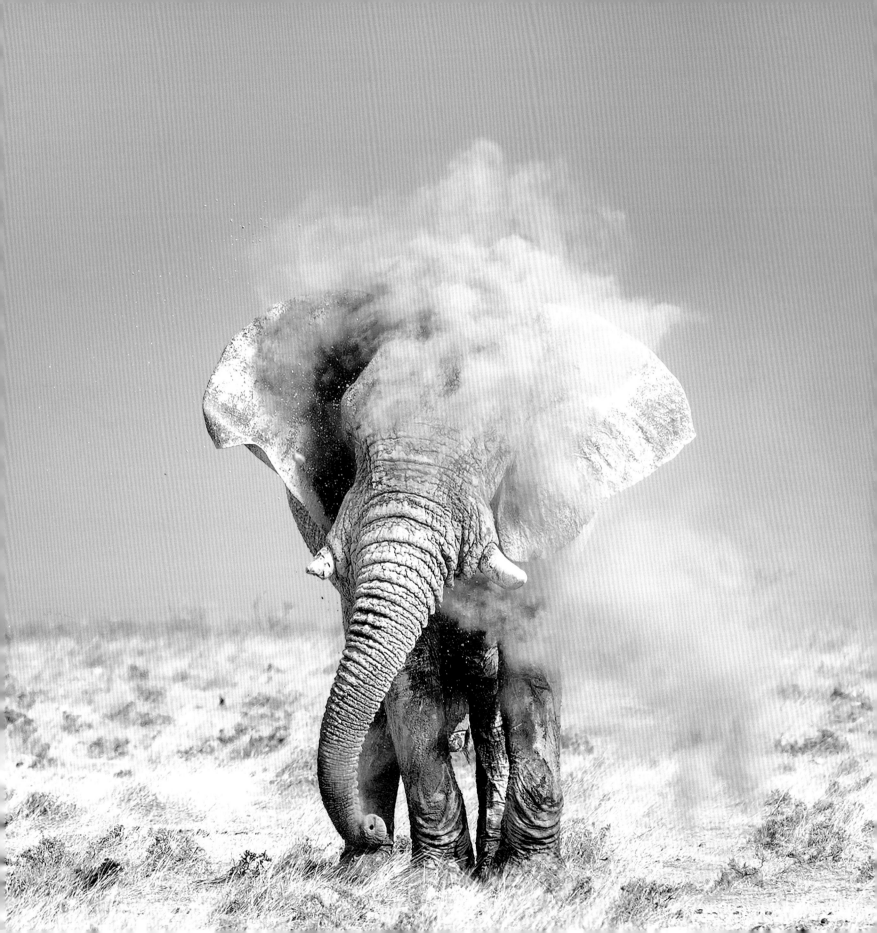

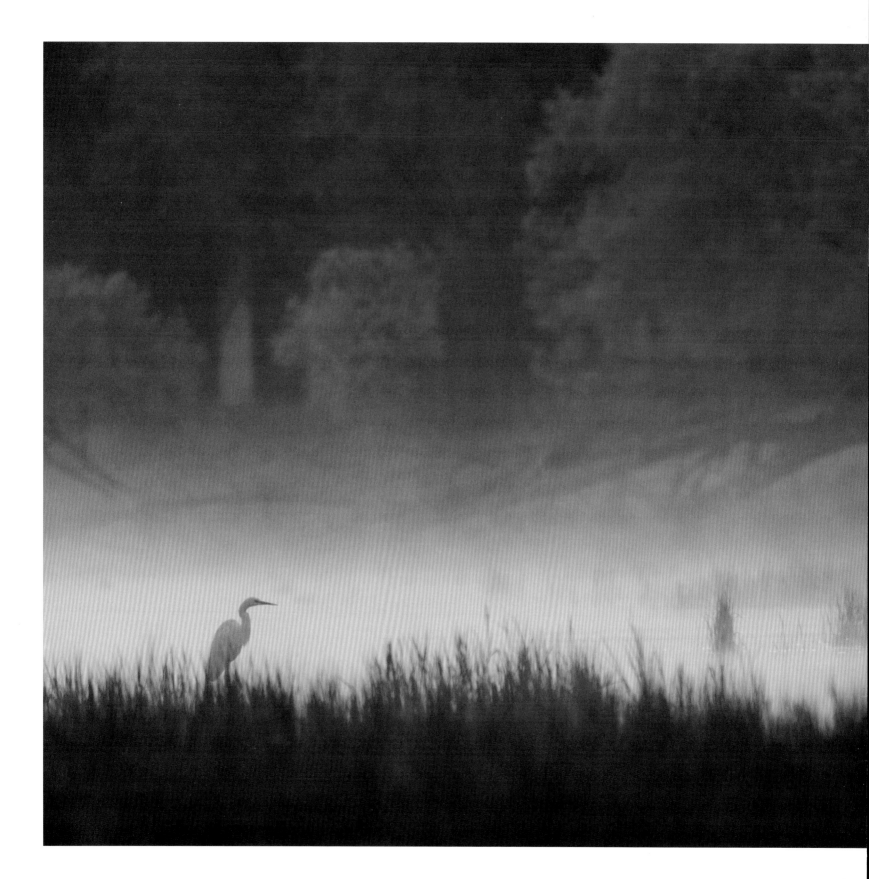

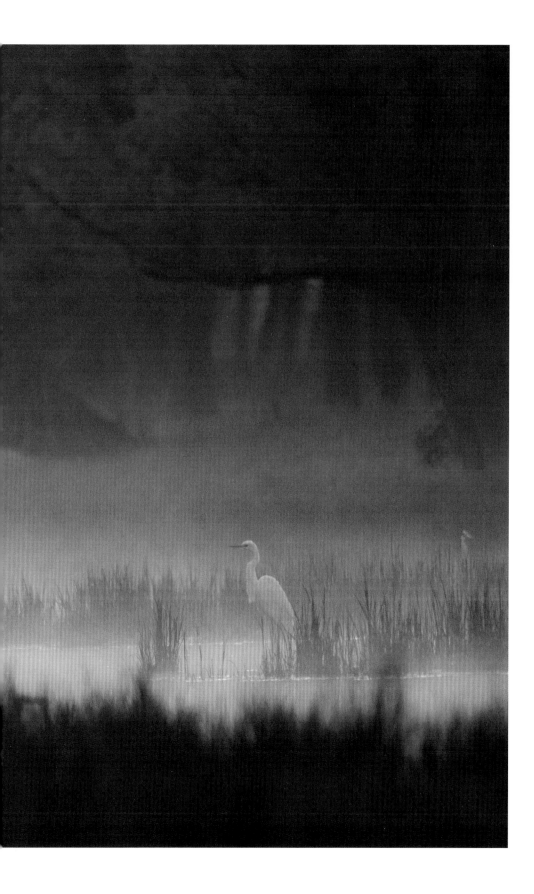

Lukàcs Gábor (Hungary)

Gemenc, Hungary. This was a magical early morning in Gemenc, a beautiful forest region in the south of the country and the only remaining tidal area of the river Danube. I was waiting to photograph deer but couldn't resist photographing this scene with the fog diffusing the colour of the light.

Nikon D4S with 500mm f/4 lens and 1.4x teleconverter, ISO 2000, 1/5000sec at f/5.6

lukacsekszer.hu

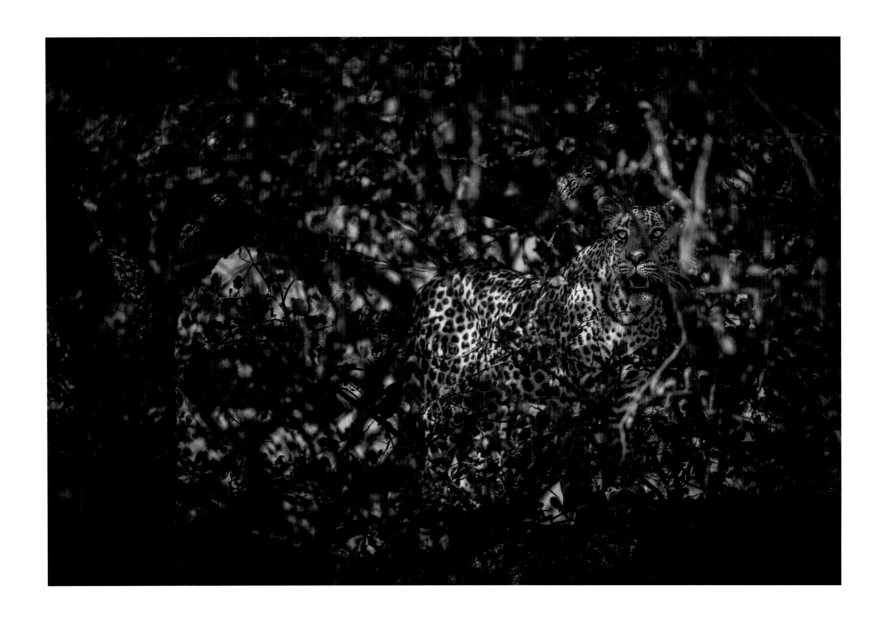

Tom Way (UK)

Maasai Mara National Reserve, Kenya. Almost
perfectly cloaked among the greenery, if this leopard
had remained still there would have been no hope
of spotting it. Leopards rely on stealth, power and
camouflage to survive, and it is easy to see how
these strengths make this one of the most successful
predators on the planet.

*Canon EOS 1DX with Canon 400mm lens, ISO 100, 1/640sec
at f/2.8*

tomwayphotography.co.uk

David Lloyd (UK)

Maasai Mara National Reserve, Kenya. Scar is probably the most celebrated lion in the Maasai Mara today. He is named on account of his distinctive scar above his right eye, which he has carried for several years. I'd wanted to take his portrait for four or five years, but he never seemed interested. One August, he provided a tiny opportunity, a half-second look. But I'd been waiting for this moment and I was prepared; I only got one picture but it was enough.

Nikon D800E with 400mm f/2.8 lens, ISO 2500, 1/500sec at f/11, beanbag

davidlloyd.net

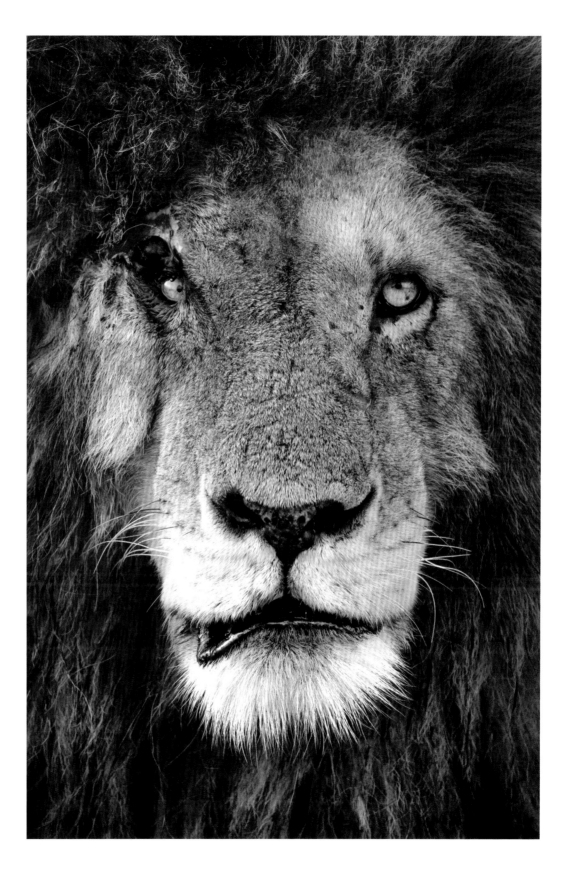

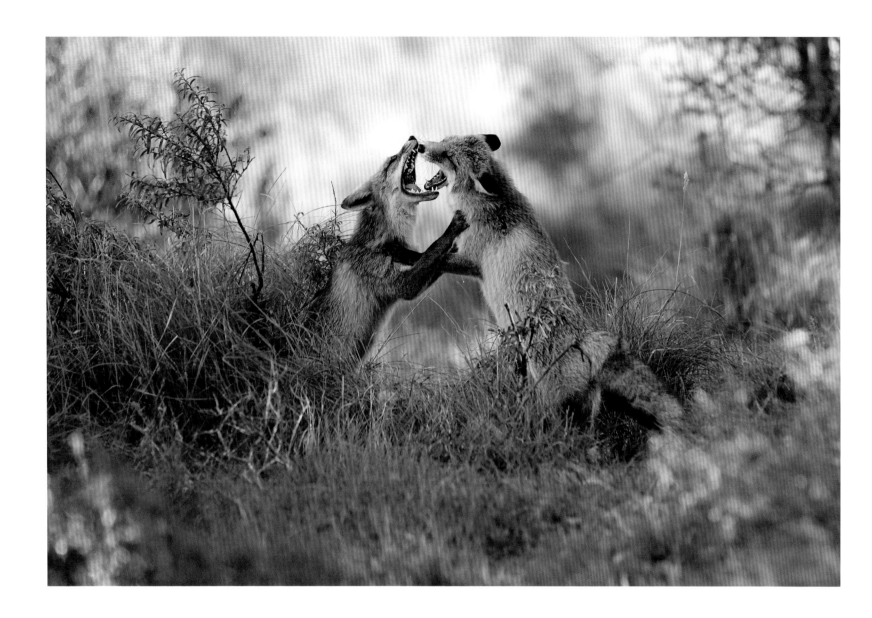

Julian Rad (Austria)

Donau-Auen National Park, Vienna, Austria. The red fox is territorial throughout most of the year. Where they are abundant, territories often overlap and in some areas seem to be shared by two or even three different family units. The distance between the foxes and my position was about 20m, and I was lucky to witness such an amazing and rare moment.

Canon EOS 60D with Sigma 120-300mm f/2.8 Sports lens at 300mm, ISO 400, 1/1000sec at f/2.8, handheld

facebook.com/julian.rad.photography

Justin Garner (UK)

Mount Salcantay, Peru. This image was taken on a three-day trek to Machu Picchu. We were ascending Mount Salcantay, and part way up the mountain I encountered this wild horse, which seemed to encapsulate the rugged environment. I used a wideangle lens to include the mountains, using the horse as the foreground interest.

Canon EOS 5D MkIII with 16-35mm lens at 35mm, ISO 400, 1/500sec at f/8

jags-photography.co.uk

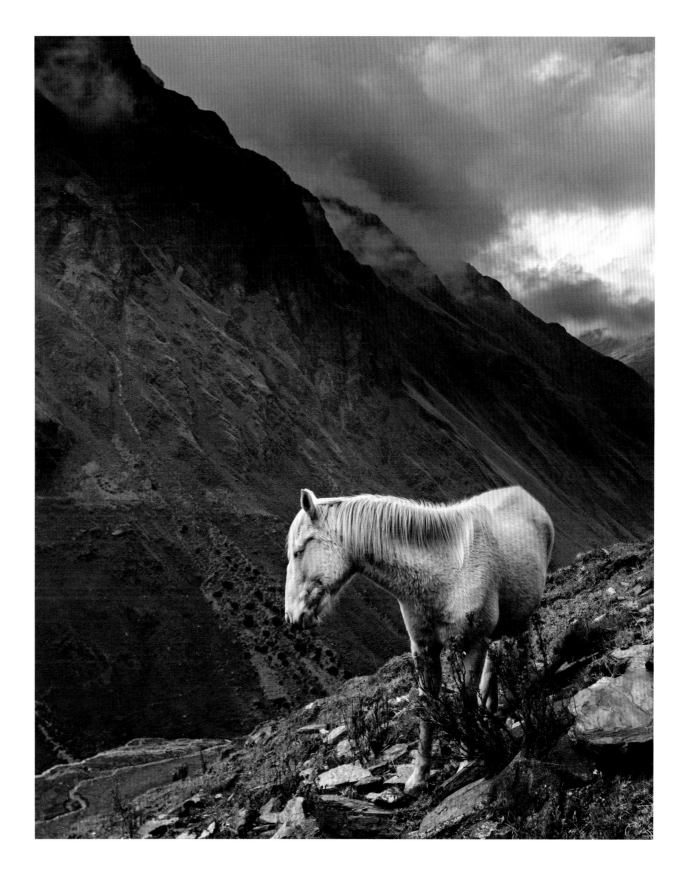

Cristian Rota (Italy)

Lake Clark National Park, Alaska, USA. Wanting
to see grizzly bears, I landed in Lake Clark National
Park during a day of rain and low clouds in September.
Along a river, I came across bears fishing the last
salmon. I felt suspended in time and space in a
magical land, and when a bear looked at me from
afar I decide to portray him and his land in the
incredible soft-light atmosphere.

*Canon EOS 5D MkIII with Canon EF 100-400mm II lens
at 152mm, ISO 320, 1/250sec at f/9*

bottegadellaluce.it

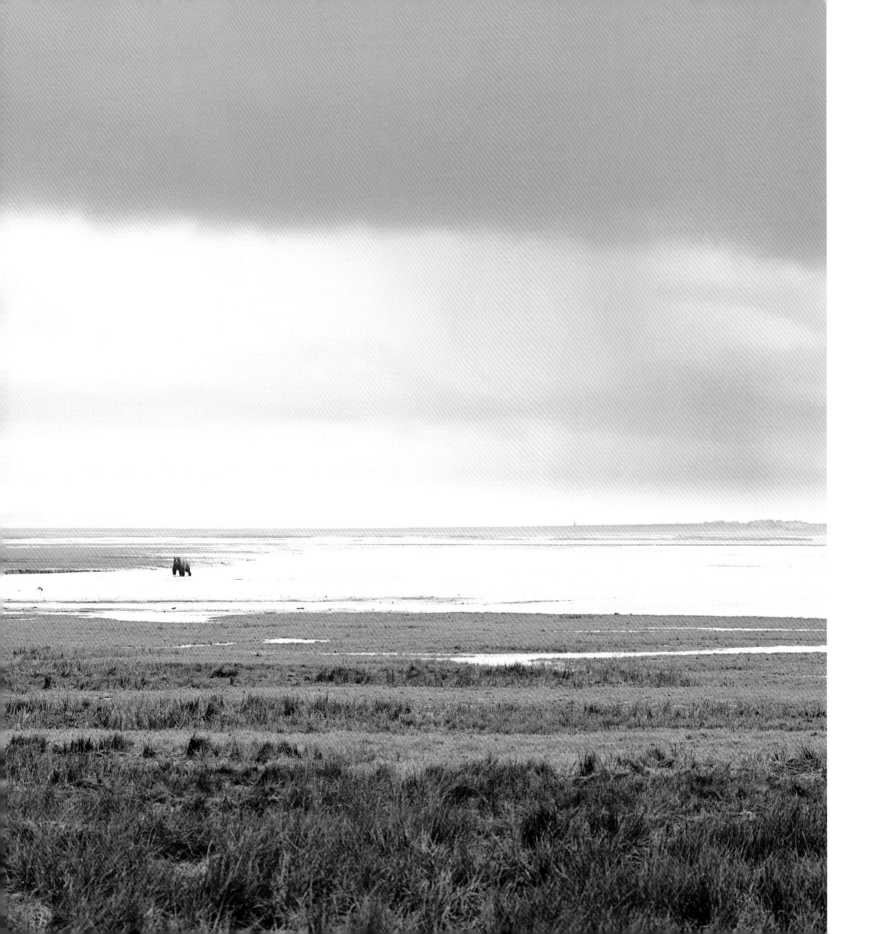

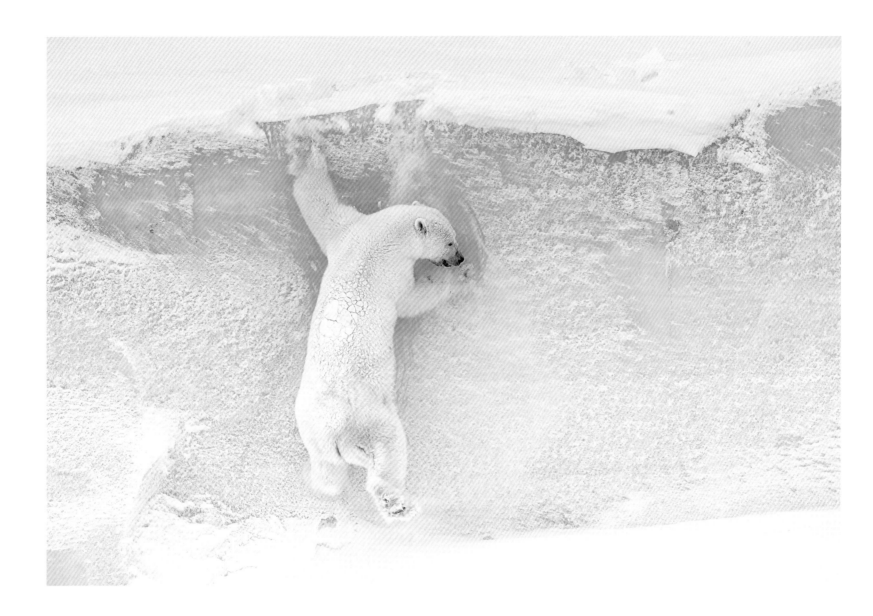

Andy Skillen (UK)

Baffin Island, Canada. In temperatures approaching -50°C, and after days of tracking on snowmobiles, we found a mother polar bear. She had left the den a few days earlier and had just killed a seal at the base of an iceberg. In this image she is lowering herself from the top of the iceberg in order to return to the seal carcass, while her newborn cubs hide out of sight.

Canon EOS 1Dx with 600mm lens, ISO 400, 1/1250sec at f/8, handheld shooting from the back of a snowmobile

faunavista.com

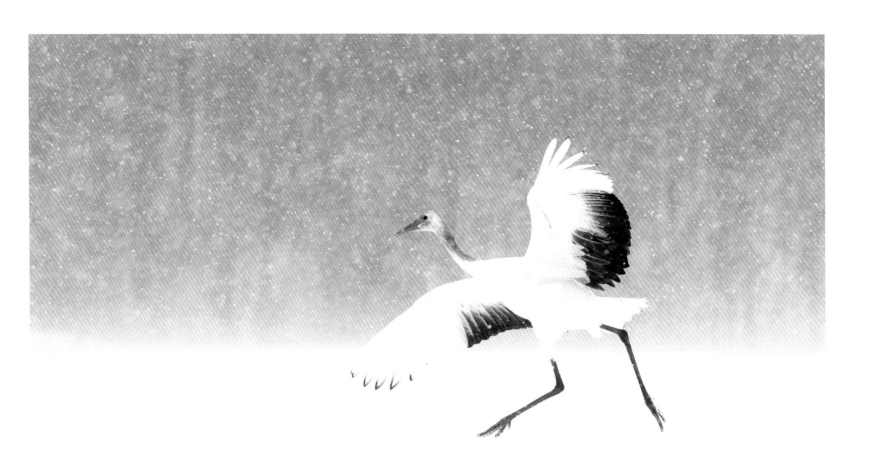

Aneurin Phillips (UK)

Hokkaido, Japan. On a cold mid-winter morning on the island of Hokkaido, a juvenile red-crowned crane is practising a courtship dance. The strong northerly wind was keeping the bird aloft for longer than normal and the heavy snow showers created the ideal conditions in which to capture the beauty and grace of this rare and charismatic bird. By adopting a low position I was able to create a simple composition to portray the bird in its natural environment.

Nikon D4 with Nikkor 500mm f/4 lens, ISO 640, 1/2500sec at f/8, Gitzo tripod, Wimberley head

aneurinphillips.com

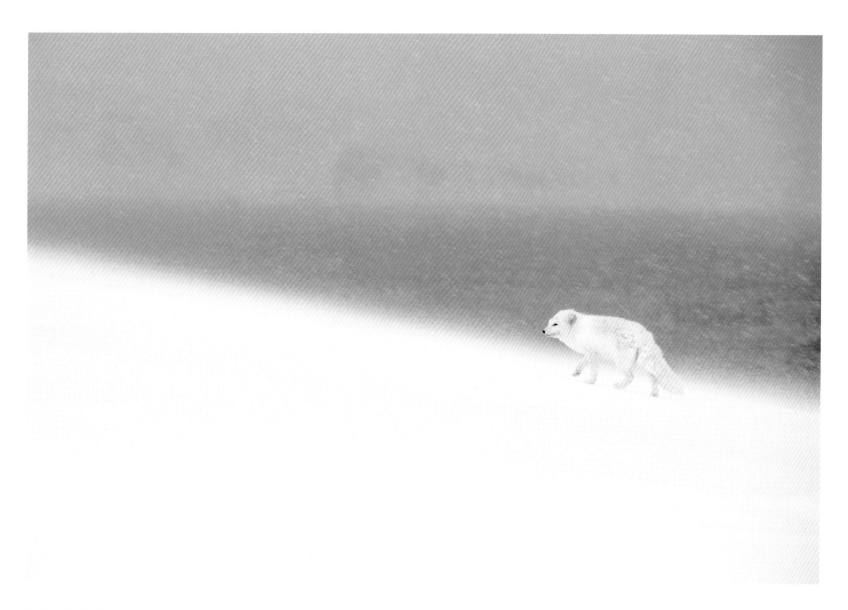

Joshua Holko (Australia)

Hornstrandir Nature Reserve, Iceland. This arctic fox is patrolling the very edge of its territory during a heavy winter blizzard. Despite the conditions, the arctic fox appeared as calm as if it were a summer's day. I took the image while lying in the snow.

Canon EOS 1DX with Canon 70-200mm f/2.8 L IS MkII lens at 200mm, ISO 800, 1/500sec at f/7.1

jholko.com

Wilson (Wai-Yin) Cheung (Hong Kong)

Gould Bay, Antarctica. This image was taken at the emperor penguin colony at Gould Bay. Once we arrived on the sea ice, most of the penguins came very close to see us, but the extreme cold and stormy conditions – the wind was blowing at around 80mph – made it very challenging to take a photograph. I shot it from a low angle using a heavy tripod, and had my back into the wind to help make the task a little easier.

Canon EOS 6D with Canon 100-400mm lens at 150mm, ISO 125, 1/640sec at f/4.5, tripod

wilsonwildernesswisdom.wordpress.com

LIVE THE ADVENTURE

Capture adventure sports activities around the globe. From hiking and mountain biking to backcountry skiing and paragliding, and everything in between, we wanted to see the thrill of life lived to its maximum.

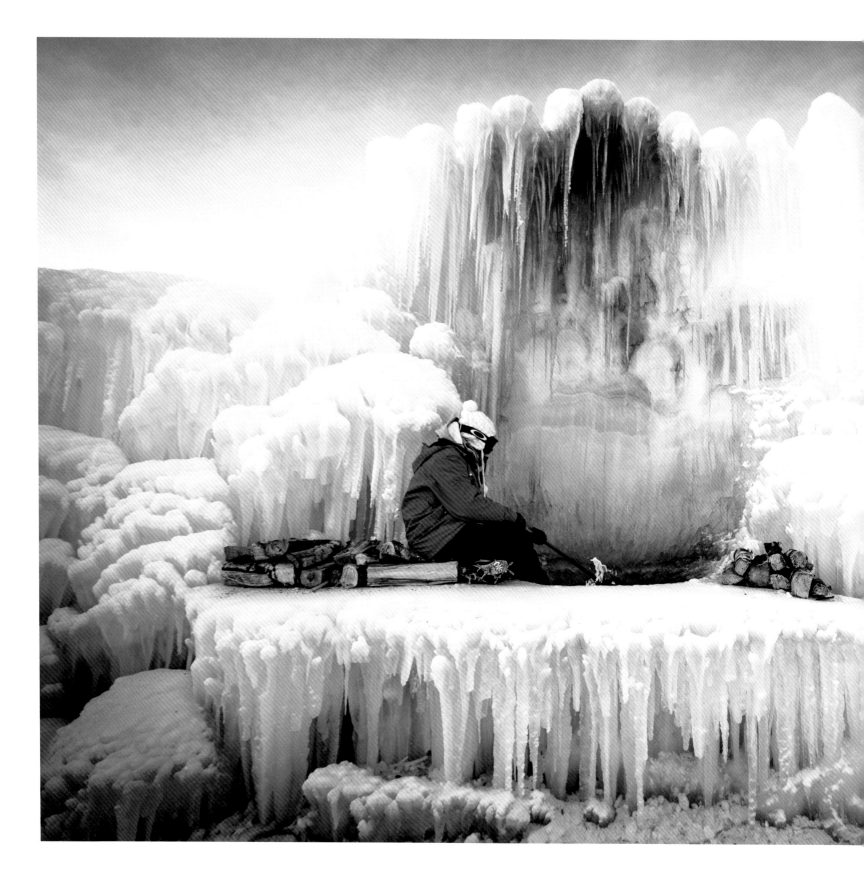

LIVE THE ADVENTURE – WINNER

Kirsten Quist (Canada)

Edmonton, Alberta, Canada. On one of the coldest days last winter, I was inspired to capture the luminous structure of this frozen fire pit. I loved the contrast of fire and ice, as well as the way both the blue light and ash-covered icicles framed my subject Halley Coxson. A big challenge was the near -30°C temperature, which caused my camera to malfunction and halted shooting until I was able to warm things up with some body heat.

Nikon D610 with Nikkor 14-24mm lens at 14mm, ISO 800, 1/640sec at f/5, handheld

kirstenquistphotography.com

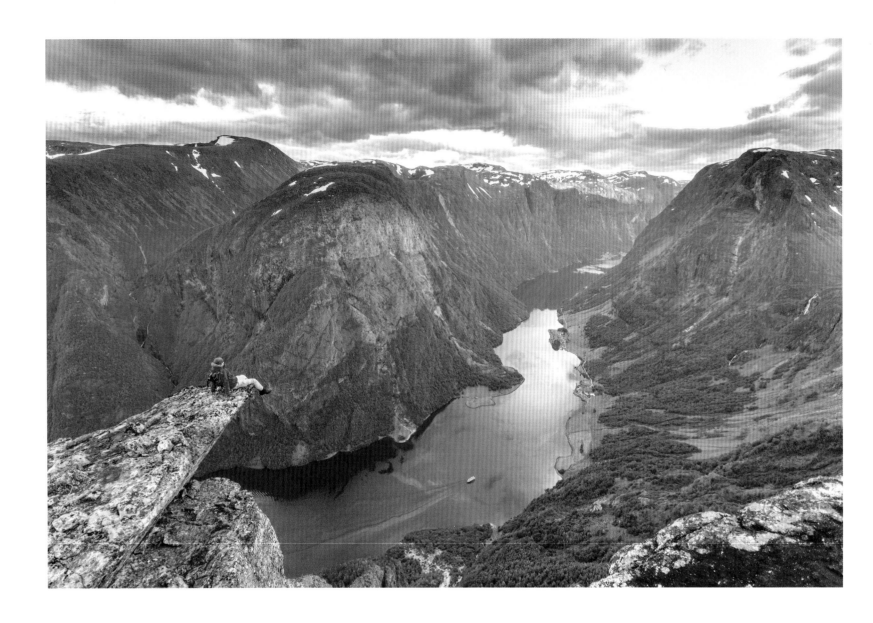

Adam Major (UK)

Breiskrednosi, Nærøyfjord, Norway. After a long hike on the steep slopes of Rimstigen and Rimstigfjellet we finally reached our destination, the magnificent Breiskrednosi viewpoint that towers over one of the most beautiful fjords in Norway: Nærøyfjord, a UNESCO World Heritage Site. My fellow hiker sat down to rest and to wonder at the beauty of the fjord, and I took the picture in the fading light of a long but rewarding day.

Canon EOS 5D MkII with Canon 17-40mm f/4 L lens at 17mm, ISO 400, 1/6sec at f/13, Lee 0.6 ND hard grad, Giottos tripod

flickr.com/photos/majoradam

Ben Read (UK)

Lake Wanaka, South Island, New Zealand. To me this photograph sums up two wonderful years of playing in the epic New Zealand landscape. It shows my friend Laurie climbing, and the summit of Mt Aspiring can be seen in the background. I had spotted this particular outcrop high above a cliff and wondered if it would have any bouldering problems on it. We decided to make the precarious hike to it to take a closer look. Laurie spotted one possible route on the far arête, in the most exposed area, and, with incredible commitment, he completed it. So for me this photo represents friendship, climbing and a landscape that will forever be etched on my mind.

Canon EOS 6D with Canon 17-40mm lens at 17mm, ISO 640, 1/60sec at f/4, handheld

benreadphotography.com

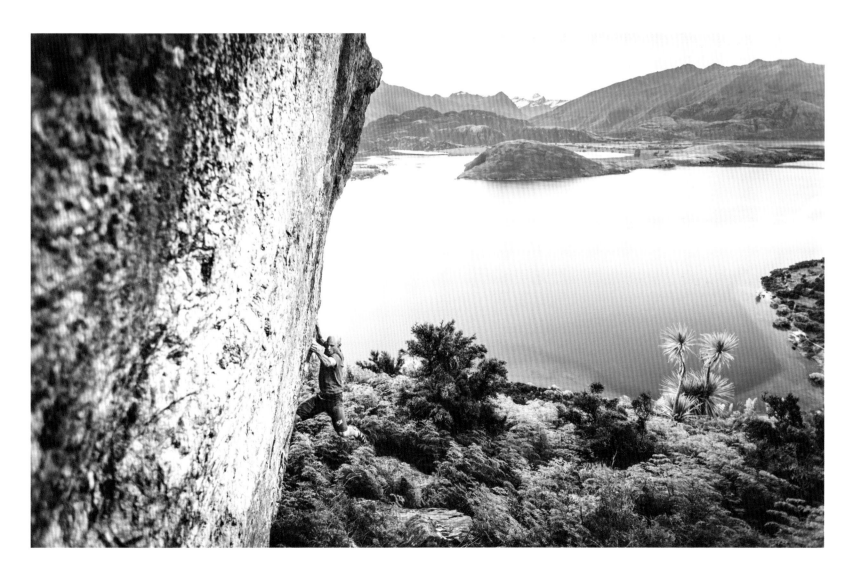

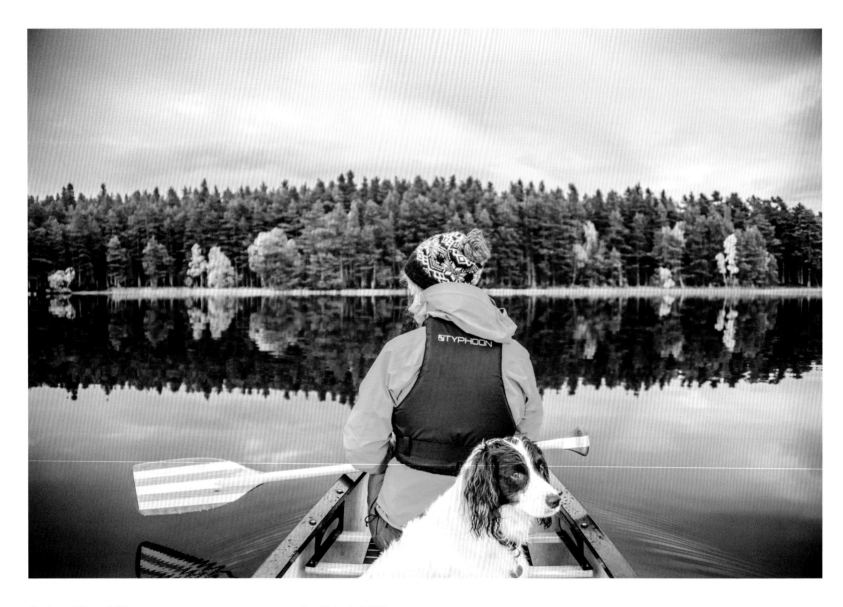

Graham Niven (UK)

Loch Garten, Cairngorms National Park, Scotland. Some places are worth going back to again and again, and this is one of them. Often silent and serene, on this particular day the glassy waters of Loch Garten let us drift almost without effort, and there was the sound of roaring stag in the surrounding forest. It was a visual feast of changing colour and light, and being out on the water reveals a whole new perspective.

Nikon D750 with Nikkor 28-300mm VR lens at 28mm, ISO 320, 1/60sec at f/3.5, handheld

nivenphotography.com

Jay Kolsch (USA)

Yukon, Canada. This was our first big rain of the 2,000-mile Pull of the North expedition. We had already been paddling for 10 hours in a big push to make our resupply that night, when the sky opened up. I could hear Martin behind me struggling to keep the canoe straight in the building storm.

Nikon D800 with Nikon 24-120mm f/4 lens at 24mm, ISO 250, 1/640sec at f/4, handheld

jaykolsch.com

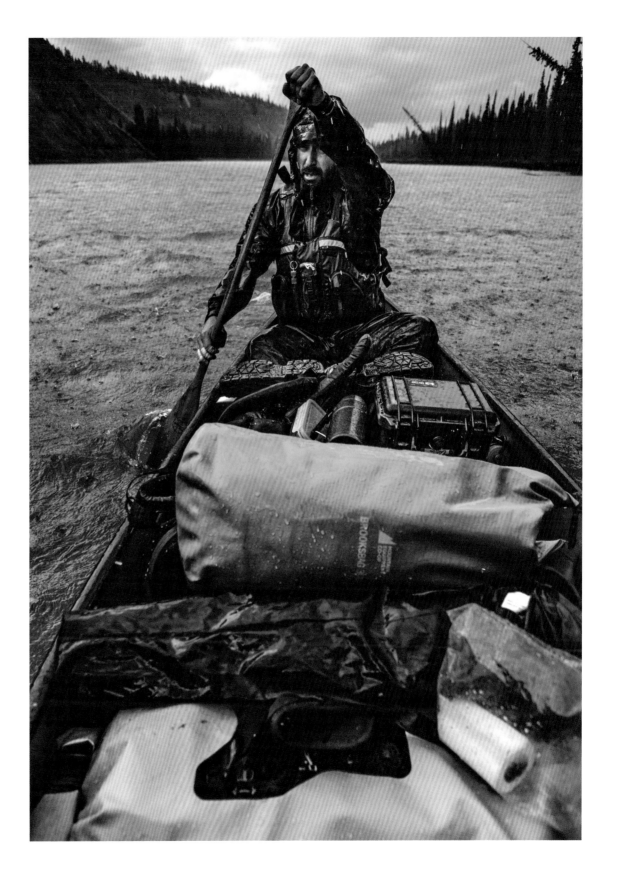

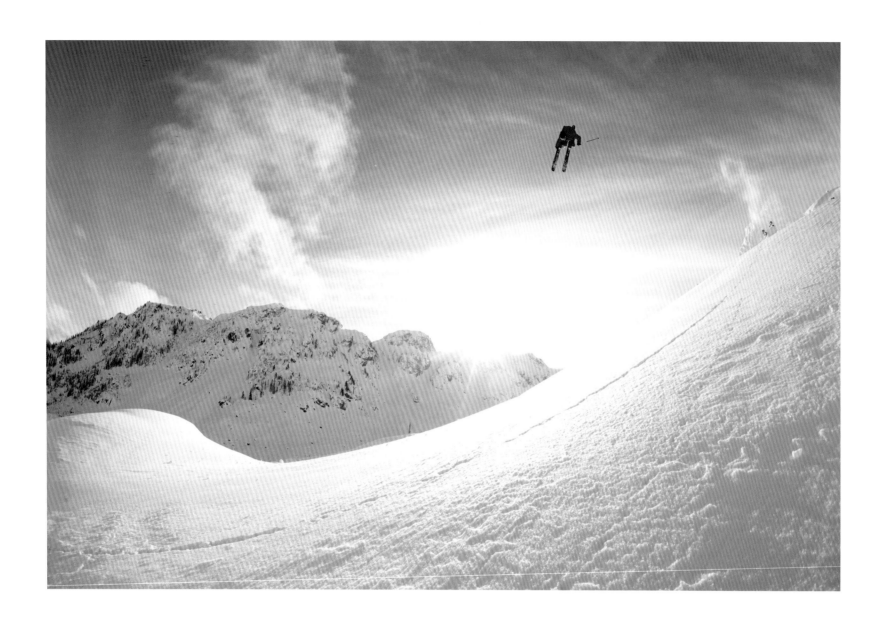

Dan Carr (Canada)

British Columbia, Canada. Professional freeskier
Anthony Boronowski sails over a huge snow jump
in the Coast Mountains of British Columbia.

*Canon EOS 5D MkII with 15mm lens, ISO 320, 1/1000sec
at f/10, handheld*

dancarrphotography.com

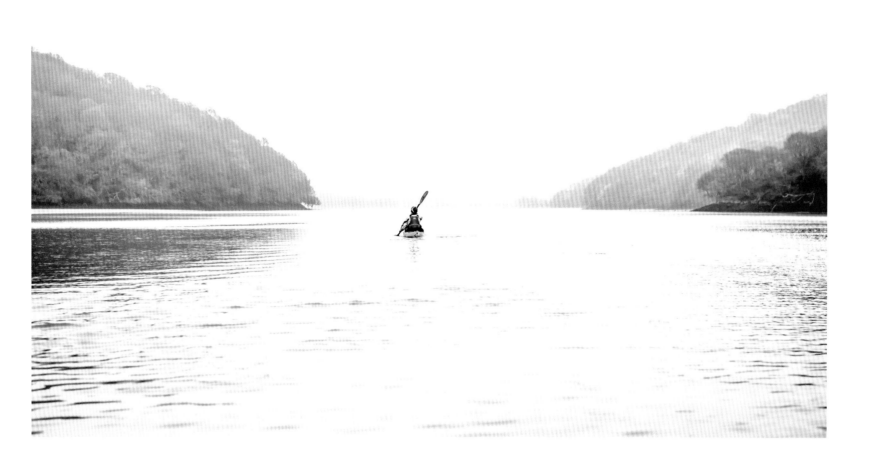

Giles Blackie (UK)

Fal River, Cornwall, England. The upper reaches of Fal River remain relatively peaceful even on the busiest of Cornish summer days, owing to the shallow water and strong tides restricting vessel movement. Kayaking and canoeing are the best way to explore the timeless banks of the estuary.

Nikon D750 with Nikkor 24-70mm f/2.8 lens at 70mm, ISO 200, 1/800sec at f/4.5, handheld

instagram.com/gilesblackie

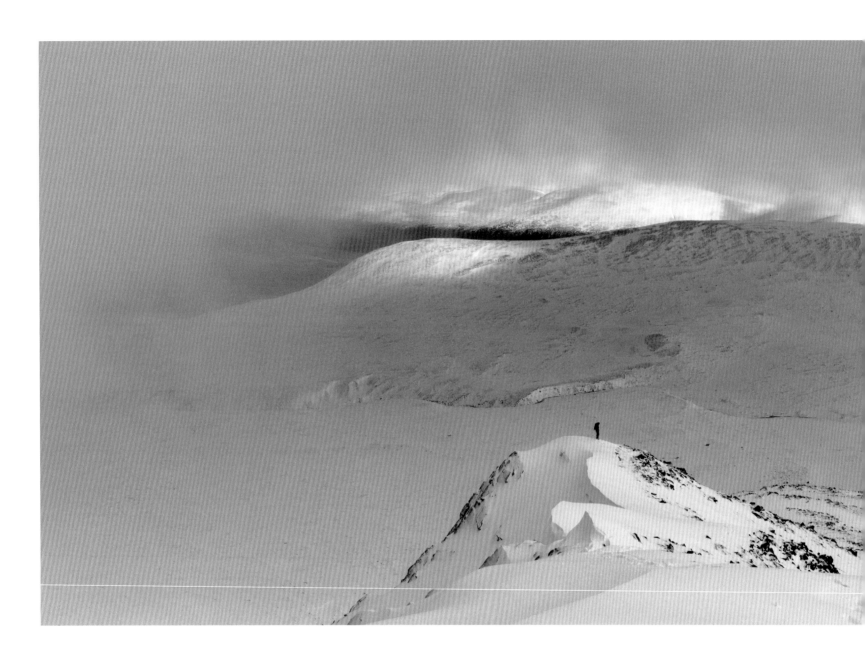

Jonathan Miles (UK)

Short Leachas ridge, Ben Alder, Scotland. Ben Alder is one of the great mountains of the central Highlands and a day trip there in winter is a challenge. A friend and I cycled eight miles to Culra bothy, then climbed the Long Leachas ridge, which was shrouded in cloud. The weather conditions cleared briefly on the summit and then again on the descent of the Short Leachas ridge, giving a spectacular view across the frozen landscape to Beinn Bheoil.

Canon EOS 550D with Sigma 10-20mm lens at 14mm, ISO 400, 1/800sec at f/9, handheld, five-shot panorama stitched together

jonathanmilesphotography.com

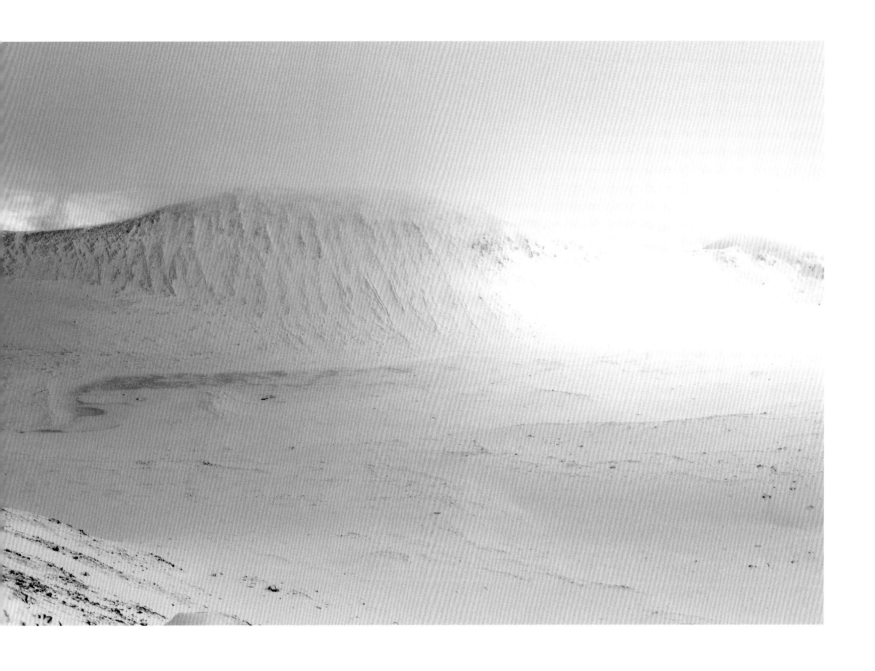

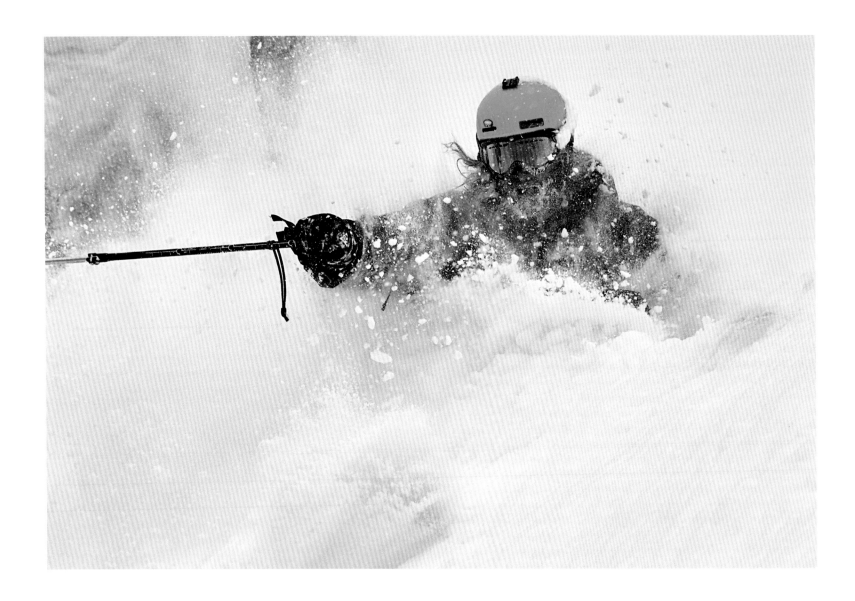

Konrad Bartelski (UK)

Hakuba, Japan. Japan is famous for its powder snow, and despite last winter being one of the worst on record the small resort of Tsugaike Kogen still delivered the famous 'Ja-Pow' powder skiing experience for Sam Horne. I would enjoy skiing the run first and then pitch up around halfway down behind a good knoll and get Sam and his father and brothers to pick their own lines. This photograph just captured the sort of moment we were all enjoying.

Nikon D750 with Nikon 24-120mm f/4 lens at 86mm, ISO 400, 1/2000sec at f/9, handheld

konradbartelski.photography

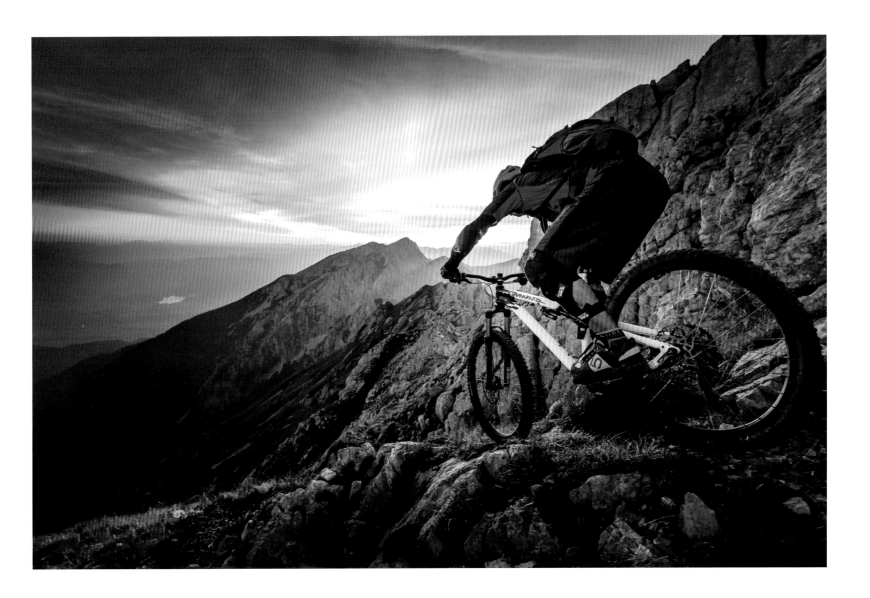

Sandi Bertoncelj (Slovenia)

Vrtača mountain, Alps, Slovenia. We had planned for a long time to tackle this mountain bike challenge on Vrtača in the Karavanke mountain chain in the Slovenian Alps. After a brief rest on the summit, we started a steep, technical and very exposed descent. The timing was perfect, just before sunset when the light was warmer and softer. It's fantastic to experience the sunset so high in the mountains, but the sacrifice we had to make for that was the lack of daylight on the bottom part of the trail, where we had to ride with helmet lights on.

Canon EOS 5D MkIII with Canon EF 16-35mm f/4 L IS USM lens at 16mm, ISO 250, 1/125sec at f/5.6, handheld

500px.com/berto

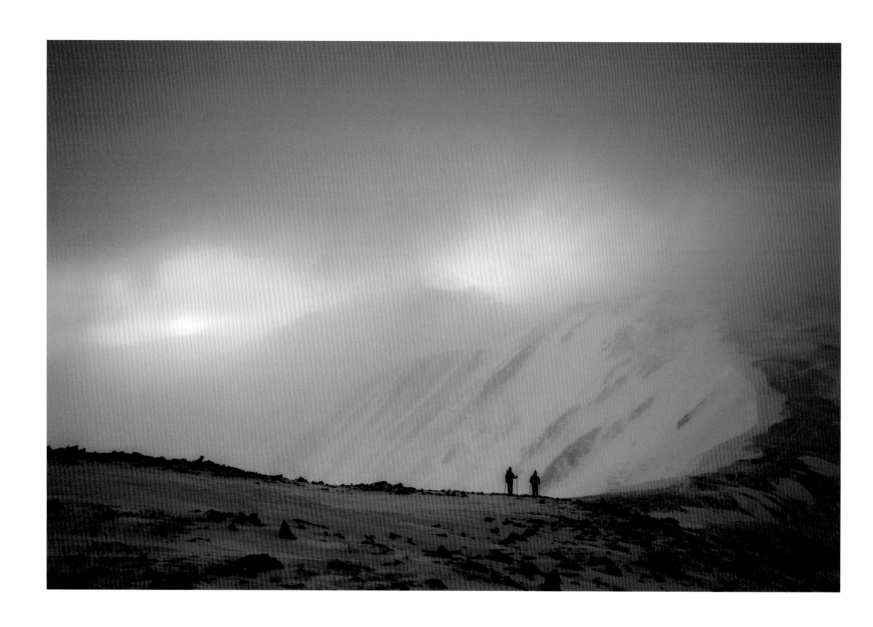

Kyle Frost (USA)

Grizzly Peak, Colorado, USA. A predawn start
in windy and sub-freezing temperatures proved
to be well worth the effort, as we ascended the ridge
to Grizzly Peak and sunrise lit up the clouds and
mountains around us.

*Sony Alpha 7 with Zeiss 16-35mm lens at 35mm, ISO 100,
1/200sec at f/5.6*

kylefrost.com

Sam Gore (UK)

Indian Creek, Utah, USA. Indian Creek is geologically amazing, with red sandstone walls rising vertically upwards for hundreds of feet. The walls have cracks running up them; some are only wide enough to fit fingers into, while others can engulf a person entirely. After a long hike, we found a huge piece of rock that had cracked and started to come away from the main wall. It had created this chimney climb where you had to push on either side to work your way up.

Nikon D7000 with Tokina 10-17mm fisheye lens at 10mm, ISO 250, 1/125sec at f/22, handheld

samgorephoto.com

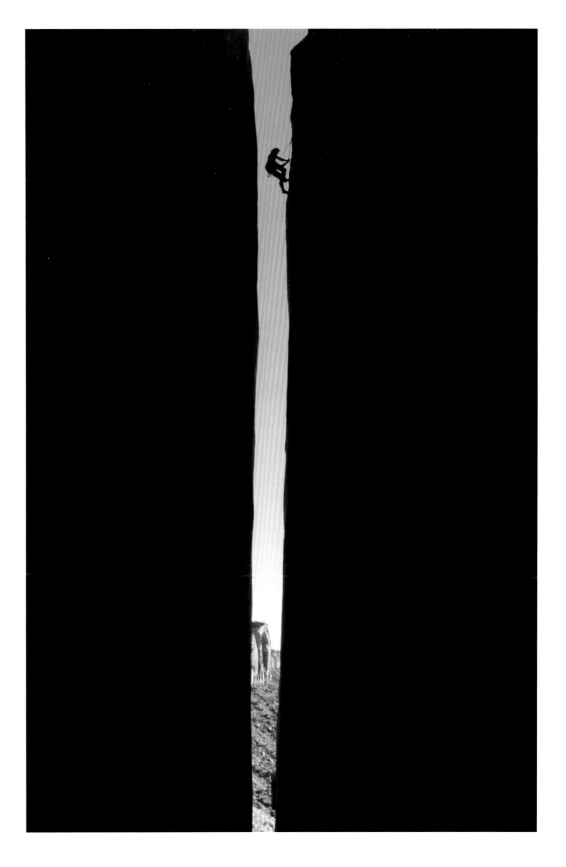

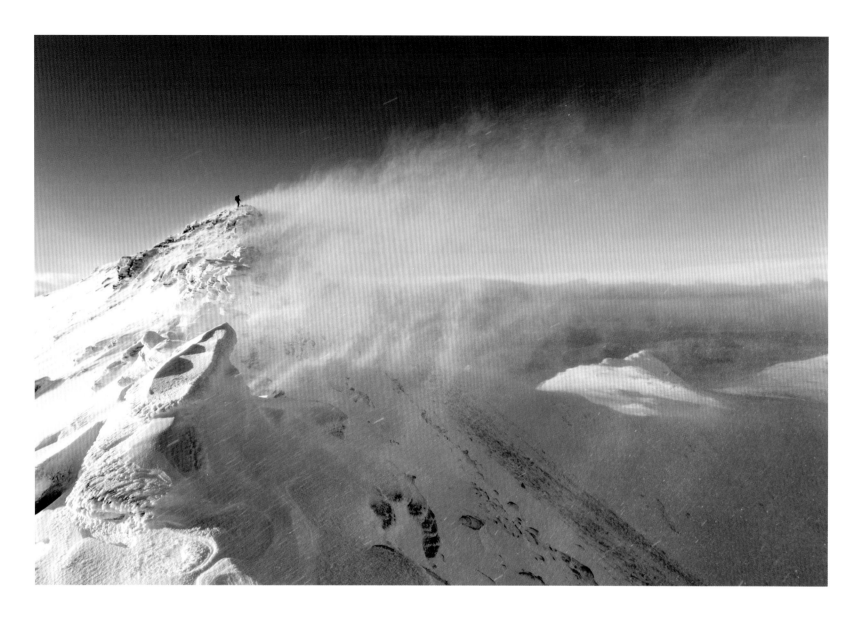

Guy Richardson (UK)

An Teallach, Dundonnell, Scotland. As the winds grew fiercer, snow and ice were launched off the south-east ridge of An Teallach. The hiker, stood alone, provided a stark silhouette against the featureless sky. I didn't have much time to think but quickly composed and took a couple of frames before the snow and ice smeared across the lens. This was a decisive moment in the hike and one that would lead to a terrifying scramble down a frozen mountain slope in face-numbing conditions.

Nikon D800 with Nikkor 16-35mm lens at 16mm, ISO 200, 1/640sec at f/11, polariser, handheld

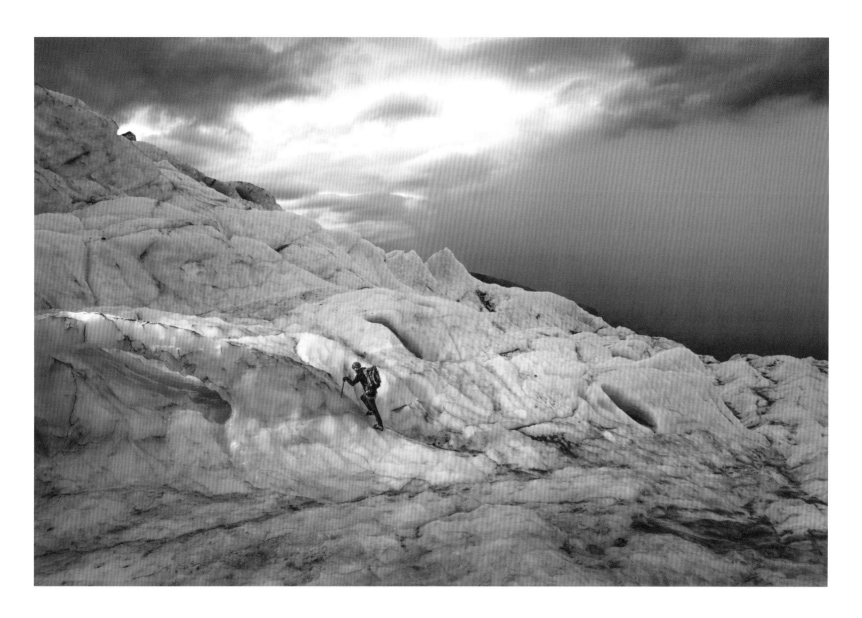

Jay Kolsch (USA)

Vatnajökull glacier, Iceland. What makes a glacier unique is its ability to move and change. As the glacier flows, the topical features change and distort. I wanted to capture an image of this wonderful ice bridge before it was gone. To our surprise the bridge had function as well as form, as it served as the fastest and safest way up.

Nikon D800 with Nikon 24-120mm f/3.5-5.6 lens at 120mm, ISO 50, 1/200sec at f/18, Broncolor Move 1200 L flash, handheld

jaykolsch.com

Thomas Heaton (UK)

Aiguille du Midi, Chamonix, France.
Photographing in the mountains can be extremely overwhelming. The awe inspiring peaks, destructive glaciers and deep valleys become all that you see. I had succumbed to these grand vistas until I spotted some movement in the far distance; the three climbers descending Mont Blanc. My eyes adjusted and soon I began to more readily see the intimate landscape; the patterns, the lines in the snow and the climbers edging closer to perfection within my composition.

Canon EOS 5DS R with Canon 70-200mm L f/2.8 IS lens (focal length unrecorded), ISO 100, 1/640sec at f/11, handheld

thomasheaton.co.uk

Nadir Khan (UK)

Cairngorms, Scotland. I was photographing friends Tom and Uisdean climbing, and to get this shot I abseiled in from a snow bollard. I was drawn to the convergence of the lines of the buttress around the climber, which lent itself to a central composition for the main subject.

Canon EOS 5D MkIII with 17-40mm L lens at 20mm, ISO 800, 1/640sec at f/8

nadirkhan.co.uk

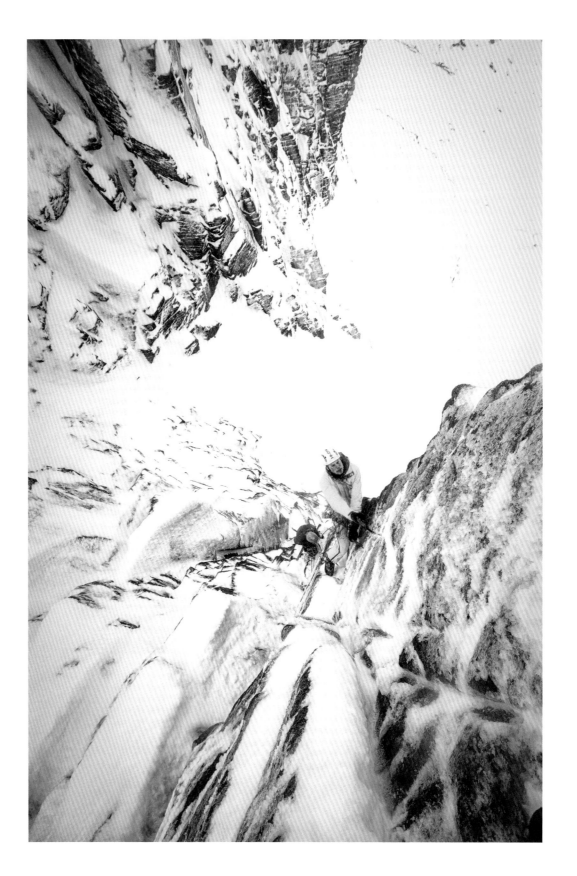

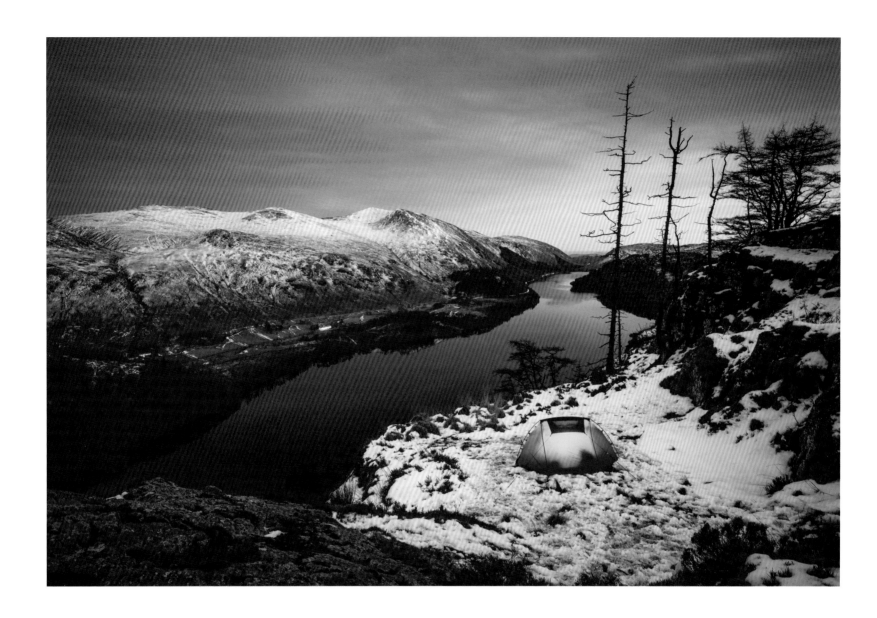

Anita Nicholson (UK)

Raven Crag, Lake District, England. This viewpoint is looking across to the snow-capped Helvellyn from our camp spot on Raven Crag, after a beautiful, pink sunset. We'd headed to the fells beside Thirlmere hoping for good conditions for our first winter wild camp. A wideangle lens was used to capture as much of the magical setting as possible, and an illuminated head torch within our tent added some extra colour, light and interest to the scene.

Canon EOS 5D MkII with Canon 17-40mm lens at 17mm, ISO 200, 30sec at f/9,
Lee 0.6 ND hard grad, tripod

anitanicholsonphotography.com

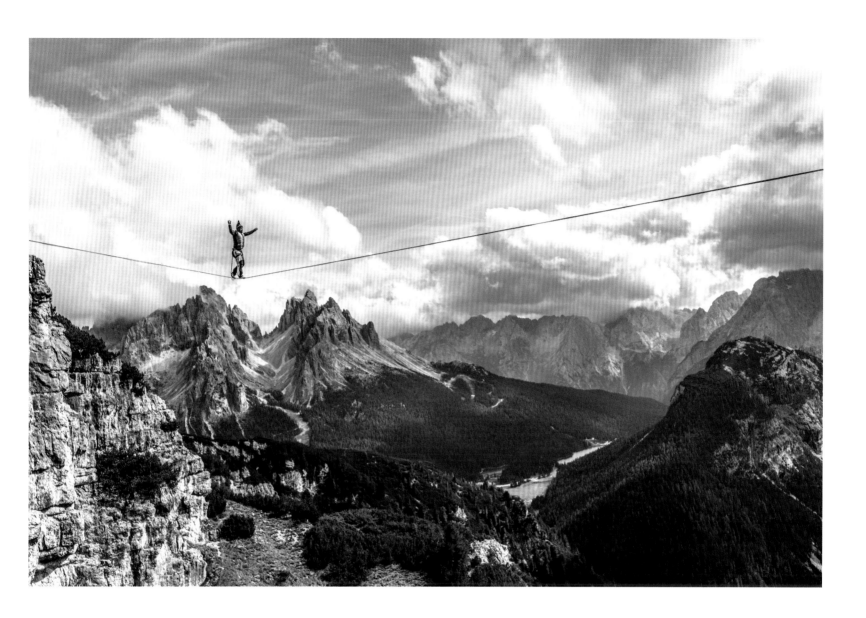

James Rushforth (UK)

Monte Piana, near Misurina, Dolomites, Italy. Monte Piana has become a world-renowned destination for highlining due to its many buttresses and spectacular backdrops, featuring the Cadini di Misurina and Tre Cime groups of mountains. Each year, a highline festival takes place and attracts enthusiasts from near and far who come to walk the one-inch wide lines. This shot was taken on a particularly windy day, and I used a relatively wideangle lens to try to capture the scale of the line in its location, while retaining the personal connection with the subject.

Nikon D810 with Nikon 16-35mm VR lens at 35mm, ISO 100, 1/320sec at f/9, handheld

jamesrushforth.com

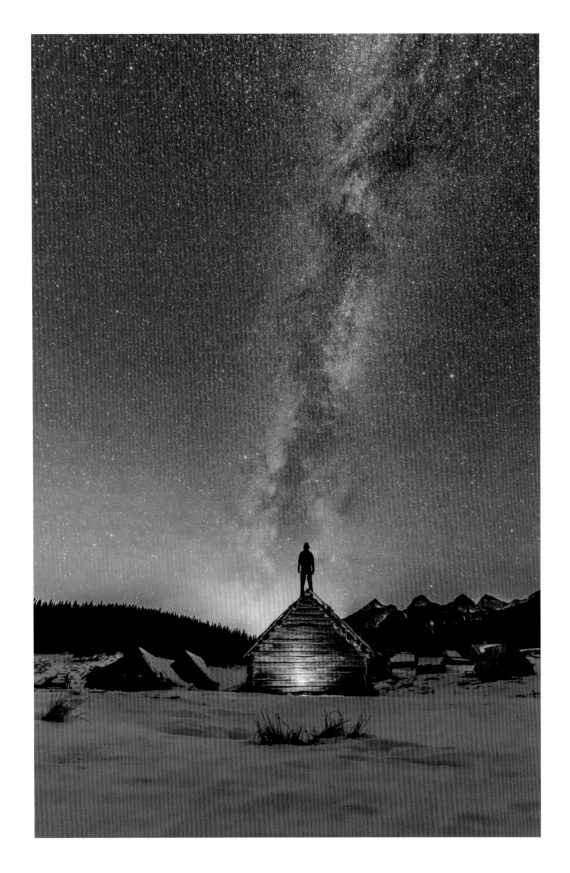

Aleš Krivec (Slovenia)

Pokljuka plateau, Slovenia. I had wanted to photograph the Milky Way on Pokljuka plateau for some time, and I decided that the abandoned village of Javornik would be a perfect spot. I used the Stellarium app to determine when the Milky Way would be positioned right above the middle cottage. I used a candle to create the light on the cottage.

Nikon D800 with Nikkor 14-24mm lens at 14mm, ISO 3200, 20sec at f/2.8, tripod

dreamypixel.com

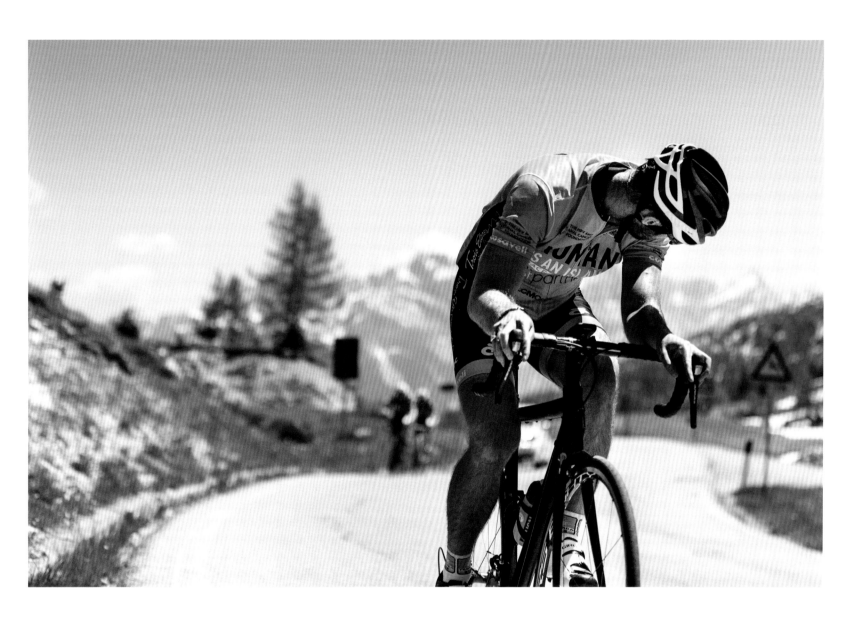

Philip Field (UK)

Passo Falzarego, Belluno, Dolomites, Italy. Competitive road cycling is a brutal sport. A breakaway rider seeking their moment of glory can have their efforts dashed just seconds from the finish by the strength of the pack behind. To show this drama, I lay waiting at the summit finish of the Passo Falzarego with my head pressed firmly to the tarmac. Using a fast shutter speed and wide aperture, I managed to capture 'the hunt' as the leader and pack emerged on their final push.

Nikon D3s with Nikkor 70-200mm f/2.8 G VR II lens at 70mm, ISO 250, 1/6400sec at f/2.8, handheld

philipfield.com

LIGHT ON THE LAND

Under sunset's fiery skies, in fleeting twilight, with the gentler light of the moon, or with the first rays of a new day, we were looking for stunning landscape images from anywhere in the world.

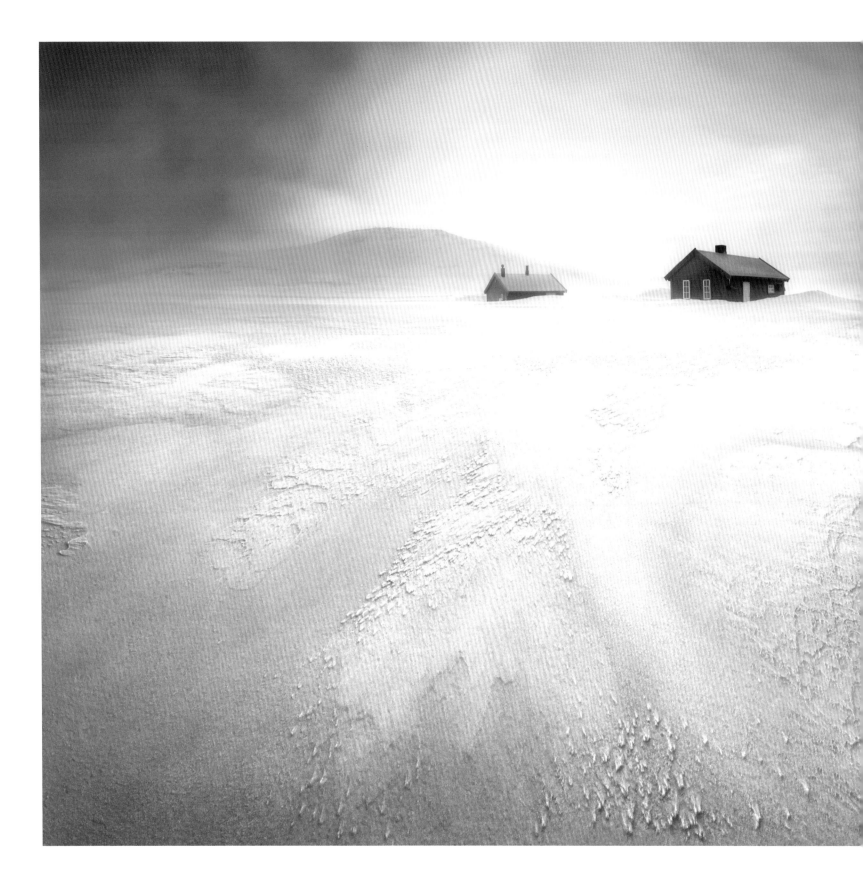

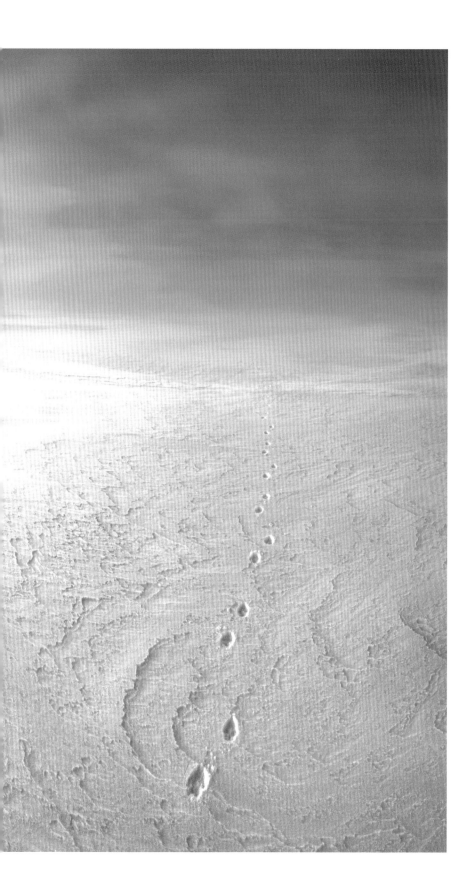

LIGHT ON THE LAND – WINNER

Stian Nesoy (Norway)

Hardangervidda National Park, Norway. After days of frigid snowstorms, a break in the weather revealed an otherworldly landscape near these hunters' cabins. The little footprints were left behind by a lone arctic fox during its relentless search for food in this barren wilderness. After scouting this frozen scene before sunrise, I discovered a spot with a snowdrift leading into the light. The placement of the hill to the left and the tracks made for a balanced image. The image is captured in a wide panoramic format to convey the vastness of the surroundings. I captured the image just before the sun broke the horizon, making for a softly lit scene that helps the textures come alive.

Canon EOS 5D MkII with Canon 17-40mm f/4 L lens at 17mm, ISO 100, 1/50sec at f/16, tripod. This is a panorama stitched from a series of vertical shots

stian.photo

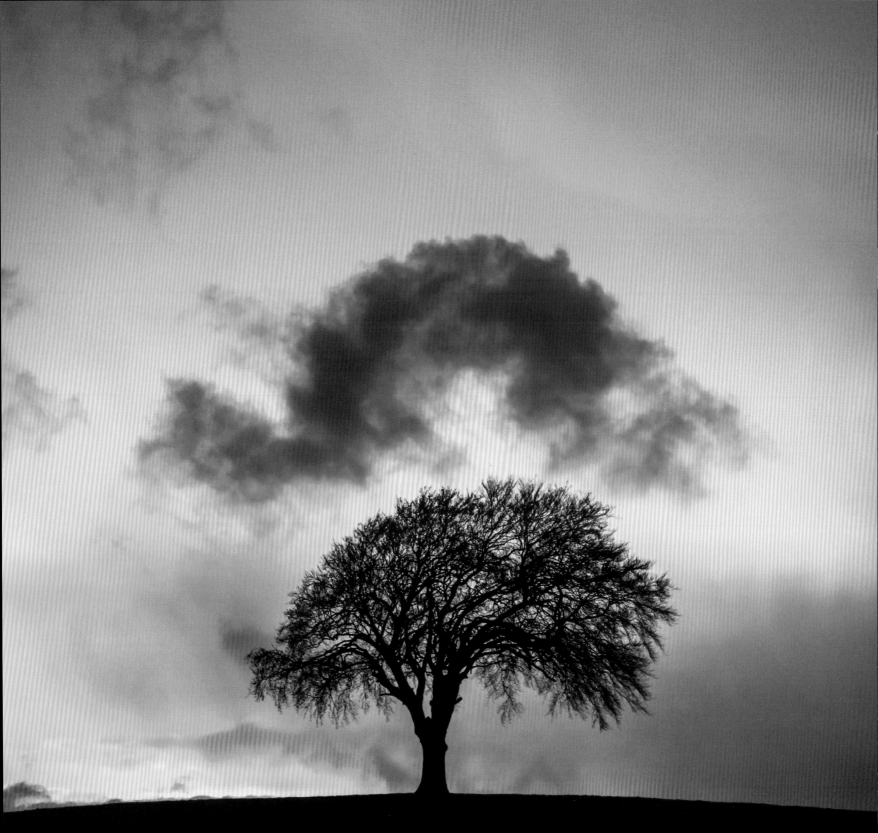

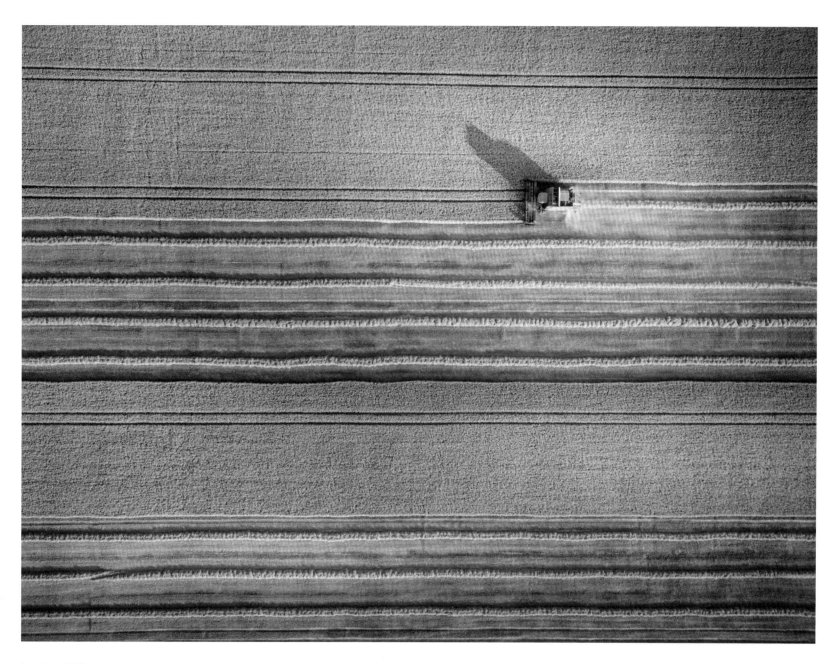

Ian Cox (UK)

How Hill, North Yorkshire, England. I was shooting this tree at sunset when a very similarly shaped cloud slowly drifted in from the left. I prayed that it would hold its shape and line up with the tree, which it finally did after what felt like an age of waiting. I opted for creating a silhouette to help focus the eye on the tree, cloud shape and sky colours. This was very much about being in the right place at the right time.

Sony NEX-6 with Sony E 55-210mm f/4.5-6.3 OSS lens at 126mm, ISO 200, 1/200sec at f/11, tripod

iancoxphotography.com

David Hopley (UK)

Grimston Bar, York, North Yorkshire, England. Following on from a series of wheat and barley crop images I had taken over the summer, I was desperate to complete the series with a few images of a field being harvested. After several unsuccessful trips out into the countryside to find a combine harvester in use, I spotted this harvester and baler as I was on my way home from work. This photograph was taken at a height of about 75m.

DJI Phantom 3 Advanced drone with lens at 3.61mm, ISO 100, 1/180sec at f/2.8

drawswithlight.co.uk

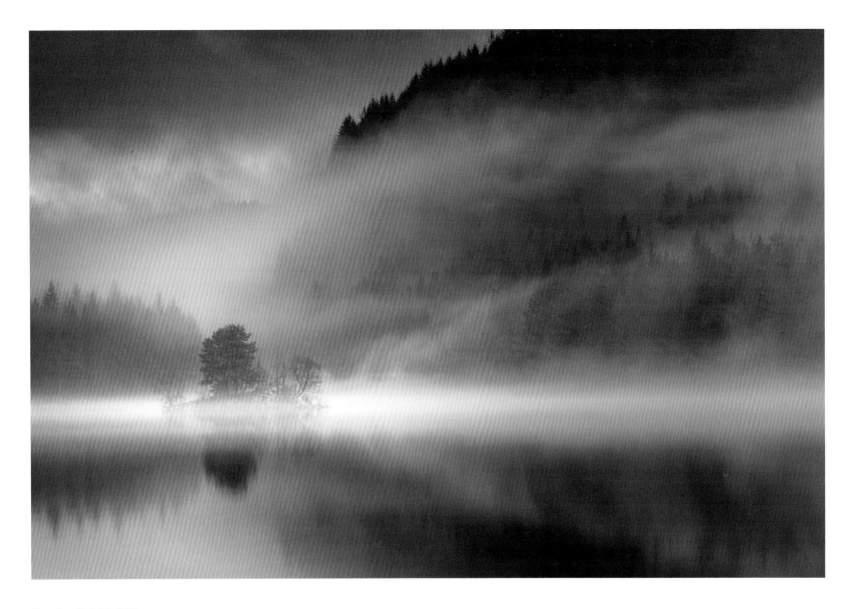

Damian Shields (UK)

Loch Chon, Trossachs, Stirling, Scotland. Tantalising glimpses of this mysterious looking loch were strobing in the corner of my eye through the trees as I drove past on my way to Inversnaid. Spotting a little isle and wonderful layers of mist drifting through the treeline had me quickly pulling over. Grabbing my camera with the 200mm lens attached, I frantically plunged into the dense thicket of fern and thorn, fearing the mist might soon evaporate. Finally, after crossing over a fast-flowing burn and zig-zagging my way through a boggy marsh maze, I found the perfect spot on the bank that afforded me a memorable view across the still waters.

Nikon D800 with Nikon 70-200mm VR-ED f/2.8 lens at 200mm, ISO 320,
1/200sec at f/5, handheld

damianshields.com

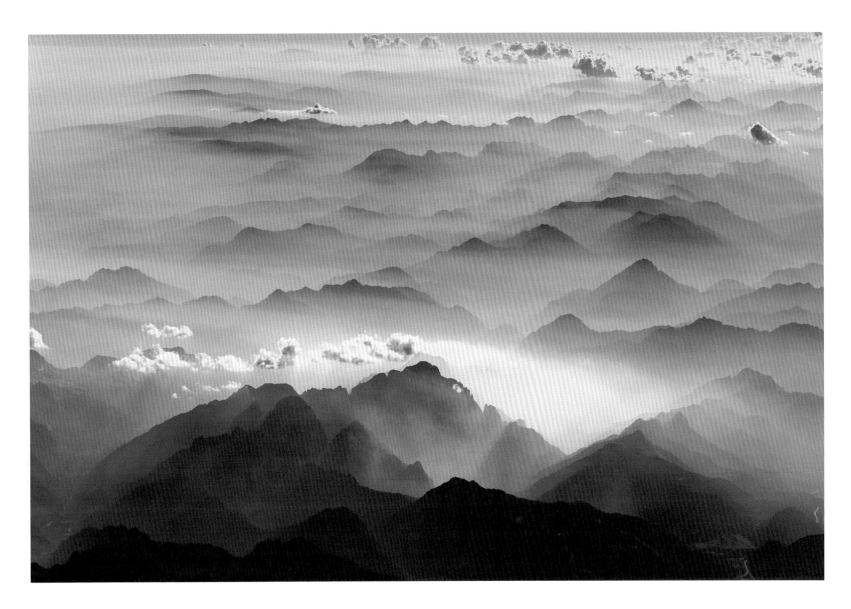

Denis Feiner (Germany)

Alps, Austria. This was taken during a flight from Munich, southbound via Austria, to Italy. The hazy weather conditions on that day and the low sun created so much depth that the Alps looked almost three-dimensional. It was quite a challenge to get a clean shot through the thick cockpit windows of the Airbus, especially shooting against the sun with all the reflections and the vibrations in the plane. The long lens compressed the haze in the image even more, so post-production was quite challenging.

Nikon D800E with Nikon 28-300mm f/3.5-5.6 lens at 122mm, ISO 100, 1/400sec at f/9, handheld

denisfeiner.com

Chris Davis (UK)

Following page: **Tre Cime region, Dolomites, Italy**. This was pretty much the first image I captured in the Dolomites, so I was caught a bit by surprise. We were hiking to the more famous Tre Cime (Three Peaks) and had stopped for a bite to eat at a mountain hut. The sun was going down behind a huge peak to our right and then for about five minutes the visual combination of mountains, clouds and light were cranked up. Instantly I knew this was the kind of shot I was after on this trip, so I quickly set up and waited for the light to creep across the scene so that it caught the foreground area, adding another layer of depth to the image.

Canon EOS 5D MkIII with 16-35mm f/4 L IS lens at 35mm, ISO 100, 1/25sec at f/20, Hitech 0.6 ND soft grad, Feisol tripod and ballhead

chrisdavis-photography.com

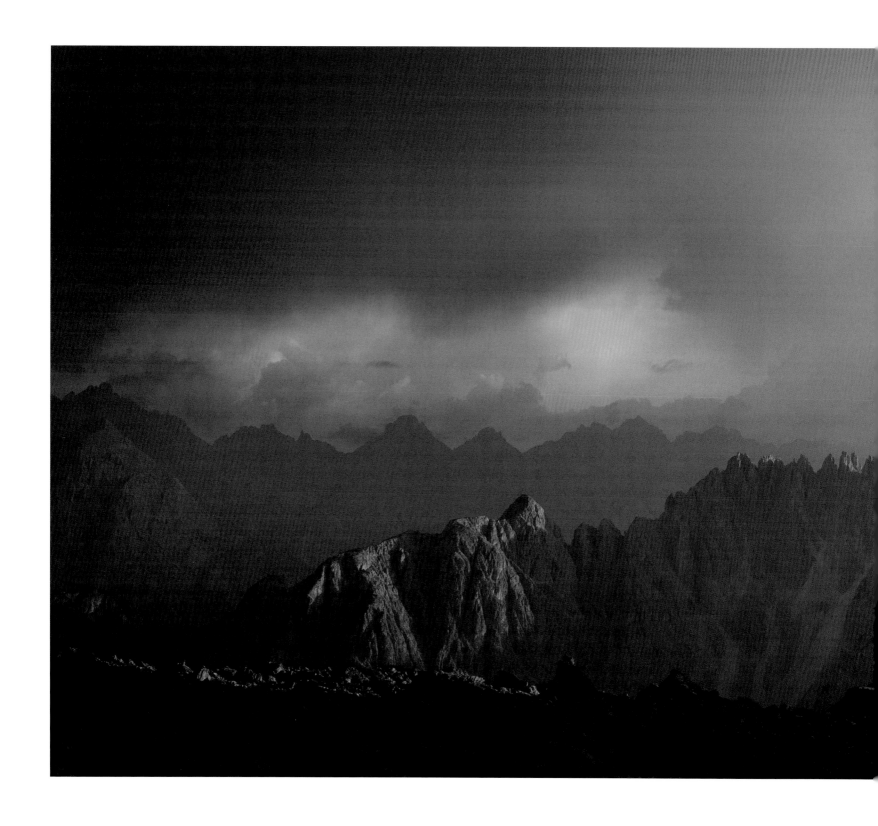

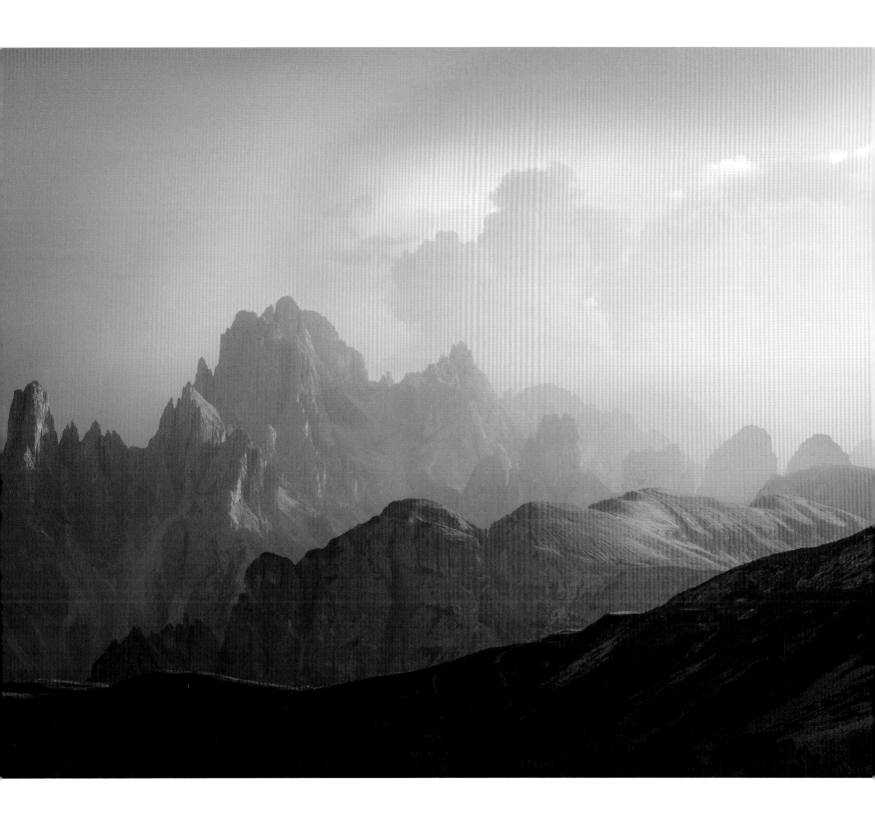

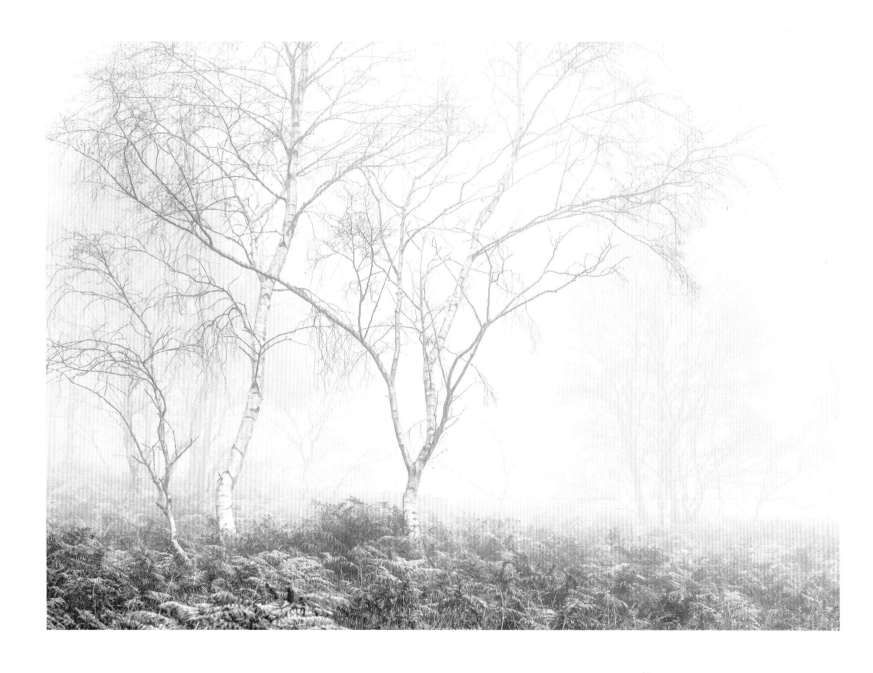

Verity E. Milligan (UK)

Surprise View, Peak District, England. The woodland that surrounds Surprise View in the Peak District comes alive when dense fog clings to the scenery. Although autumn had yet to reach its peak, these three glorious birch trees were already naked. Framed by the rusty colour of the faltering bracken, they represented the beauty found in nature's annual demise.

Fujifilm X-T2 with 50-140mm f/2.8 lens at 50mm, ISO 1250, 1/40sec at f/4.5, polariser, handheld

veritymilliganphotography.com

Greg Whitton (UK)

Snowdonia, Gwynedd, Wales. A lone white tree struggles to survive a bleak winter. On this day all the seasons came at once. As I set up after a bright start, snow began to fall and so I opted for a wider aperture to render the snowflakes more clearly and to give this wonderful dreamlike effect. The cool toning only adds to the atmosphere of winter, and combined they render a sense of fantasy.

Sony Alpha 7R II with 70-200mm lens at 194mm, ISO 100, 1/200sec at f/4.5, tripod

gregwhitton.com

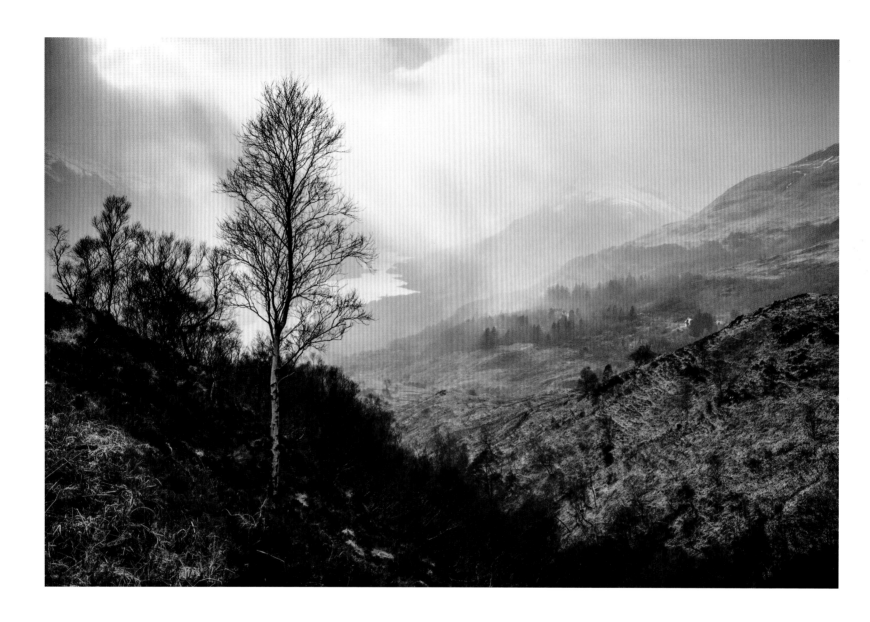

Guy Richardson (UK)

Kinlochleven, Lochaber, Scotland. Hiking into the Mamores in late winter, the weather began to turn. As heavy rain started to fall I began to doubt my already ambitious hike. As I tried to take shelter, I watched the snow and rain showers pass over Loch Leven and the surrounding peaks. A break appeared and light from the afternoon sun filled the valley with a warm glow. A nearby silver birch tree provided some much needed foreground interest against the dramatic backdrop.

Nikon D800 with Nikkor 16-35mm lens at 16mm, ISO 200, 1/640sec at f/11, polariser, handheld

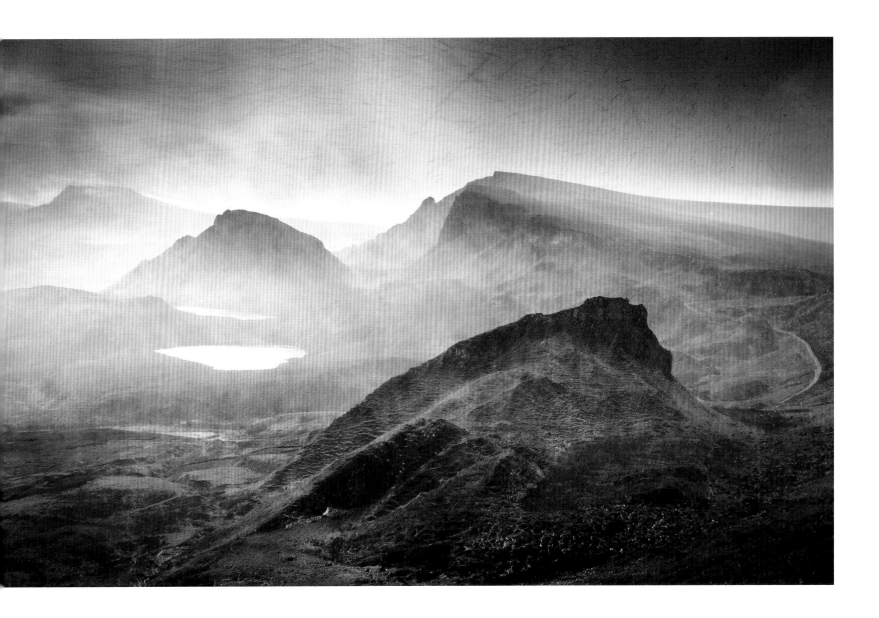

Dave Fieldhouse (UK)

The Quiriang, Isle of Skye, Scotland. A hailstorm hits the Quiriang during Storm
Abigail, the first winter storm of the year. Taking this image was besieged with
challenges, but not all of a technical nature. I'm not great with heights or narrow
ledges, so concentrating on keeping the lens clean and taking shots was almost
secondary to keeping my balance in the strong winds and not falling down the
mountainside. It's an amazing location, but for once I'll admit to being glad to
being back in the car after I got the image.

Canon EOS 5D MkIII with 24-70mm lens at 30mm, ISO 200, 1/30sec at f/8, tripod

davefieldhousephotography.com

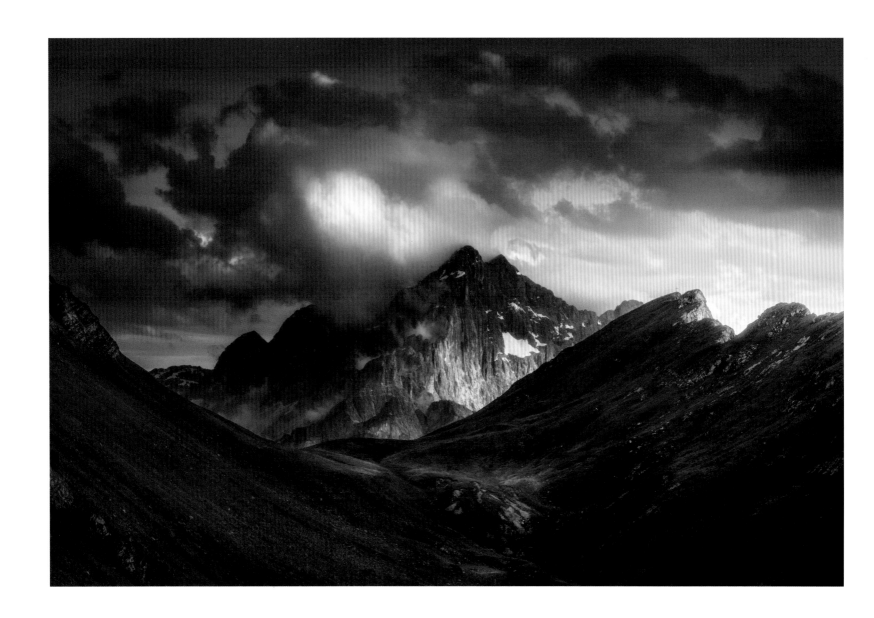

Isabella Tabacchi (Italy)

Mount Civetta, Mondeval Alp valley, Dolomites, Italy. I had pitched my tent near Lake Baste, on the green Mondeval Alp plain, at 2,360m above sea level, which is a kind of natural panoramic terrace from where you can admire the most important peaks in the Dolomites, such as Mount Civetta. As the sun rose, I captured the scene with Mount Mondeval on the left and Piz del Corvo on the right.

Nikon D810 with Nikkor 70-200mm f/4 ED VR lens at 78 mm, ISO 40, 1/15sec at f/11, Sirui tripod

isabellatabacchi.com

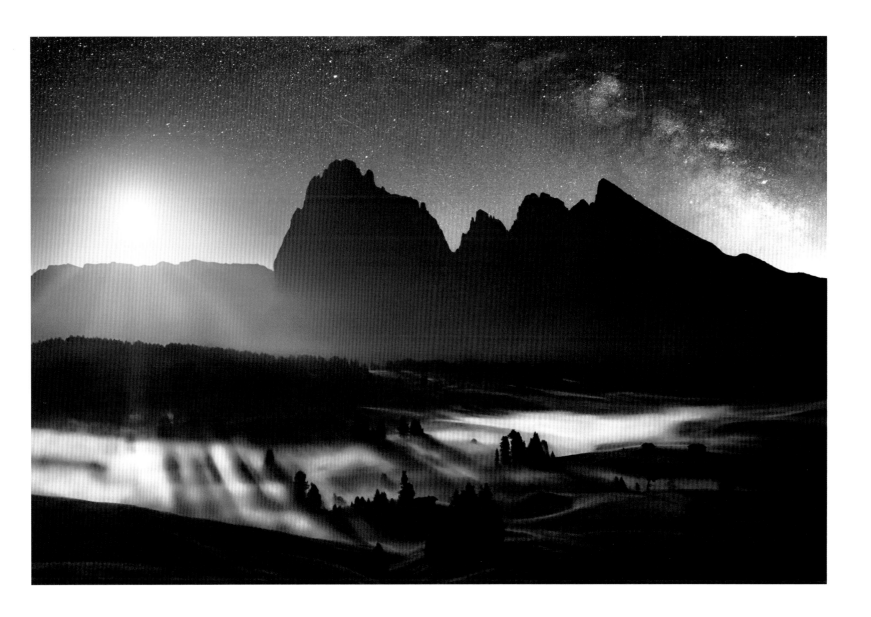

Isabella Tabacchi (Italy)

Seiser Alm plateau, South Tirol, Italy. I went to Seiser Alm in July to take some shots of the Milky Way. After taking a panoramic image of the Milky Way, the moon rose to the left of Langkofel peak and illuminated the valley, which was full of fog, and I took another panoramic. The moonlight washed out the Milky Way, so I then merged the two panoramic images to show the complete scene.

*Nikon D810 with Nikkor 14-24mm f/2.8 G AF-S ED lens at 24mm, ISO 3200, 13sec at f/2.8
for the stars; Nikkor 50mm f/1.8 G AF-S lens, ISO 1000, 6sec at f/8 for the rest of the landscape;
Manfrotto tripod*

isabellatabacchi.com

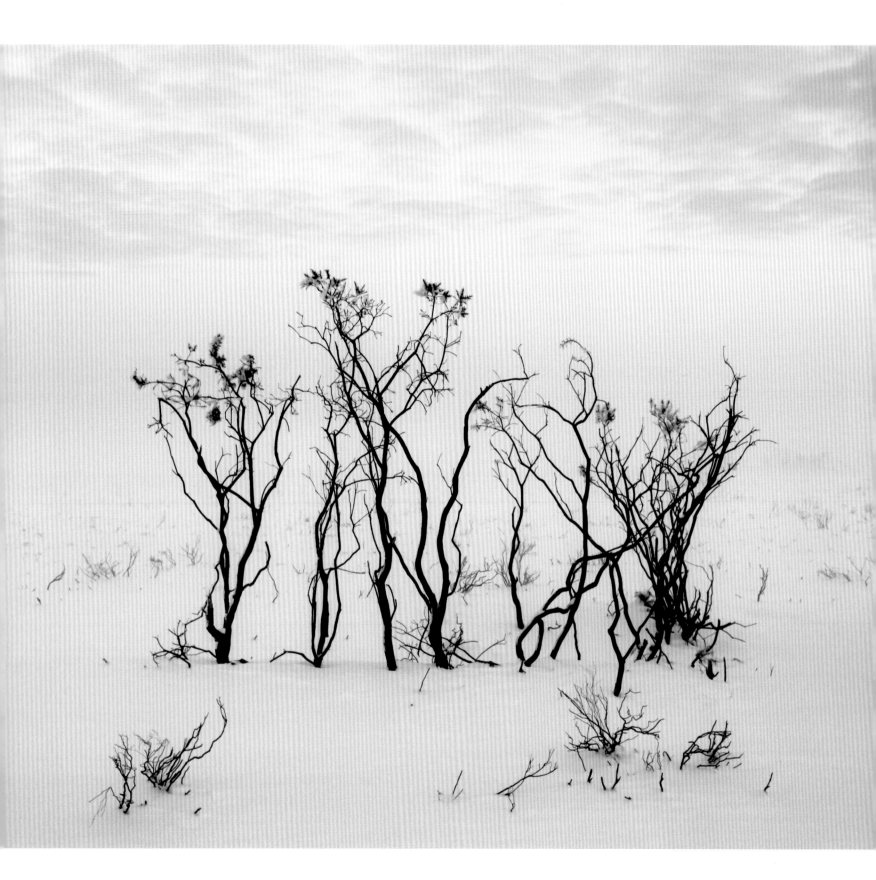

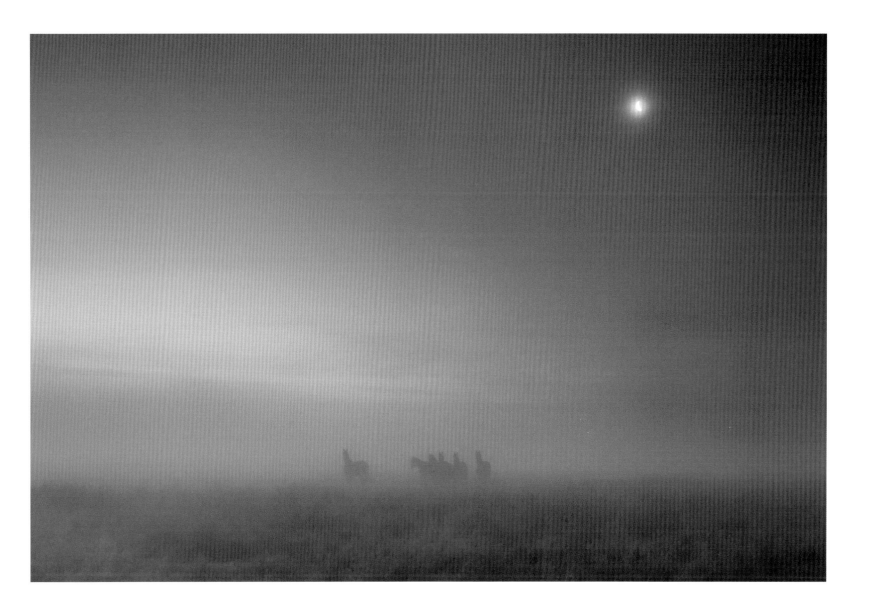

Kevan Brewer (UK)

Left: **Beaulieu Heath, The New Forest, Hampshire, England**. During a rare snowy spell, I'd headed out on foot for a change as the conditions were too difficult to use my car. I'd spotted the burnt gorse and taken a few shots as I left, as I'd been drawn to the contrast between the blackened stems and the white snow. On my return journey home, just after sunset, the sky had developed a subtle pink hue behind this particular group of gorse, and a light mist had begun to form.

Canon EOS 5D MkII with EF 24-105mm f/4L IS USM lens at 40mm, ISO 400, 1/20sec at f11, tripod

newforestimages.com

Hannu Mäkelä (Finland)

Jokioinen, Finland. I have always loved the light and atmosphere of summer nights. On this particular night I went to the nearby town Jokioinen, where I saw a beautiful valley filled with fog. I couldn't see very far but I could hear distant neighing and realised there were horses in the fog. The horses stayed still long enough for me to focus manually and shoot a quite long exposure.

Canon EOS 6D with Canon EF 24-70mm f/2.8 USM II lens at 35mm, ISO 1600, 1/5sec at f/2.8, Lee 0.9 ND grad, tripod

hjm.kuvat.fi

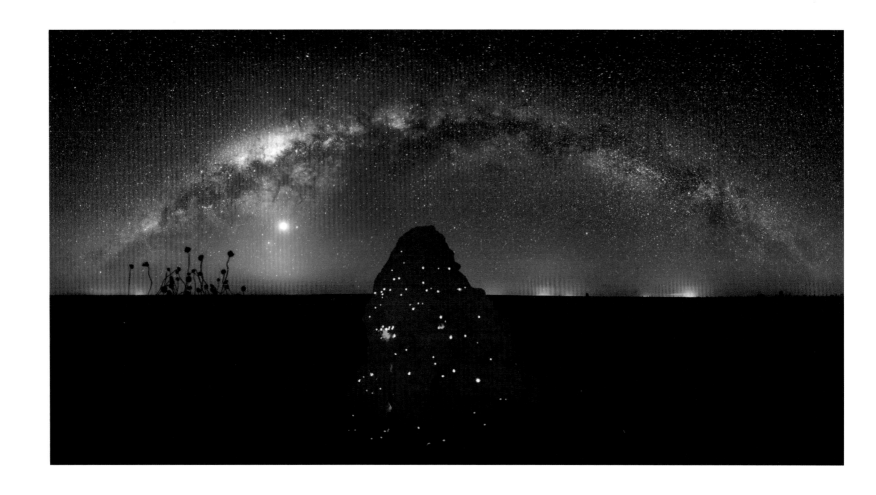

Marcio Cabral (Brazil)

Parque Nacional das Emas, Brazil. This is a termite mound covered with firefly larvae that produce a terrestrial bioluminescence at night. This is a rare phenomenon and this national park is the only place it occurs, for just a few weeks of the year.

Canon EOS 5DS R with Nikon 14-24mm lens at 14mm with a Fotodiox adapter; ISO 5000, 30sec at f/2.8 for the Milky Way images; ISO 640, 241sec at f/4 for the termite mound; Manfrotto tripod, Scurion 1200 Warm LED lamp. This is a panoramic made with four sequential images; three focusing on the Milky Way and one focusing on the mound. I used the Scurion 1200 Warm LED lamp to lighten the termite mound

fotoexplorer.com

Marcio Cabral (Brazil)

Salar de Uyuni, Bolivia. This is an electric storm during sunset in the Salar de Uyuni. It is a rare scene of this salt desert, where the winds can reach more than 50mph. When the storm approached, we had to leave in order to not be hit by the lightning. The storm showed the impressive force of nature as I had never seen it before.

Canon EOS 5D MkIII with 70-200mm L f/4 IS lens at 70mm, ISO 160, 13sec at f/16, Manfrotto tripod

fotoexplorer.com

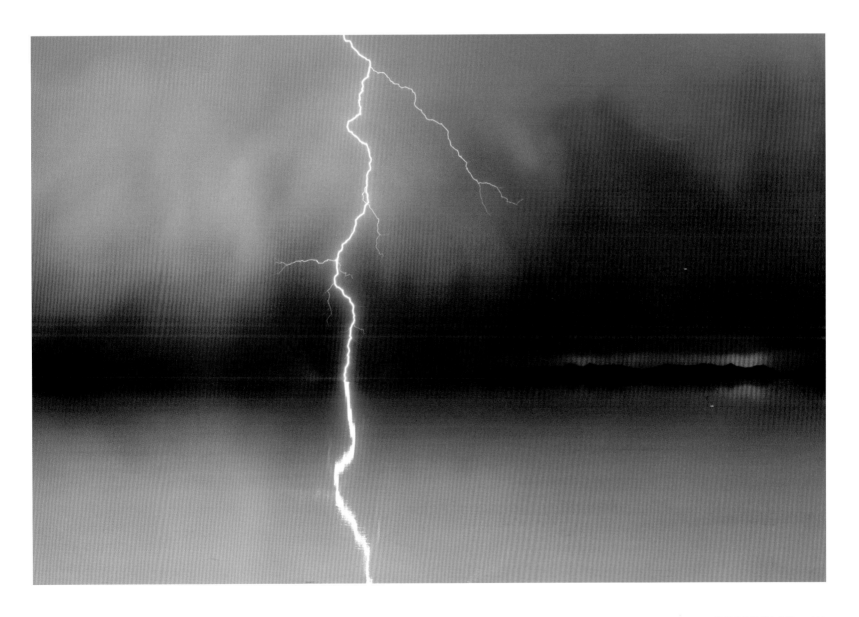

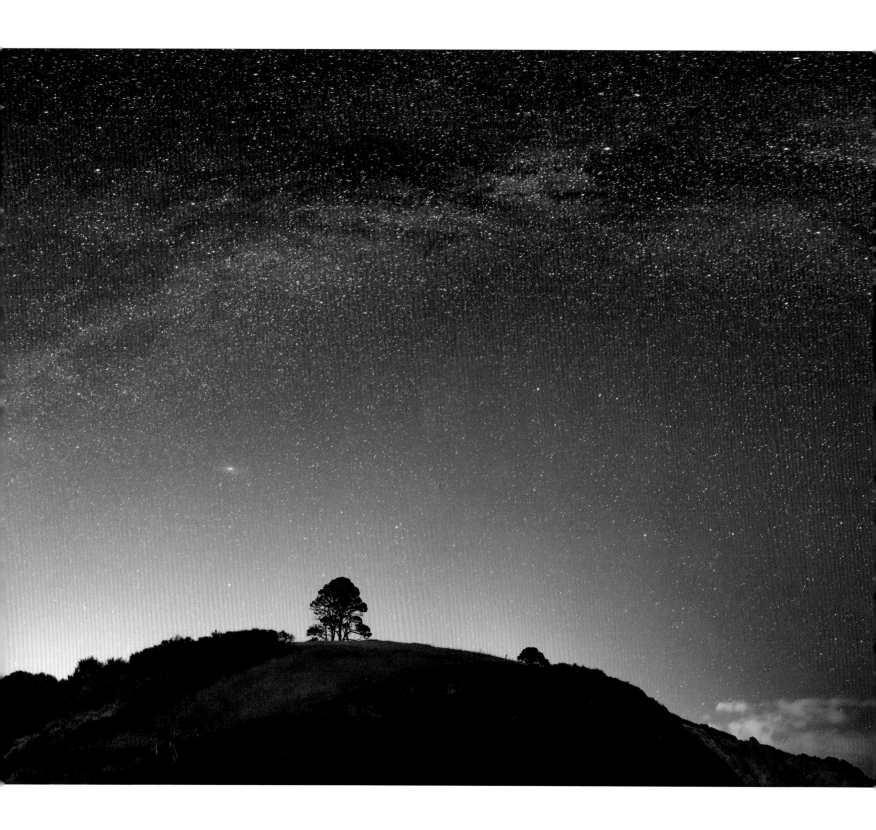

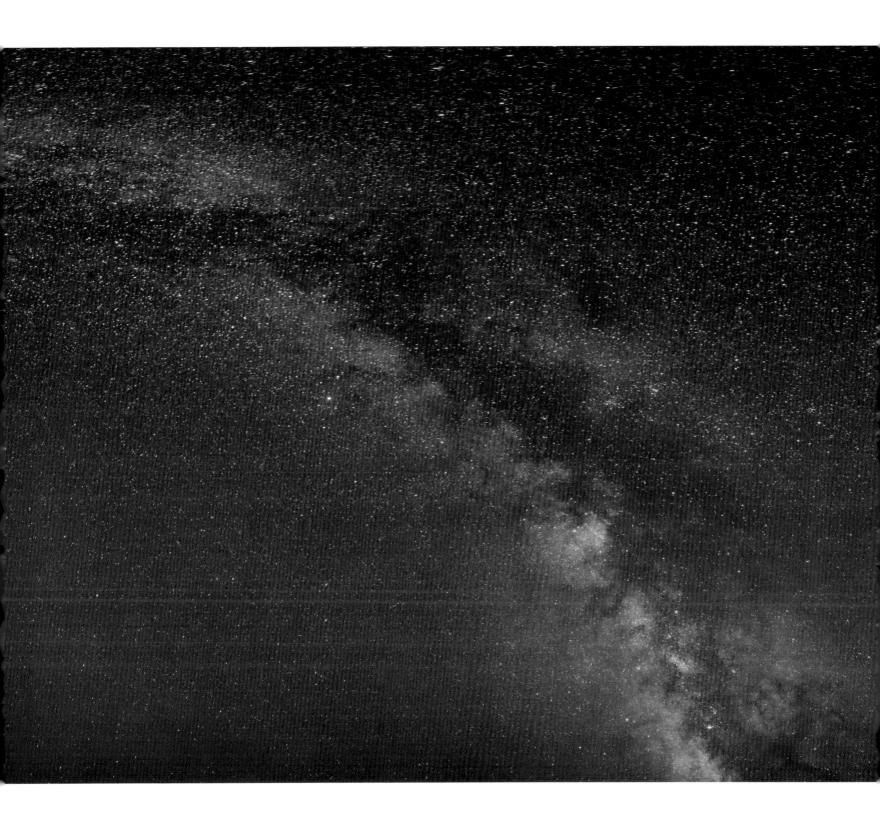

Mark McColl (UK)

Previous page: **Polperro, Cornwall, England**. I was looking for a summer photography project and decided I would photograph parts of Cornwall at night while on holiday there. A moonless, clear night afforded the perfect opportunity, and a short walk to a beach near Polperro revealed this image as a possibility. The field of view required to take in the full extent of the Milky Way was immense; it needed 11 vertical images stitched. The little tree sitting atop a hill was the simple composition element I needed to show the Milky Way in all its glory.

Sony Alpha 7R II with Samyang 24mm lens, ISO 3200, 11 vertical images stitched, each shot at 20sec at f/2, tripod

markmccoll.co.uk

Roberto Marchegiani (Italy)

Sibillini National Park, Italy. There is a plateau at 1,400m in the park that for around two weeks each July has the most spectacular blossoming of wildflowers. It is an ephemeral phenomenon, where flowers of different colours overrun the entire plateau. After sunrise one day a layer of fog was over the meadow, and a white arc fogbow appeared for only a few minutes.

Nikon D810 with Zeiss 21mm f/2.8 zf2 lens, ISO 64, 1/50sec at f/13, Lee 0.6 ND hard grad, polariser, tripod

joyoflight.it

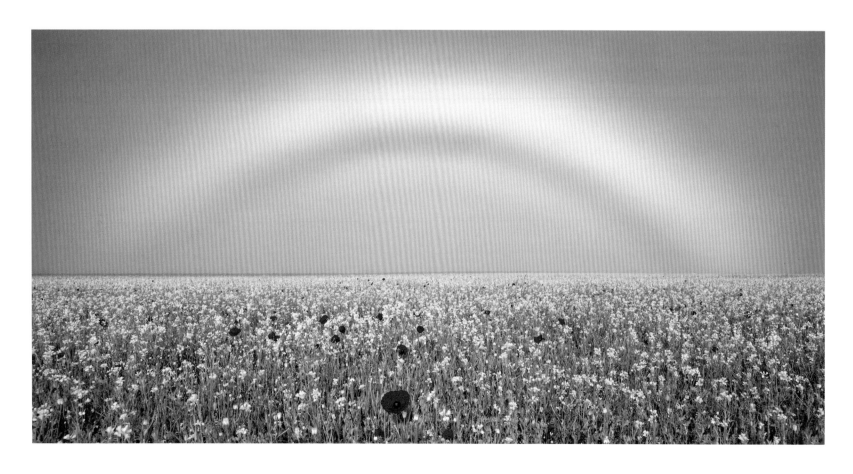

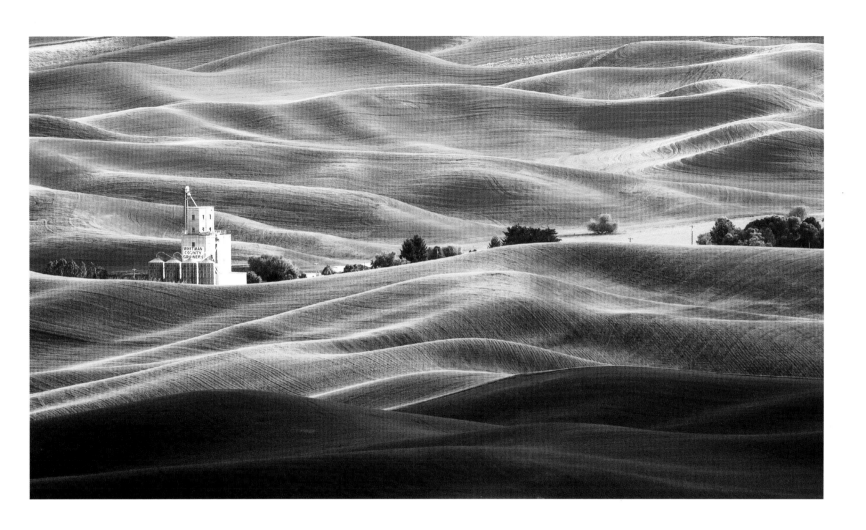

Hamish Mitchell (Canada)

Steptoe Butte, Washington State, USA. When I first drove up Steptoe Butte I envisioned the exact shot I wanted. I knew the old grain elevator surrounded by the seemingly endless rolling fields would be a beautiful image. Unfortunately, it took three nights for the light to be just right. My patience was finally rewarded when the sky finally opened up and the setting sun transformed the landscape before me into a sea of beautiful rich colours and textures.

Nikon D750 with Nikon 300mm f/2.8mm VR lens, ISO 100, 1/60sec at f/11

hamishmitchellphotography.com

Darren Ciolli-Leach (UK)

Central highlands, Iceland. We were driving along a remote road in Iceland's barren interior when I noticed a small gulley a few hundred metres away that appeared to be filled with large broken slabs of snow and ice. I ventured a little further and in the middle of one of the bergs found a 3m vertical fissure filled with the most astonishing ice and light.

Canon EOS 1Ds MkIII with Canon EF 24-105mm f/4 L IS USM lens at 105mm, ISO 100, 1/25sec at f/16, Lee polariser, tripod

darrenciollileach.com

Mark McColl (UK)

Jökulsárlón, Iceland. I have been to Iceland on a number of occasions, but the conditions on this morning were exceptional, with a beautiful pre-dawn hue and a setting full moon. Rather than capturing the entire view, I opted for a longer lens and identified an interesting part of an iceberg with a little 'pocket' that looked as though the moon would just fall into it. I like the colour contrast, textures and shapes in the final image.

Canon EOS 5D MkIII with Canon 100-400mm II lens at 400mm, ISO 100, 1/4sec at f/16, Gitzo tripod

markmccoll.co.uk

Matthew Dartford (UK)

Guist, Norfolk, England. I had known about this location with its derelict cricket pavilion for a while and it always struck me as a potential subject for a foggy morning. So when I arrived I knew exactly where to be for a good perspective. Shooting the scene in infrared was going to be the best option, as this would bring out the details in the structure and the woods, and give everything a mysterious other-worldly feel.

Infrared converted Sony Alpha 7 with Canon 16-35mm lens (focal length not recorded), ISO 100, 1/20sec at f/9, Gitzo tripod with panoramic head; the image is made up of four images stitched together, and I swapped the red and blue channels to give the image a cold feel

mdartford.photography

Ollie Batson (Republic of Ireland)

Tre Cime di Lavaredo, Veneto, Italy. I felt that the Tre Cime World War One commemorative chapel deserved its own space, independent of the Tre Cime peaks towering over it. Placed centre right, the eye is drawn along the gravel track to the chapel, seemingly perched precariously beside the steep slope to the left, and then beyond into the space surrounding it. I feel these elements along with the dramatic weather and surrounding landscape combine to isolate the chapel and emphasise its poignancy.

Nikon D7100 with AF-S DX Nikkor 35mm f/1.8 G lens, ISO 100, 1/200sec at f/8, polariser, handheld

flickr.com/photos/144279145@N04

Fan Sissoko (UK)

Þingvellir National Park, Iceland. In the depths of winter in Iceland there are only a few hours of daylight. On a clear day, this makes for dramatic transitions from sunrise to sunsets, as the light changes quickly. On this particular day, I was chasing the sun in a snow-covered landscape. This picture was taken in the rift valley between the North American and Eurasian tectonic plates. This lonely tree was stealing the spotlight; a minute later, the light was gone.

Fujifilm FinePix X100 with 23mm lens, ISO 100, 1/60sec at f/2, handheld

flickr.com/photos/fan_tastic

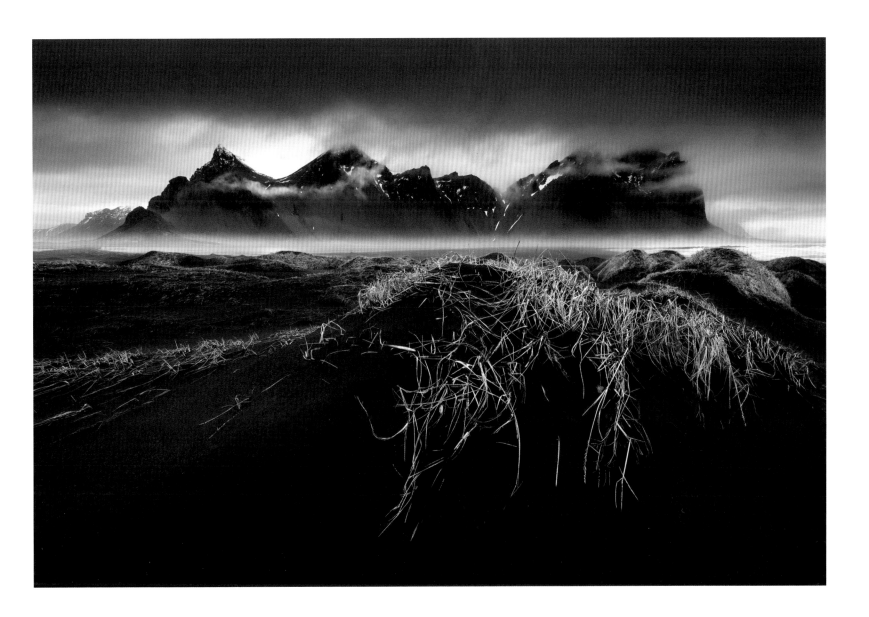

Sharon Wilson (UK)

Vestrahorn, Iceland. Vestrahorn was the last stop on our weeklong tour of Iceland, and it was the place we were most looking forward to. We only had a few hours to spare so had to make the most of the changing weather conditions. The wind was gaining strength and the light fading fast, so time was of the essence.

Nikon D800 with Nikon 16-35mm VR lens at 16mm, ISO 50, 0.5sec at f/11, Gitzo tripod

500px.com/Sharonwilson77

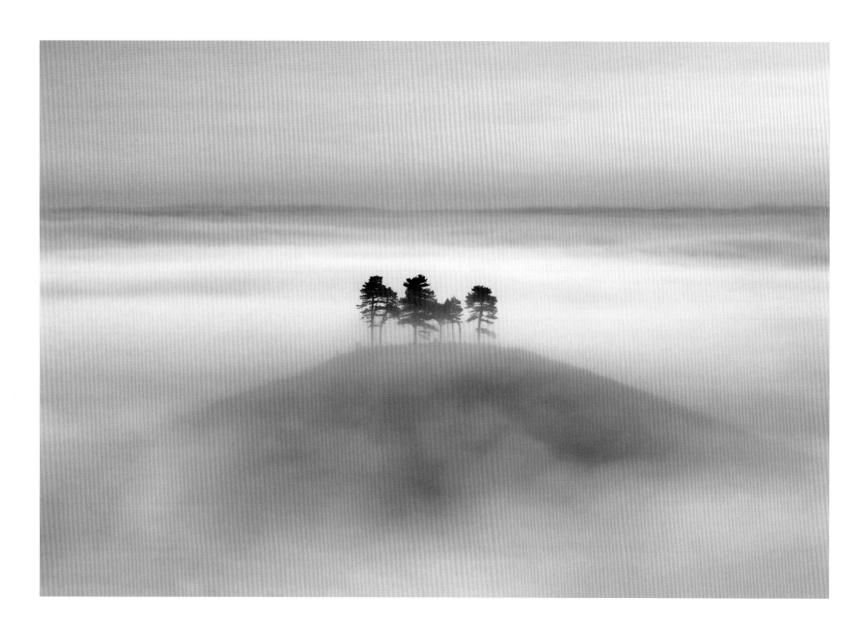

Tony Gill (UK)

Colmer's Hill, near Symondsbury, Dorset, England.
Colmer's Hill is a well-known local landmark,
distinctive for its conical shape and crown of pine
trees. It also lies in an area prone to fog, and on this
particular morning it was thicker than ever. The air
was cold and the sky clear, allowing the steely blue
tones to colour the low cloud, with the hill proudly
raising its head above the morning murk.

Canon EOS 5D MkII with 24-105mm L lens at 90mm, ISO 100,
1.3sec at f/13, Lee 0.6 ND grad, Manfrotto tripod

flickr.com/photos/heytony

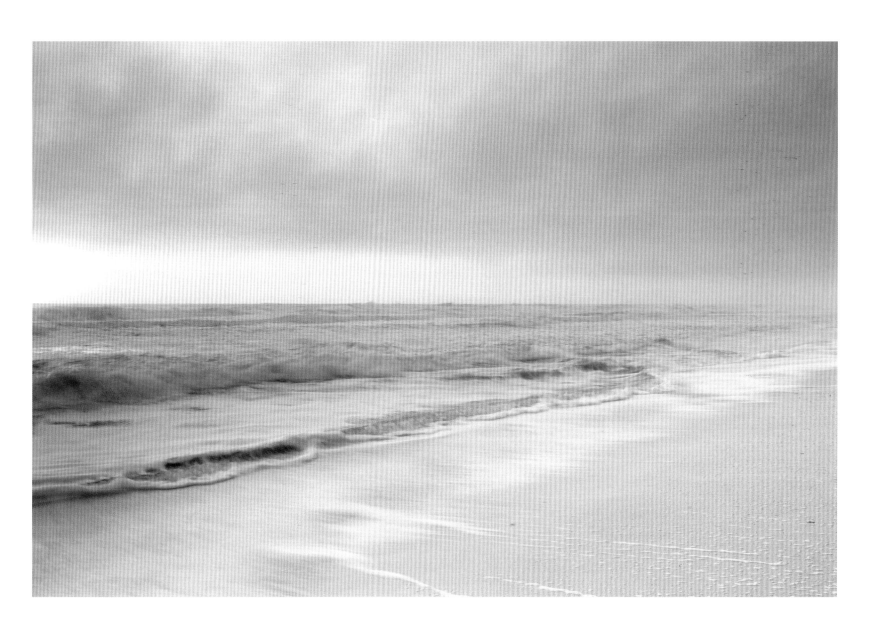

David Pascoe (USA)

Fernandina Beach, Florida, USA. I set out early the
day after Thanksgiving to photograph this coastal
scene and was initially disappointed by the heavily
clouded sky. Surprisingly, for a brief moment the sun
poked through under the cloud cover, glowing a
brilliant orange. A longer exposure gives a watercolour
characteristic to the image.

*Canon EOS 5DS R with Canon 16-35mm lens at 31mm,
ISO 100, 1/4sec at f/11, ND grad, tripod*

davidpascoephotography.com

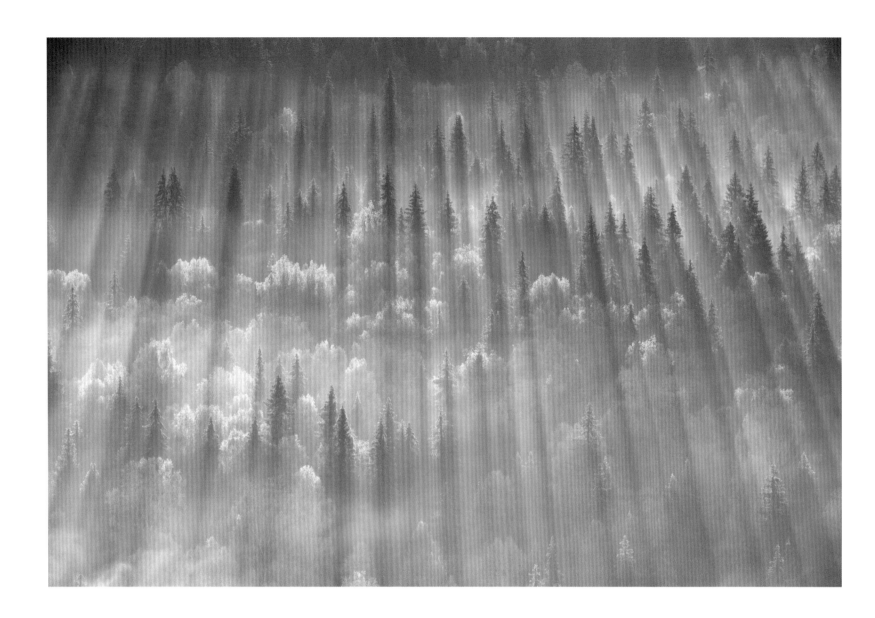

Vadim Balakin (Russia)

Usva Pillars, Perm Krai, Russia. This picture was
taken at end of September when the autumnal
forest was covered by fog. I was standing on a rock
high above the fog and forest, and the rising sun
streaming through the tree tops made it a magical
scene to photograph.

*Nikon D810 with Tamron 70-200mm f/2.8 Di VC USD lens
at 200mm, ISO 100, 1/160sec at f/9*

vadimbalakin.com

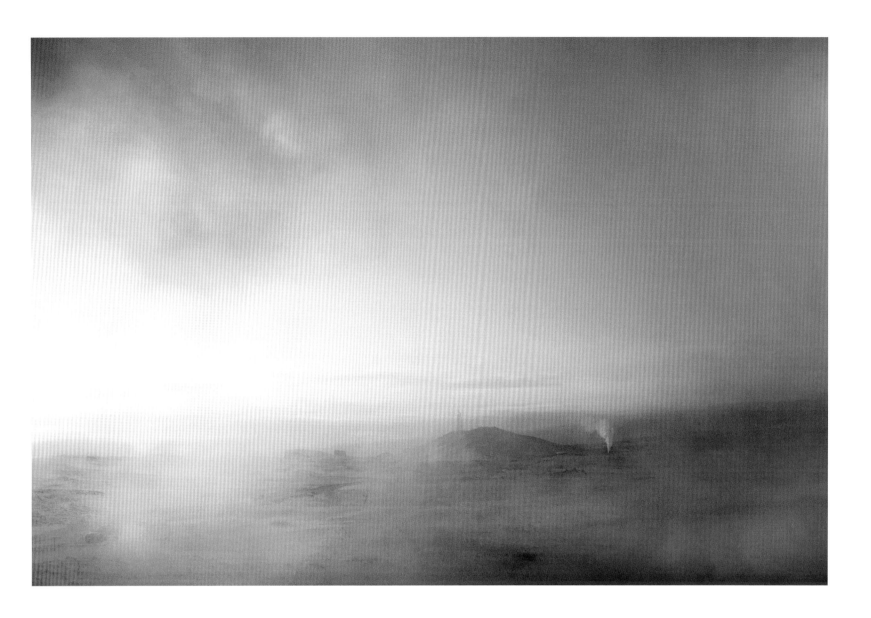

Yao Sullivan (UK)

Reykjanes lighthouse, Gunnuhver, Iceland. To celebrate my 50th birthday
I wanted to experience something magical, and heading to Iceland was an easy
choice to make. I booked a day shooting with local photographer Bragi Kort,
and together we explored the Reykjanes peninsula. After an exhilarating day,
in the late afternoon we arrived at the geysers of Gunnuhver. The sky was
filled with huge plumes of steam, blazing in a golden setting sun. In the
distance, the Reykjanes lighthouse crowned the horizon.

Nikon D7000 with Sigma 10-20mm f/4-5.6 EX DC lens at 20mm, ISO 200, 1/125sec at f/11

yao-photography.co.uk

SMALL WORLD

Nature can be at its most amazing in the smallest forms. We wanted to see macro and close-up photographs of the plants and insects all around us that often go unnoticed.

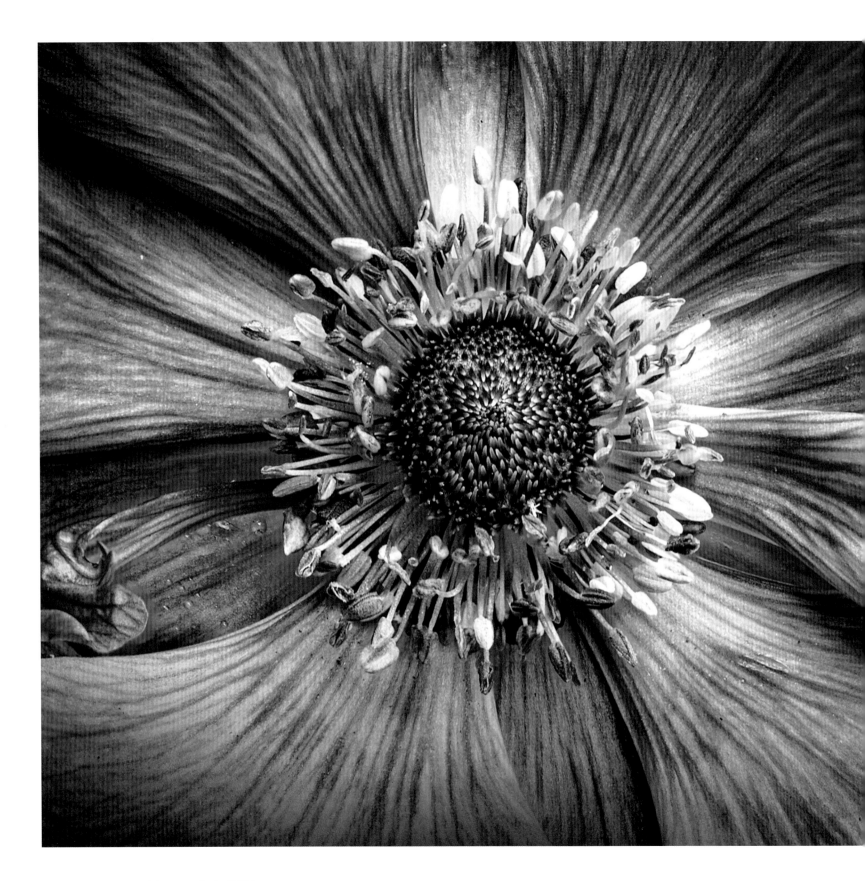

Justin Garner (UK)

Manchester, England. We grow flowers on our balcony at home, which offer many photographic opportunities. I noticed the rich textures in the blue anemone's petals, and I waited for the flower's textures to be at their best. Choosing to shoot on an overcast day prevented harsh shadows from the sun affecting the image. I used a plant clip to steady the flower, enabling me to take 15 shots that I then photo stacked in post-processing.

Canon EOS 5D MkIII with 100mm macro lens, ISO 100, 1/15sec at f/7.1, tripod, macro focusing rail, plant clip

jags-photography.co.uk

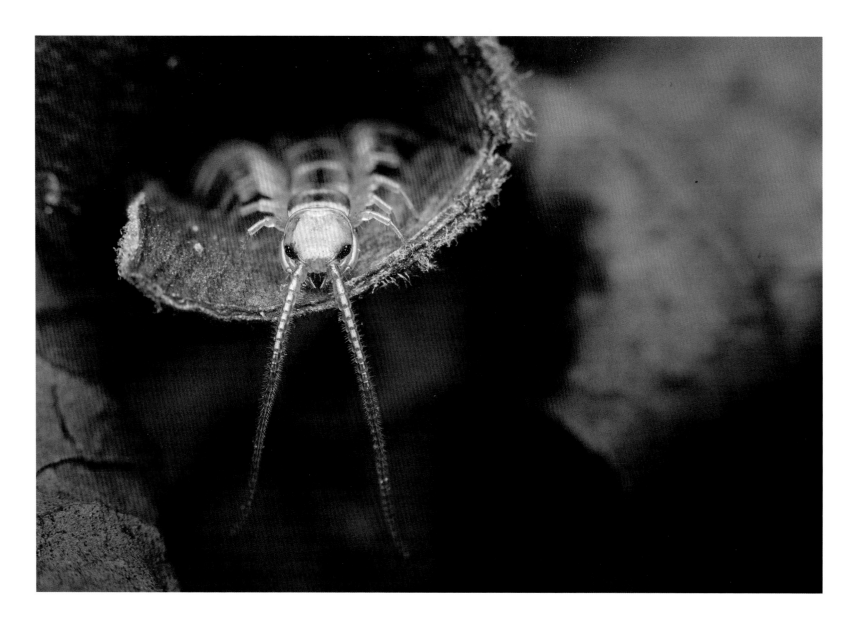

Neil Burnell (UK)

Churston Village, Devon, England. While looking
in my garden for macro subjects, I spotted this
centipede resting inside a dried up leaf. To get a low
point of view I slowly moved into position by lying
on the ground and edging closer to the centipede,
being careful not to spook it. Luckily I managed
several shots before the centipede moved back into
the darkness.

*Nikon D7200 with Tamron 60mm f/2 lens, ISO 100, 1/180sec
at f/8, Nikon SB400 speedlight (diffused), handheld*

neilburnell.com

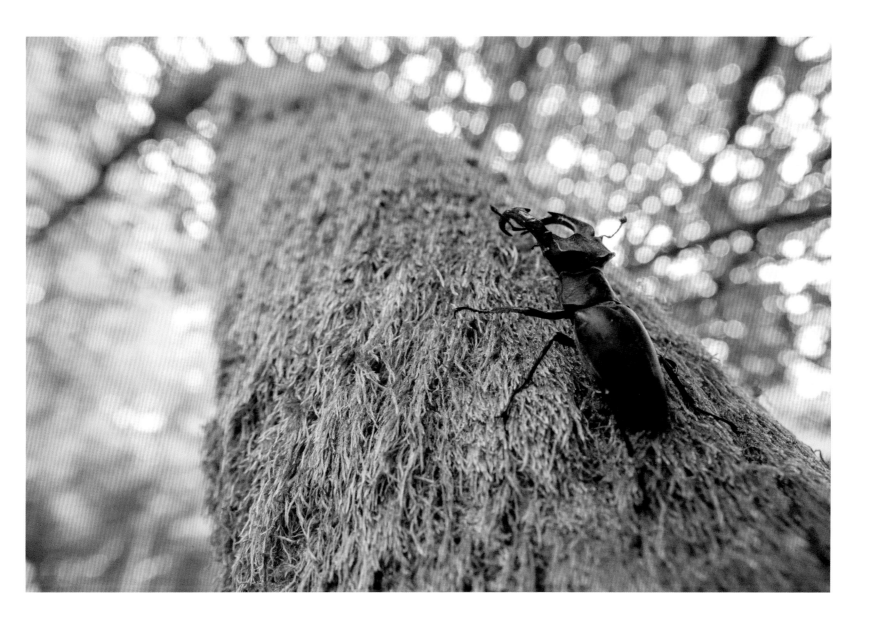

Mart Smit (Netherlands)

Vierhouten, Gelderland, Netherlands. One
morning I went to a forest to search for the biggest
beetle we have: the stag beetle. This male was just
leaving the 'battlefield' and was heading for a higher
spot from which to fly away. I changed my macro
lens for a wideangle lens, as I wanted to show the
stag beetle's natural environment.

Canon EOS 1DX with Zeiss 21mm lens, ISO 2000,
1/64sec at f/5.6

smitinbeeld.nl

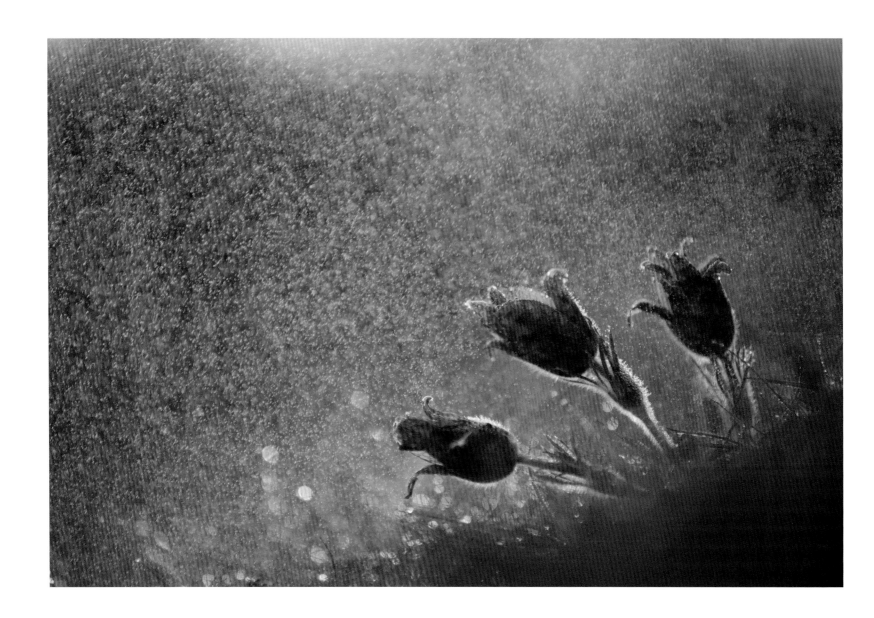

Daniel Trim (UK)

Therfield Heath, Hertfordshire, England. Pasque flowers grow very low to the ground, so photographing them at their own level is critical to making them stand out. With added afternoon light they can look very striking. For this photo I used a spray mister to add further atmosphere, and underexposed slightly so that the backlit water droplets would become more visible.

Canon EOS 5Ds with Canon 70-200mm f/2.8 L IS USM lens at 150mm, ISO 1000, 1/2500 at f/2.8, handheld

danieltrimphotography.com

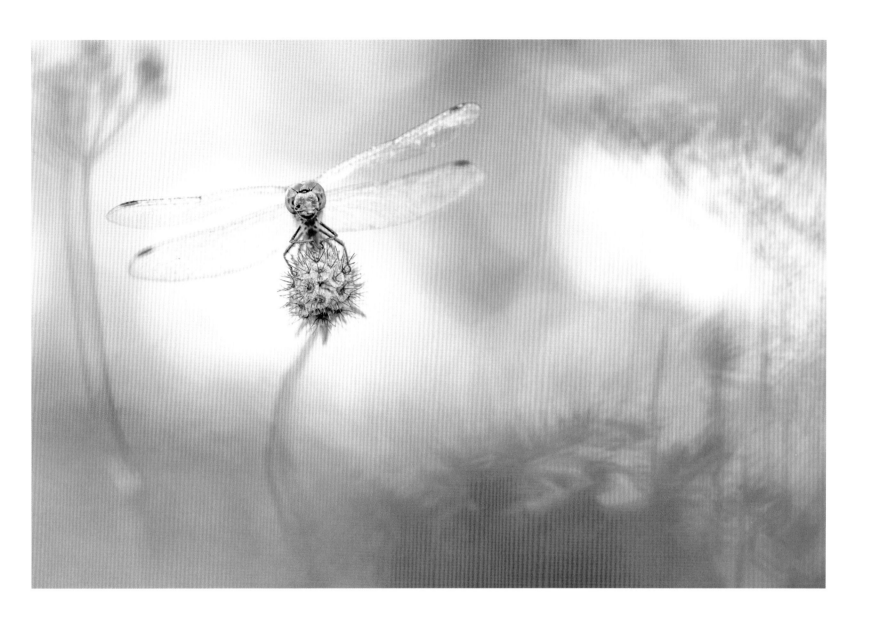

Perdita Petzl (Austria)

Near Vienna, Austria. Dragonflies are a very rare
find for me. I photographed this one shortly after
sunrise. I didn't want to show the dragonfly from
the usual side view, so I decided to photograph it
from the front. This view, in which only the head
and the wings are recognisable, makes the dragonfly
appear almost abstract.

*Canon EOS 5D MkIII with Canon EF 100mm f/2.8 macro
USM lens, ISO 640, 1/250sec at f/3.2, tripod, remote trigger*

facebook.com/naturfotografiepetzl

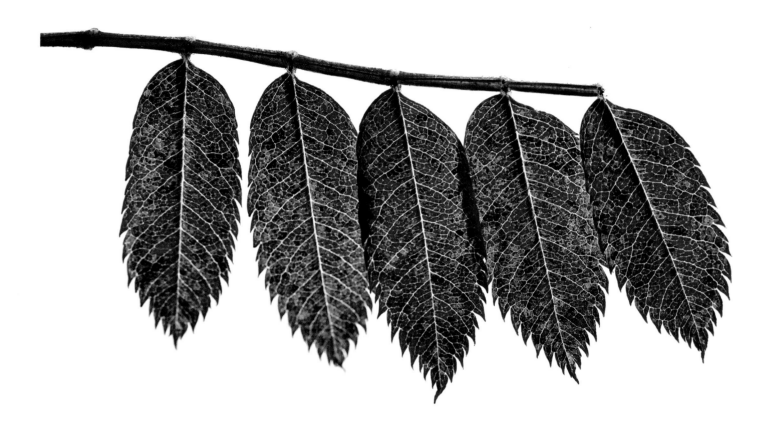

Simon Gakhar (UK)

Northumberland, England. While searching for samples to photograph for creative leaf macros, I noticed partially decayed rowan leaves with unusual but striking colour patterns. I decided to photograph some backlit by the sun against cloud to give a white contrasting background. It required good technique, and this photo was the best example of many different samples and compositions taken during the shoot. I named this photograph 'Sympathy for the Devil' owing to the shape of the tips.

Canon EOS 5D MkIII with Canon EF 100mm f/2.8 L macro lens, ISO 800, 1/1000sec at f/8, handheld

flickr.com/photos/simmyg

Stefan Gerrits (Netherlands)

Kampina Nature Reserve, Oirschot, Netherlands.
Almost every year, I visit the Kampina Nature
Reserve to photograph silver-studded blues (*Plebejus
argus*) in the very early morning. I am always excited
when I go there, wondering whether I will actually
find them. If I do, it's then all about composition and
looking for natural lines. Here, five of them are
warming up lying into the wind.

*Canon EOS 5D MkIII with Canon EF 100mm f/2.8L macro
IS USM lens, ISO 1250, 1/125sec at f/13, handheld, converted
partially into black & white using Silver Efex Pro*

stefangerrits.com

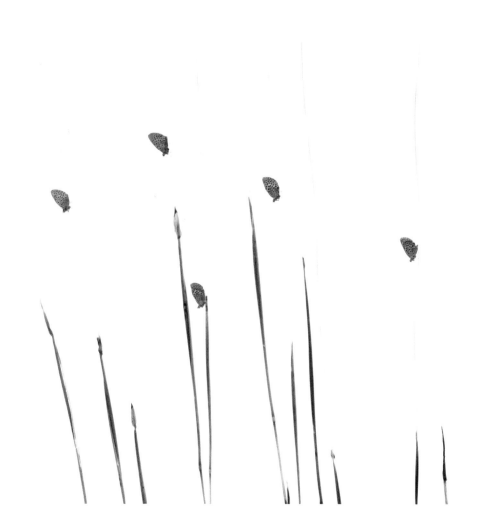

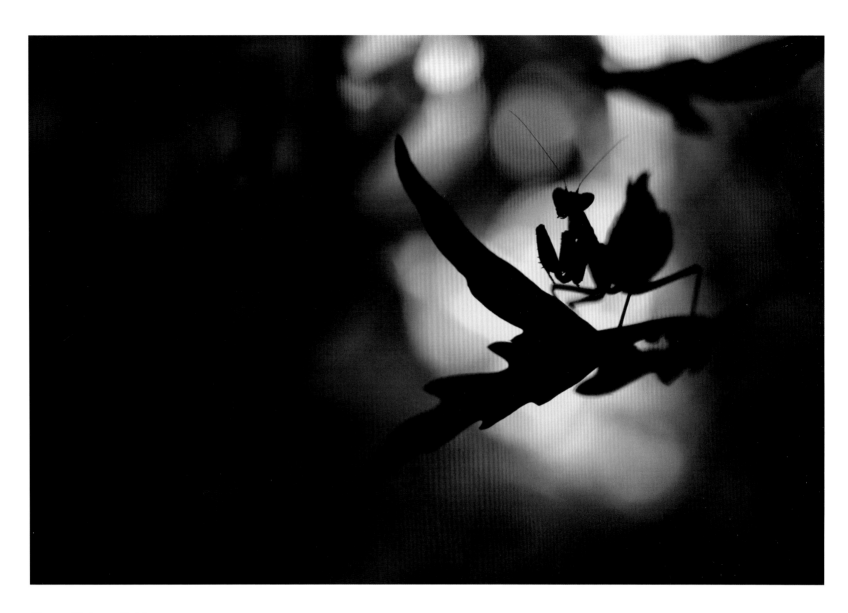

Simona Tedesco (Italy)

Tuscany, Italy. During a recent summer I spent a lot of time observing the life of the European dwarf mantises (*Ameles spallanzania*) living in the leaves of a large arugula plant in my garden. This species is very territorial and it was interesting to find the subjects in the same spot every day. The dwarf mantis is an excellent predator, and its hunting technique is based on expectations and immobility. The black silhouette recalls the image of a killer ready to strike and the atmosphere is full of pathos.

Canon EOS 1D MkIV with EF 100mm f/2.8 L IS USM macro lens, ISO 160, 0.5sec at f/3.5, tripod

simonatedesco.com

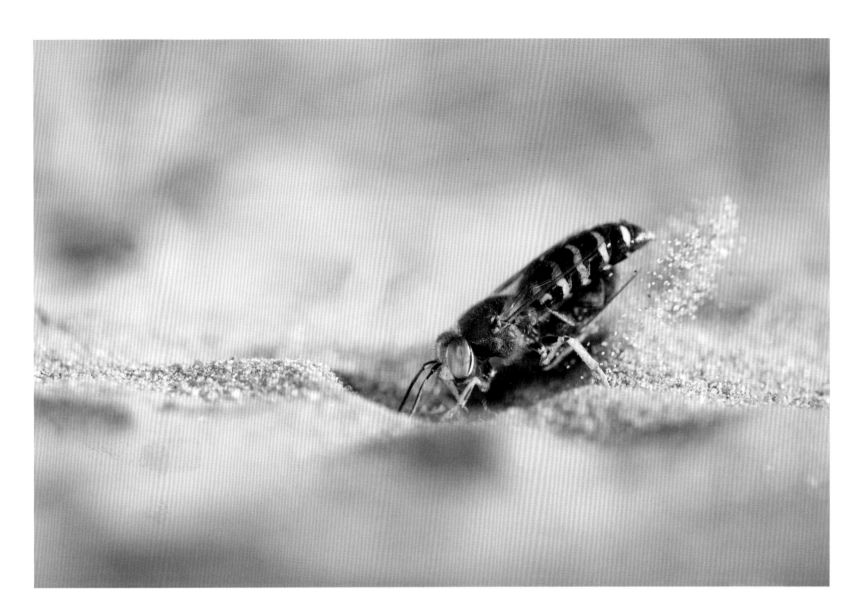

Mart Smit (Netherlands)

South Öland, Sweden. This sand wasp (*Bembex rostrata*) lives in a big family. I followed this individual for a while and stayed at its nest, where I was surprised to see it returning with a fly, which it uses to lay its eggs in. It buried the fly in the sand.

Canon EOS 1DX with Canon 180mm macro lens, ISO 800, 1/2500sec at f/4.5, beanbag. A reflector was used to create some extra light on the wasp

smitinbeeld.nl

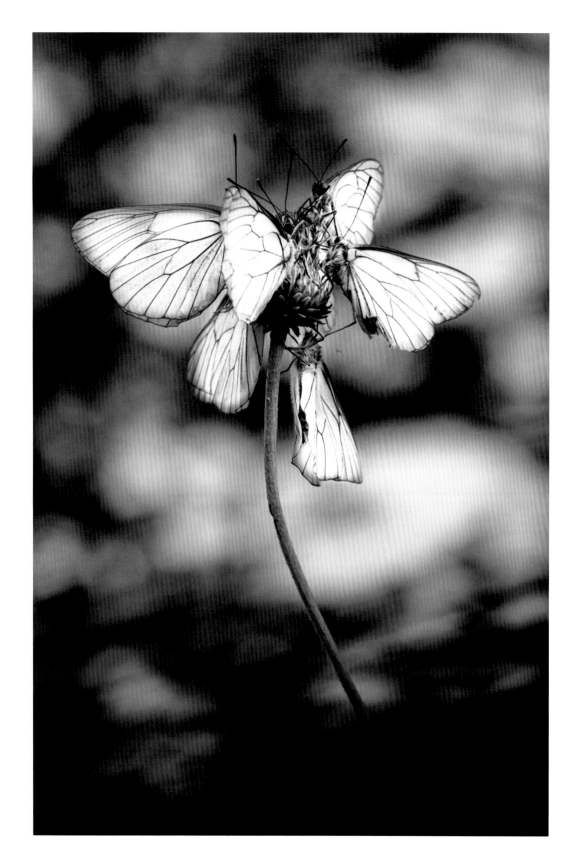

Thomas Delahaye (France)

Pralognan la Vanoise, France. One morning in the French Alps I found a dorm of seven black-veined white butterflies, a really amazing number to see on the same flower. I tried to capture the atmosphere of the scene in this photograph.

Canon EOS 7D with Canon 100mm L IS USM f/2.8 macro lens, ISO 250, 1/250sec at f/8

thomasdelahaye.fr

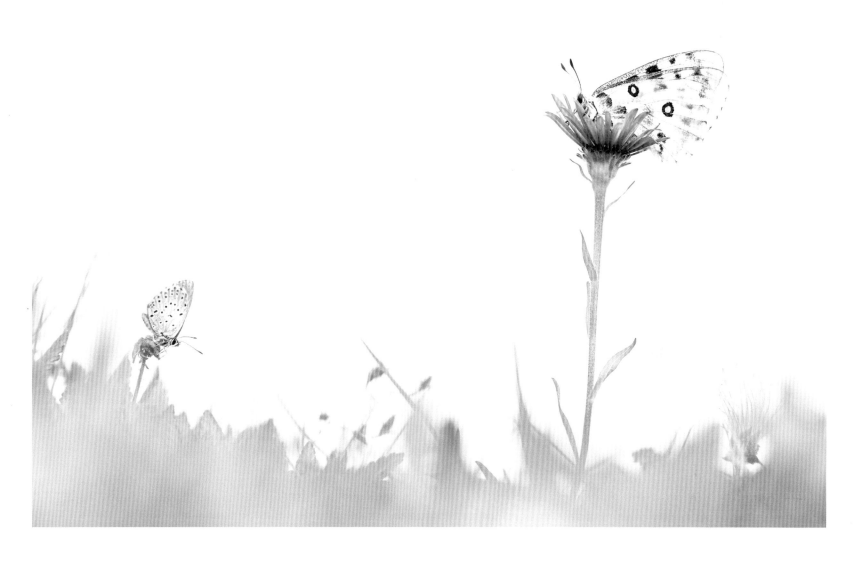

Thomas Delahaye (France)

Pralognan la Vanoise, France. I discovered this scene one morning in the French Alps. The two butterflies, the rare mountain apollo and a large blue, are in the same plane, and it is interesting to see the difference in their sizes. I was stretched out on the grass to create the green foreground, which gives the impression of a watercolour. The white background is the overexposed sky.

Canon EOS 5D MkIII with Canon 100mm L IS USM f/2.8 macro lens, ISO 500, 1/640sec at f/4

thomasdelahaye.fr

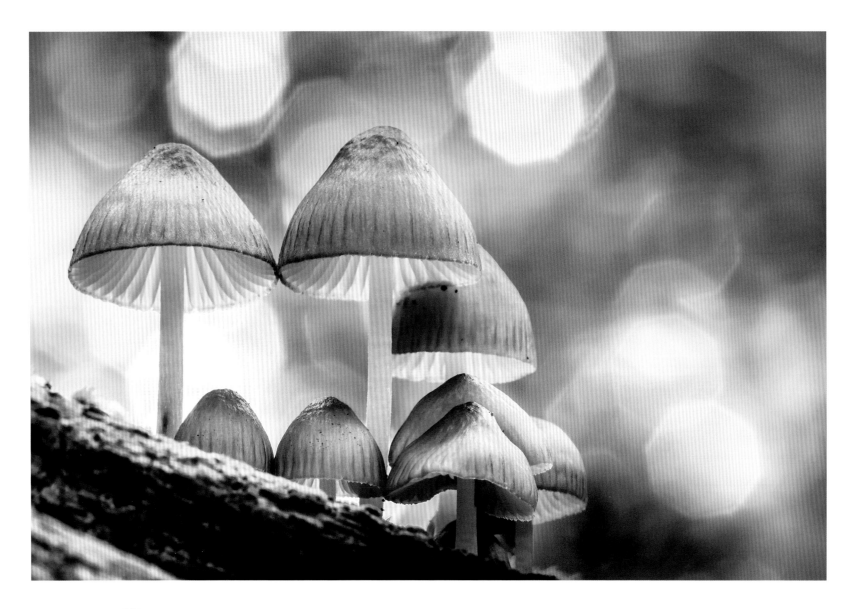

Alistair Nicolson (UK)

Elsea Wood, Bourne, Lincolnshire, England. On a
cloudless autumnal morning I set off to a local wood
to shoot mushrooms. I had in mind the woodland
canopy as the background with the light coming
through. I found these mushrooms in the perfect
location, less than one metre off the ground on
a fallen tree – there was no need to invert the tripod
and get dirty for this shot. The woodland canopy was
a nice distance away with no distractions in the way.

*Canon EOS 700D with Canon EF 70-200mm f/4 L IS USM
lens at 127mm with 25mm extension tube, ISO 100, 15sec
at f/16, tripod*

Ben Andrew (UK)

The Lodge, RSPB Nature Reserve, Bedfordshire, England.
Every year on the reserve, natterjack toads breed in ponds
away from the footpaths. This year, however, spawn appeared
in a pond right next to a car park, which gave me the
perfect opportunity to photograph the newly emerged
toadlets. I used my macro lens but strayed away from
taking an obvious close-up image; instead I wanted to try
to put the amphibian into some habitat – a tiny creature
finding its feet in a big new world.

*Nikon D800 with Nikon 105mm f/2.8 macro lens, ISO 400, 1/250sec
at f/4, handheld*

benandrewphotography.co.uk

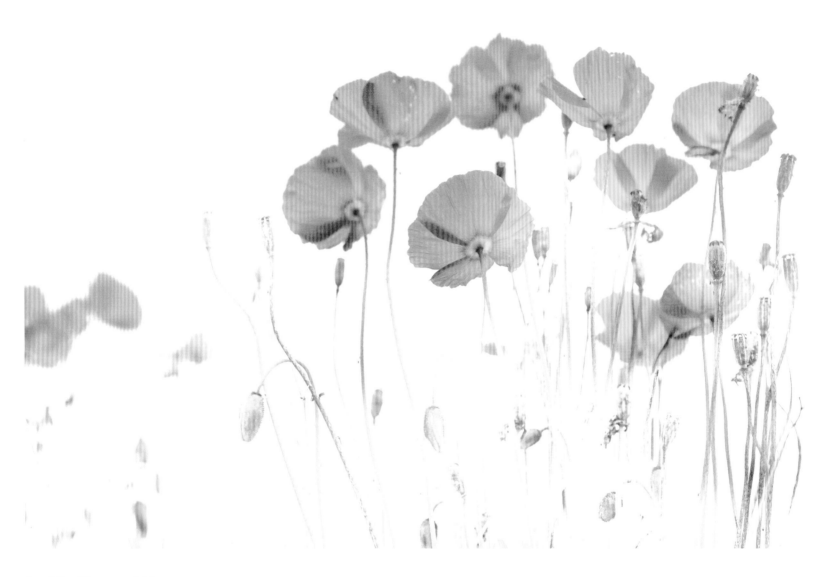

Geraldine Westrupp (UK)

Northern Iceland. Taken at a roadside location graced with a fabulous array of Iceland poppies; I particularly love the orange variety. The conditions were perfect: a bland sky with a slight breeze giving a little movement, and late enough in the season for some interesting seedpods. Lying flat on the ground allowed me to angle the camera upwards, eliminating the background except for the sky.

Nikon D800E with Nikkor 60mm micro f/2.8 lens, ISO 80, 1/800sec at f/5, handheld

wildphotographyholidays.com

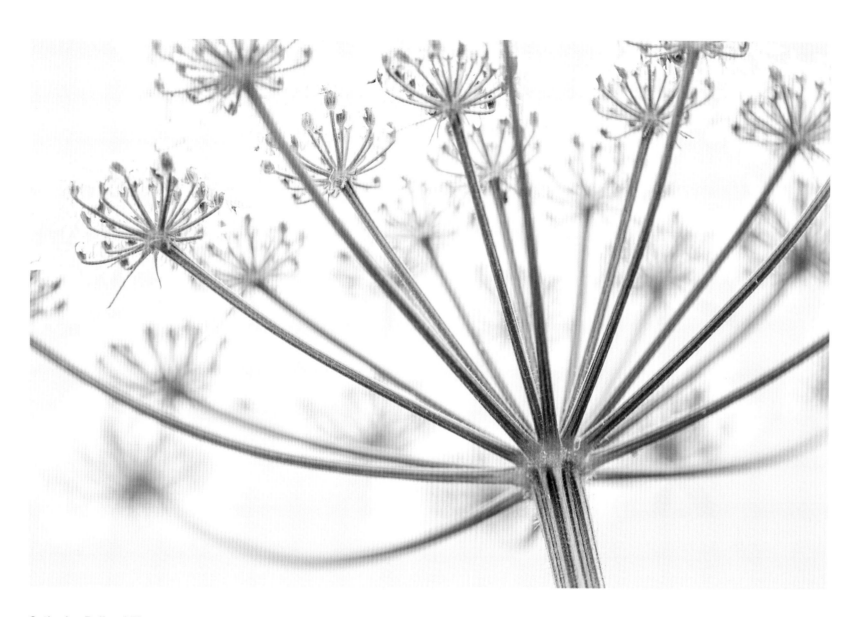

Catherine Bullen (UK)

Strumpshaw, Norfolk, England. The Norfolk
Broads are a haven for a variety of wildlife, but it's
also a great location for flora photography. This is
a plant that is so common along the riverbank that
it can easily be overlooked. I wanted to capture an
image of these flowers that highlighted their beauty.
The grey clouds parted to give a peek of blue sky and
their height made it easier for me to get down low to
create an image from an unusual viewpoint.

*Nikon D300 with Tamron 180mm macro lens, exposure
not recorded, handheld*

catherinebullen.co.uk

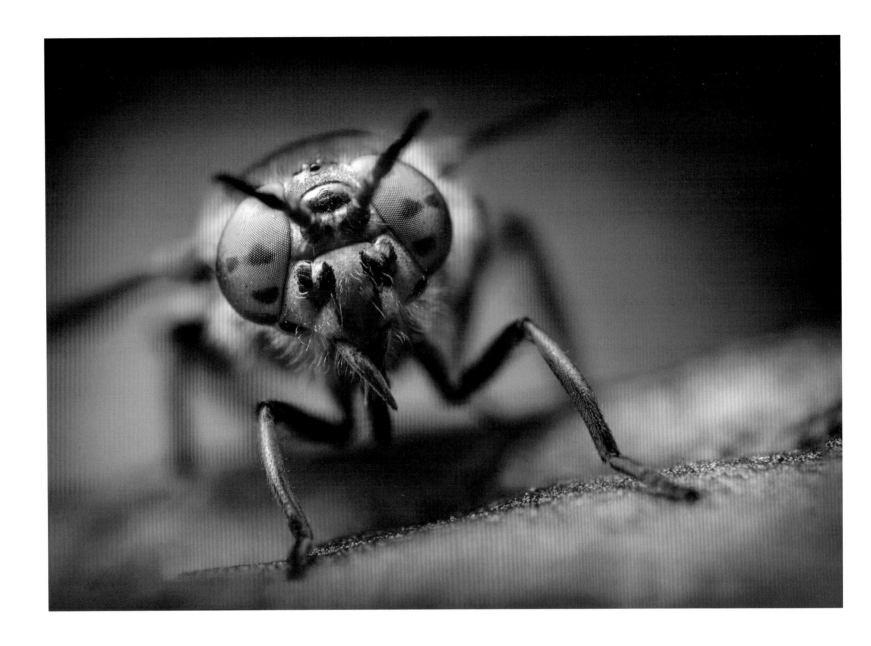

Geraint Radford (UK)

Swansea, Wales. Insects are a true masterpiece of nature. I photograph only wild, free insects, therefore I was very grateful that this splayed deer fly landed on an orange flower, which offered a nice contrast to its eyes. It remained still for long enough for me to create a focus stack. Nature is my inspiration; I hope that my images encourage others to take care of the miniature world around us.

Nikon D3S with 28mm lens reversed, extension tubes, ISO 250, 1/50sec at f/5.6, flash, handheld, focus stack

bewilder-photography.com

Carolyne Barber (UK)

Victoria Park, East London, United Kingdom. Very early one morning I spotted a group of beautiful common blue damselfly (*Enallagma cyathigerum*) right at the water's edge. The water sparkled, like blue diamonds, in the sunlight. I was captivated and had a feeling the sparkles would create some lovely background bokeh. Armed with my macro lens, I took this picture of one of the damselflies that was perched in a perfect position with the light behind it. I had to get down really low, almost into the water, to capture this image.

Nikon D7000 with Nikon 60mm macro lens at 40mm, ISO 160, 1/320sec at f/10, handheld

carolynebarberphotography.org.uk

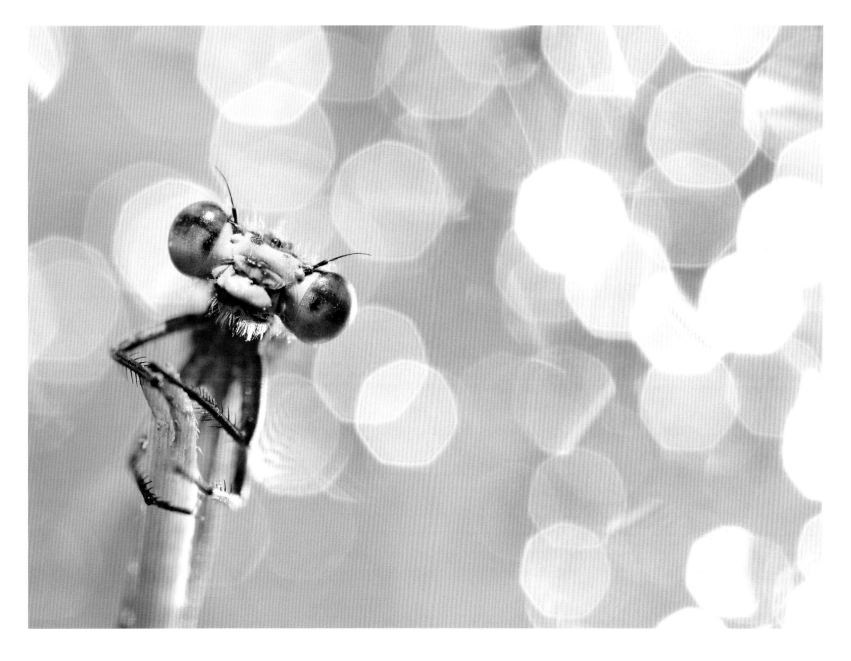

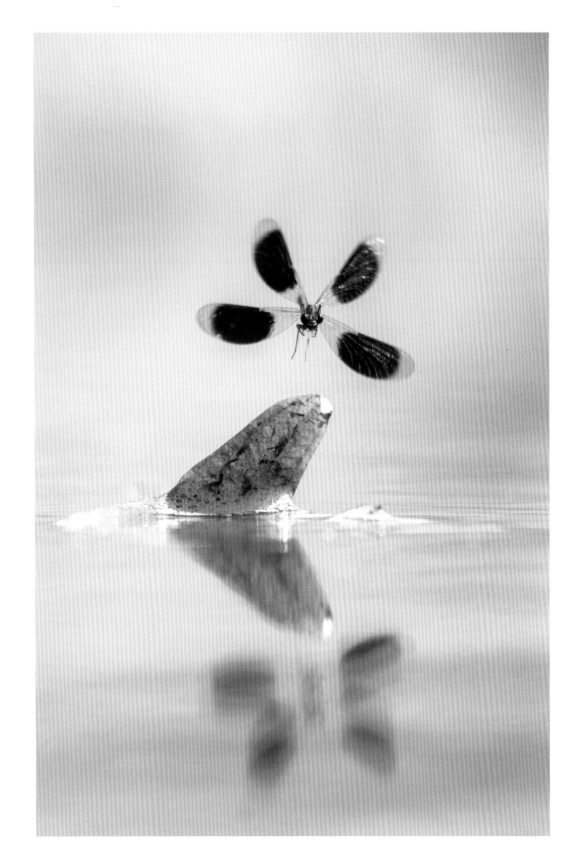

Johannes Klapwijk (Netherlands)

Drenthe, Netherlands. To get down to the perfect low angle for the best reflection, I put on my swimming trunks and spent a whole day on my knees in a brook. I chose a yellow field of flowers as the background, to contrast the metallic blue of this magnificent banded demoiselle damselfly (*Calopteryx splendens*). In order to get enough yellow in the reflection, I needed to keep my camera less then a few centimetres from the water surface. It was intense in the cold water, but the result was worth it.

Canon EOS 5D MkKII with Sigma 150mm lens and 1.4x converter, ISO 160, 1/1250sec at f/4, tripod

johannesklapwijk.com

Lea Foster (USA)

Lafayette, Indiana, USA. This past summer I had several assassin flies take up residence in my garden. Assassin flies are fierce hunters and normally ambush their prey in midair. They use their sharp proboscis to inject venom into their victim, which immediately paralyses it. Assassin flies are usually quite skittish, but they became accustomed to me being out in my garden. They would often come very close, which allowed me the opportunity to photograph them with my macro lens.

Canon T5i with Canon 100mm L IS macro lens, ISO 400, 1/125sec at f/6.3, polariser, handheld

leafosterphotography.com

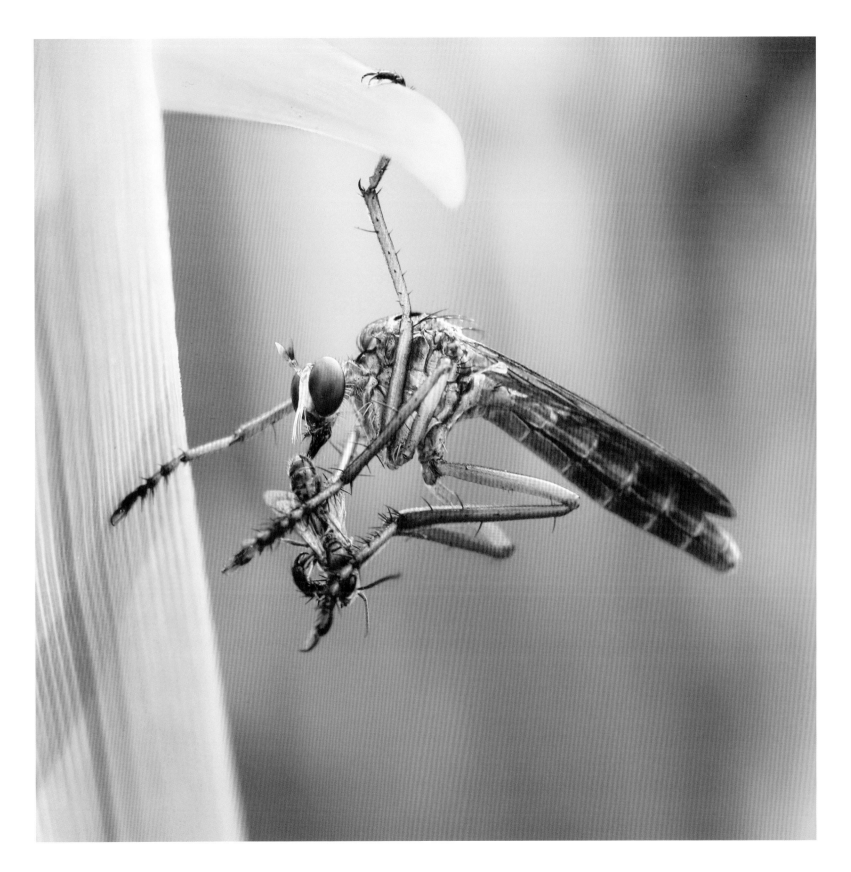

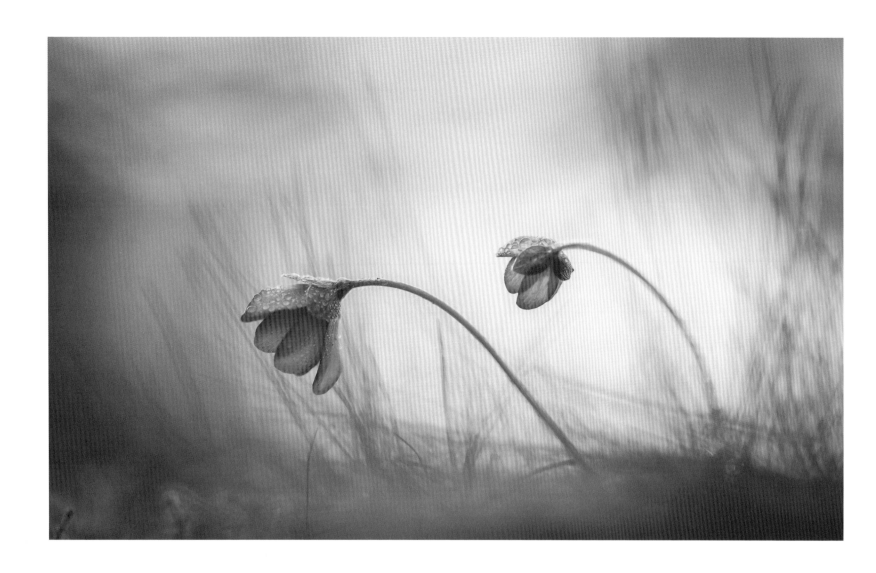

Ville Airo (Finland)

Hauho, Hämeenlinna, Finland. I photographed these *Hepatica nobilis* flowers while they were preparing for the night and leaning towards the last light of the day. I chose the location carefully so that the setting sun was reflected from the surface of the lake, providing a moody background for the shot. I added a few drops of water using a spray bottle.

Canon EOS 6D with Sigma 150mm OS macro lens, ISO 640, 1/250sec at f/2.8

500px.com/villeairo

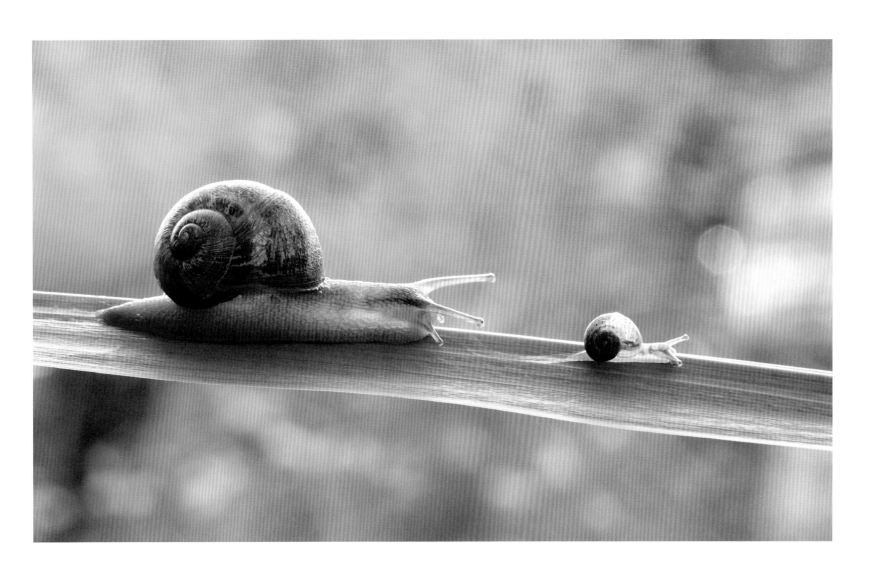

Savo Ilic (UK)

Barnet, London. This image shows a common
garden snail and little baby snail moving along
a leaf. The shallow depth of field visually separated
the colourful flowers in the background from the
main subject. The beautiful, soft backlight shows
the partial transparency of the snails' shells.

Canon EOS 450D with Canon EF-S 60mm macro lens,
ISO 200, 1/15sec at f/10, tripod

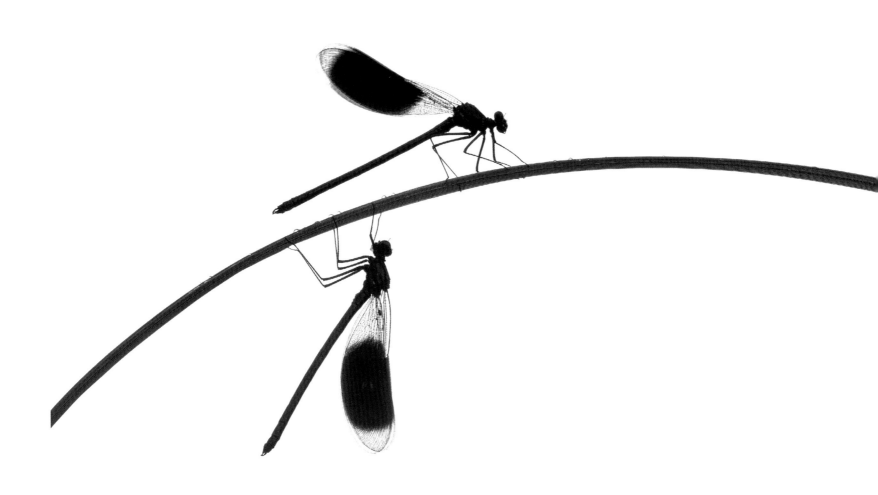

Stefan Gerrits (Netherlands)

Lake Kvarnträsk, Espoo, Finland. I was searching for banded demoiselles (*Calopteryx splendens*), preferably the more photogenic males. By making my way through thick vegetation, I ended up in the perfect location, a grassy, moist area with a small stream trickling beautifully through it. Hundreds of dragonflies were warming up in the early sunlight. I just had to find the perfect composition. It was taken against an almost cloudless sky, and later converted into black & white to create a simple, fine art effect.

Canon EOS 5D MkIII with Canon EF 100mm f/2.8L macro IS USM lens, ISO 250, 1/100sec at f/10, handheld, converted to black & white using Silver Efex Pro

stefangerrits.com

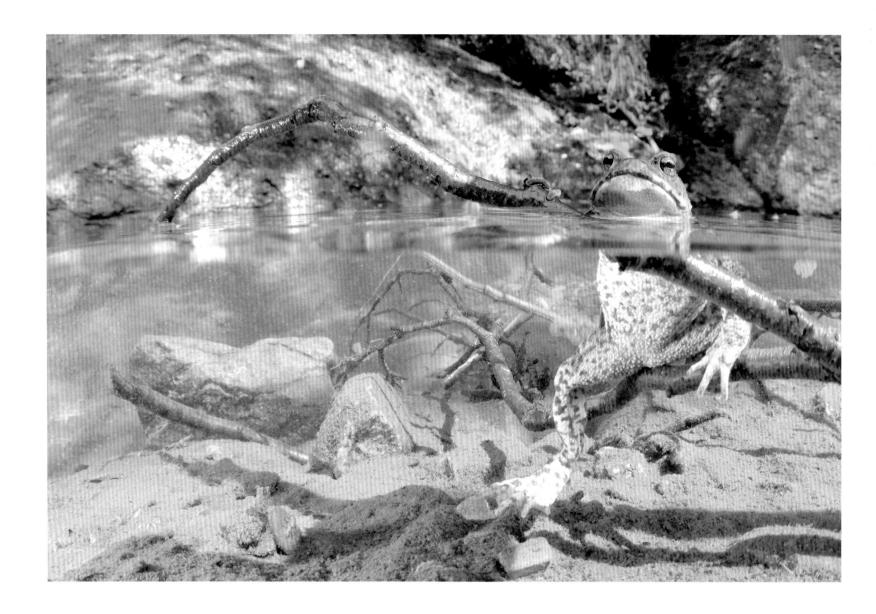

Vittorio Ricci (Italy)

Aveto Regional Park, Liguria, Italy. I was on a daylong photo expedition at the end of spring to find rare and endemic types of amphibian in some secretive spots in this remote park. En route we found this common toad (*Bufo bufo*) that was very active and collaborative. I took as many shots as I could, and this one is my favourite due to its pose.

Nikon D300 with Tokina 10-17mm lens at 14mm, ISO 320, 1/30sec at f/13, Nikon SB 800 flash, two other strobes, underwater housing

vittorioricci.com

Paul Gath (UK)

Ngapali beach, Thandwe District, Myanmar. This dragonfly was flying in the midday sun by the swimming pool at my hotel. Just as I sat down to rest in the shade, the dragonfly landed on the top of a plant by the pool. The combination of blue water in the pool, the purple and green of the plant and the red dragonfly, glowing as the warming sun lit it from behind, was both magical and irresistible.

Canon EOS 5DS R with Canon EF 100-400mm f/4.5-5.6 L IS II USM lens at 312mm, ISO 320, 1/100sec at f/13, handheld

paulgath.co.uk

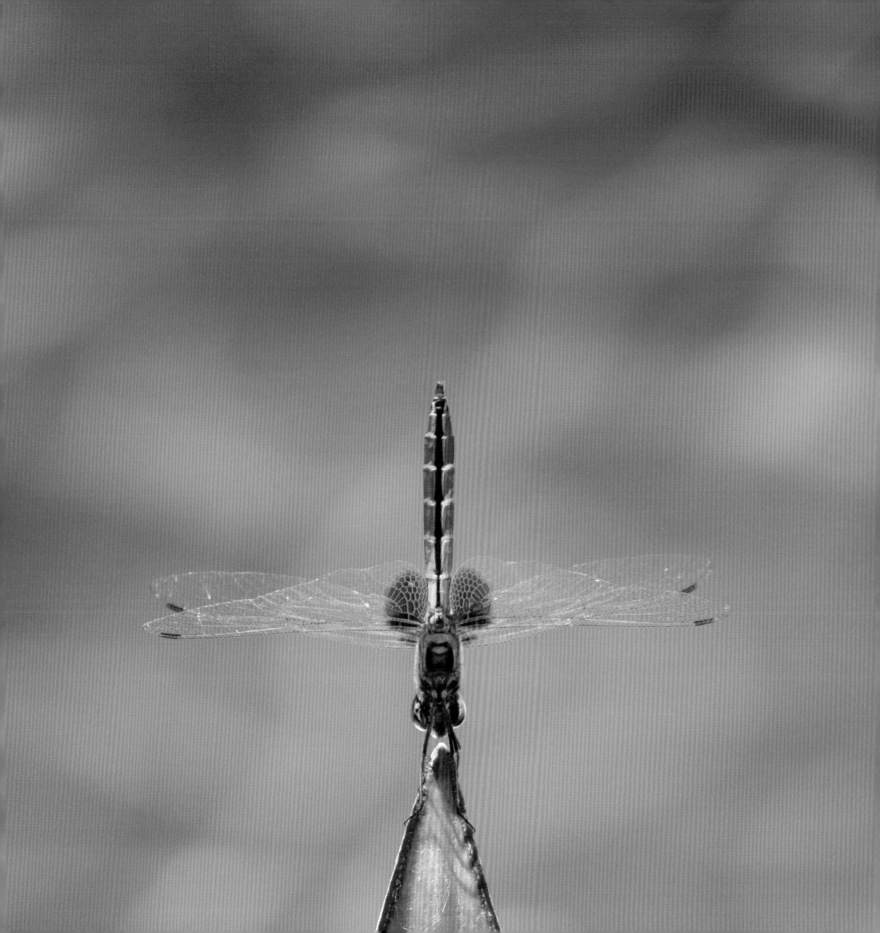

UNDER EXPOSED

We wanted to celebrate the breathtaking photographic work that is going on underwater. From seas and oceans to rivers and lakes, we were looking for images that showcase the remarkable world beneath the surface.

UNDER EXPOSED - WINNER

Johan Sundelin (Sweden)

Santa Fe Island, Galapagos Islands, Ecuador. While snorkelling with a colony of California sea lions I quickly noticed two particular photography challenges. The first was how to avoid the attention of the large, aggressive and protective alpha male. The second was the enormous speed of the animals in the water. Lying very still in the water and using high ISO solved the issues. That allowed me to freeze this moment of tenderness using only natural light.

Nikon D600 with Nikkor 16-35mm lens at 16mm, ISO 1600, 1/180sec at f/13, Sea&Sea underwater housing with large dome port

visionsinblue.org

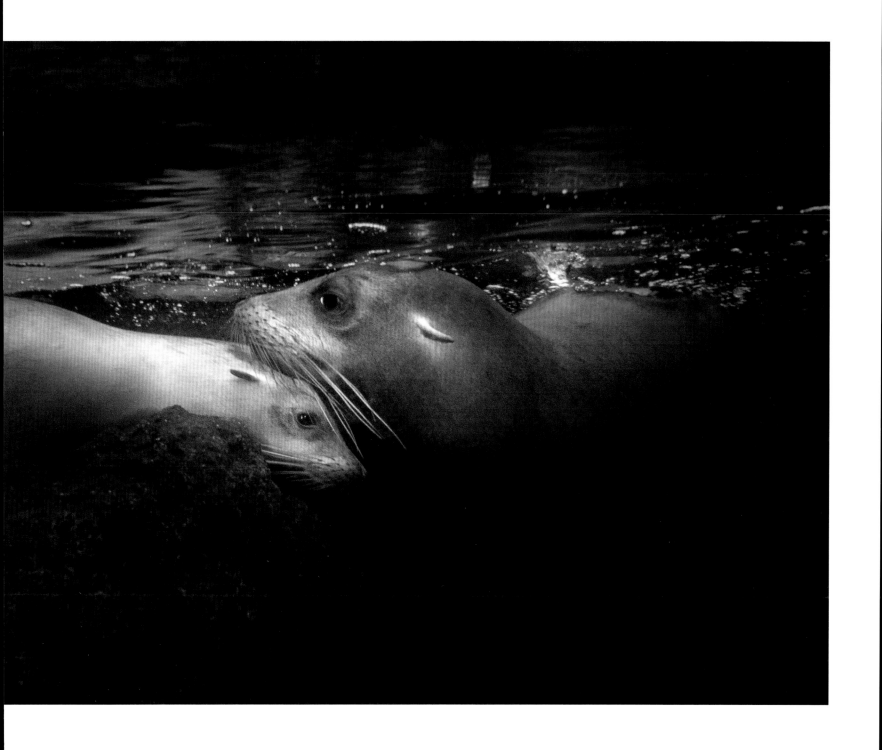

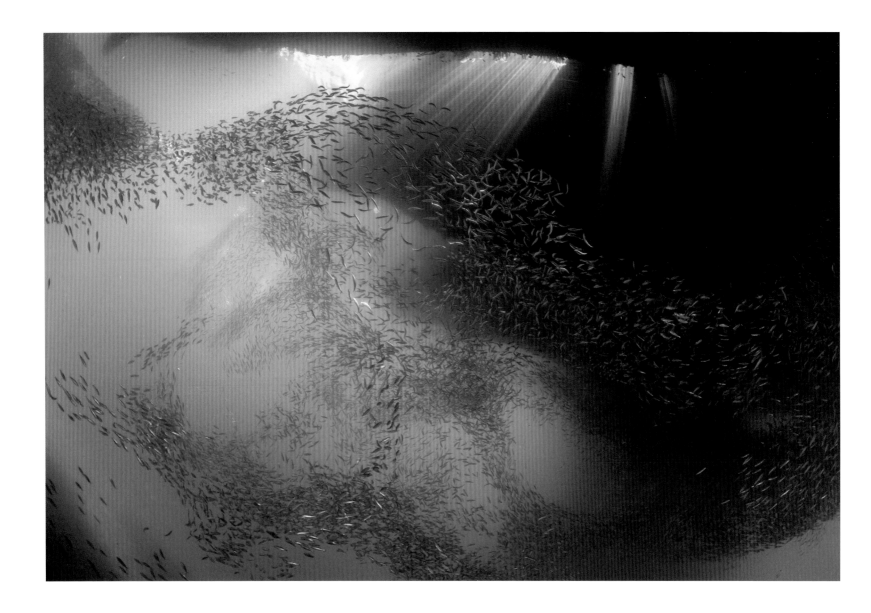

Joe Daniels (UK)

Ambon, Indonesia. Thousands of silversides school beneath docked fishing boats in Ambon Harbour, Indonesia. Ironically, just beneath the fishermen's feet are clouds of fish dancing in shafts of light that squeeze between the boats. Timing is everything in order to catch the light shafts. Once beneath the boats, I hovered mid water and waited for the fish to create their beautiful shapes beneath the light show. I should mention that diving beneath boats can be risky, especially when they leave the dock.

Canon EOS 7D with Tokina 10-17mm fisheye lens, ISO 200, 1/80sec at f/8, Nauticam housing, Sea&Sea YS-D1 strobes

jldaniels.co.uk

Jim Catlin (Cayman Islands)

Isla Mujeres, Yucatán, Mexico. The white dots and dark skin of a whale shark immediately lend themselves to a black & white image. Shooting this whale shark from above enabled me to capture the animal as a whole. For the shot to work, the shark needed to be beneath me and parallel to the surface and my camera; fortunately it came together.

Olympus OMD-EM5II with Olympus 7-14mm lens at 7mm, ISO 320, 1/100sec at f/6.3, Nauticam NA-EM5II housing

jimcatlinphotography.com

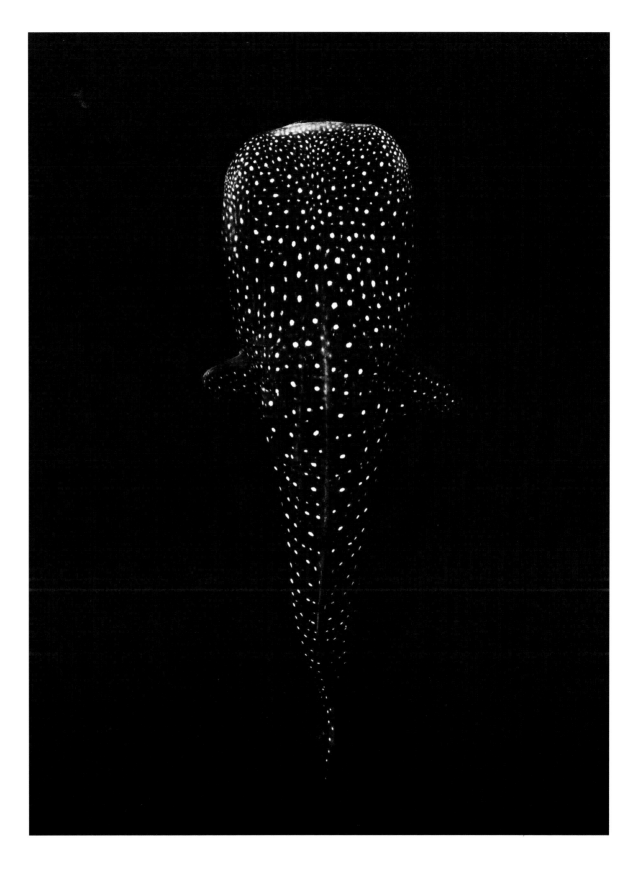

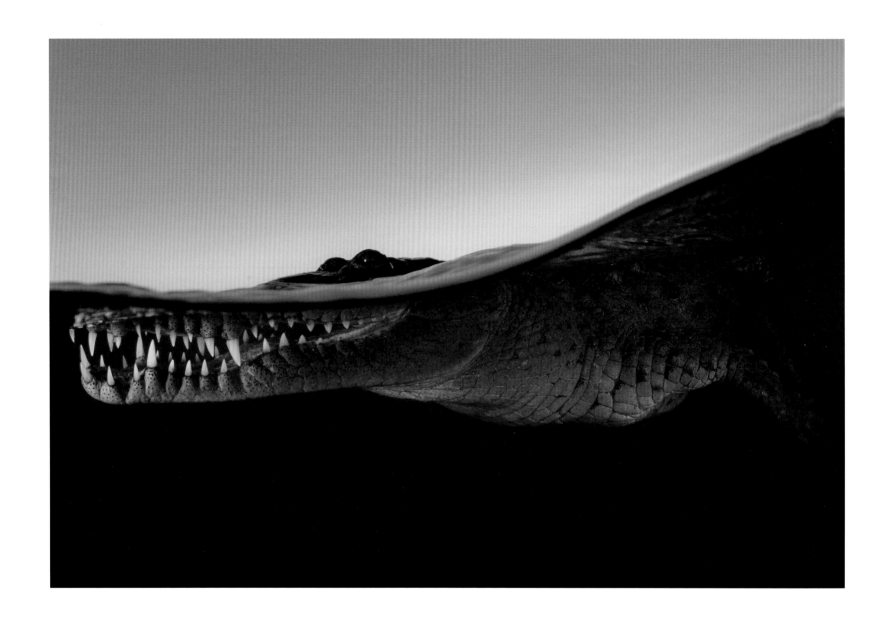

Brett Lobwein (Australia)

Jardines de la Reina Marine Park, Cuba. Swimming with American crocodiles is definitely something that gets your heart racing. After spending a few hours in the water I became much more comfortable in their presence, allowing me to focus in on the shot. I really wanted an image that showed the crocodile's eyes and teeth; the waterline in this image perfectly frames them and hopefully changes people's perspective on these beautiful animals.

Nikon D7200 with Tokina 10-17mm fisheye lens at 10mm, ISO 100, 1/160sec at f/9,
Seacam underwater housing, Seacam 9in dome, two Ikelite DS161 strobes

brettlobwein.com

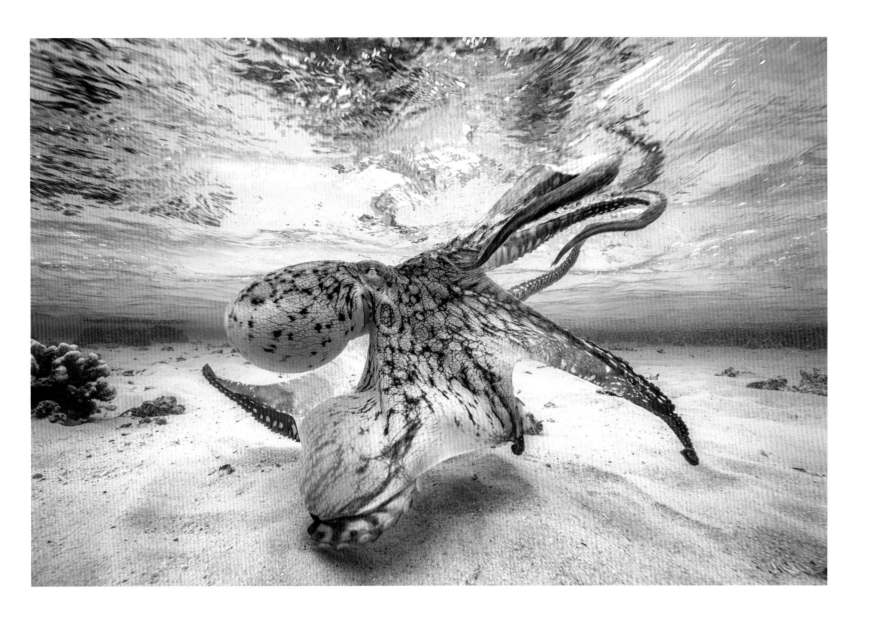

Gabriel Barathieu (France)

Mayotte, near Madagascar. An octopus making his 'show' in the lagoon of Mayotte, a small group of islands to the north of Madagascar that is a department and region of France. Cephalopods are able to change their colour and even the appearance of their skin in response to their environment; they are a beautiful and very smart animal.

Canon EOS 5DS with Canon 14mm f/2.8 II lens at 14mm,
ISO 100, 1/125sec at f/16, Subal housing with DP-230 dome port

underwater-landscape.com

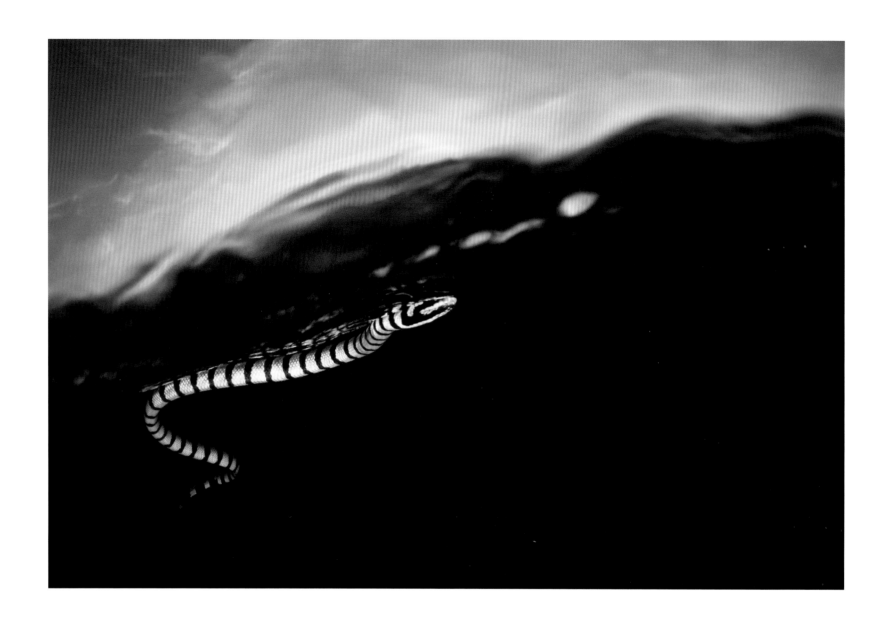

Grant Thomas (UK)

Tioman Island, Malaysia. This image was shot in warm, shallow waters as the sun set over the horizon. The reef below was teeming with life and there was a predator in search of its next meal, the highly venomous banded sea krait. I watched patiently from above waiting for him to surface for air. The moment came and he swam straight for me, I kicked back and positioned myself ready to take the photograph.

Canon EOS 5D MkIII with Tokina 10-17mm lens at 15mm, ISO 250, 1/125sec at f/13, Ikelite underwater housing, two Inon Z-240 strobes

grantjpthomas.com

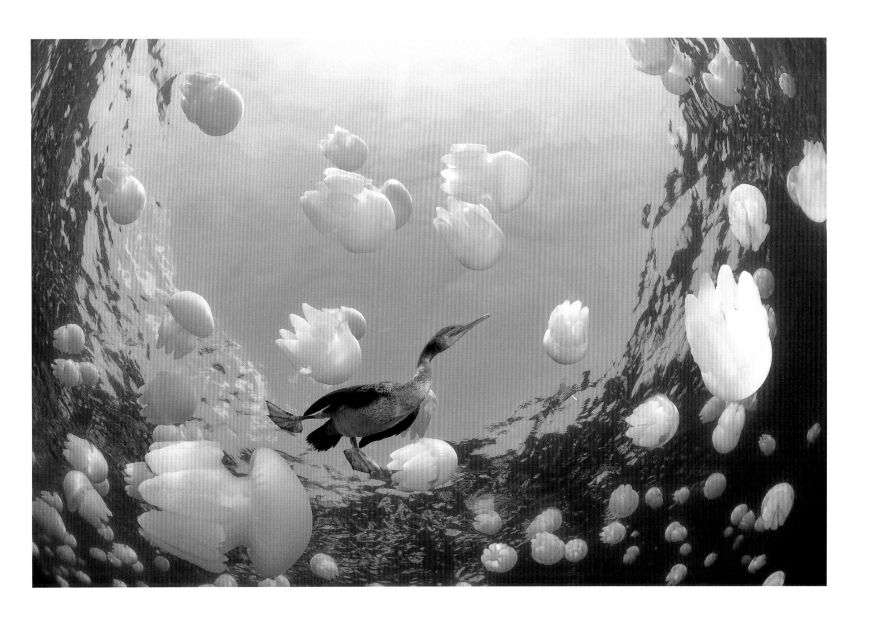

Hani Bader (Kingdom of Bahrain)

West coast, Bahrain. I was aiming to shoot images of jellyfish off the west coast of Bahrain, where they appear in large quantities during May and July. I was intrigued and amused by their movement and flow. As I was taking the shot, I was surprised by a sudden visit of Socotra cormorants searching for a meal, the hidden tiny fish residing in the jellyfish.

Nikon D7000 with Nikkor 10.5mm fisheye lens, ISO 125, 1/160sec at f/11

flickr.com/photos/39026878@N02

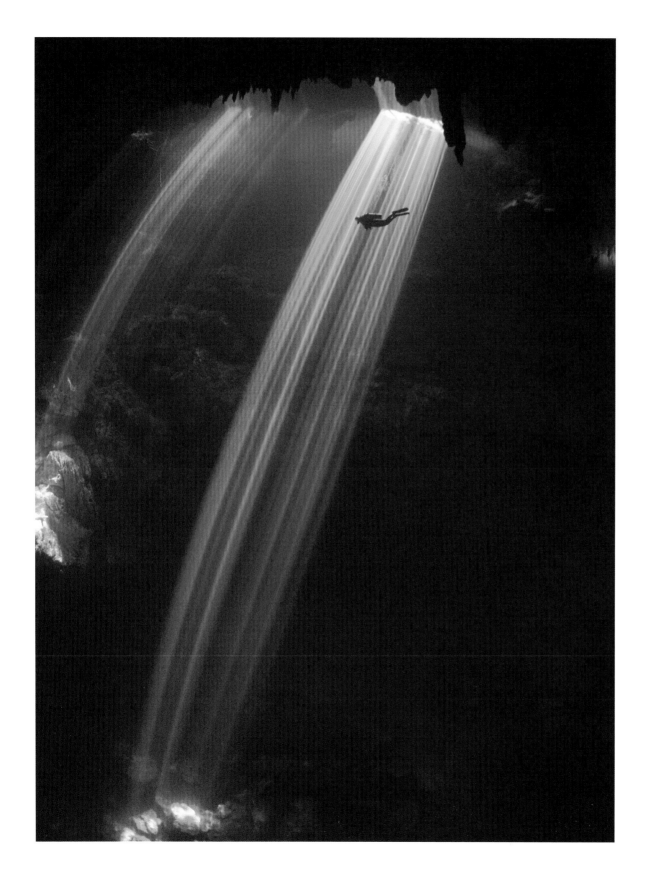

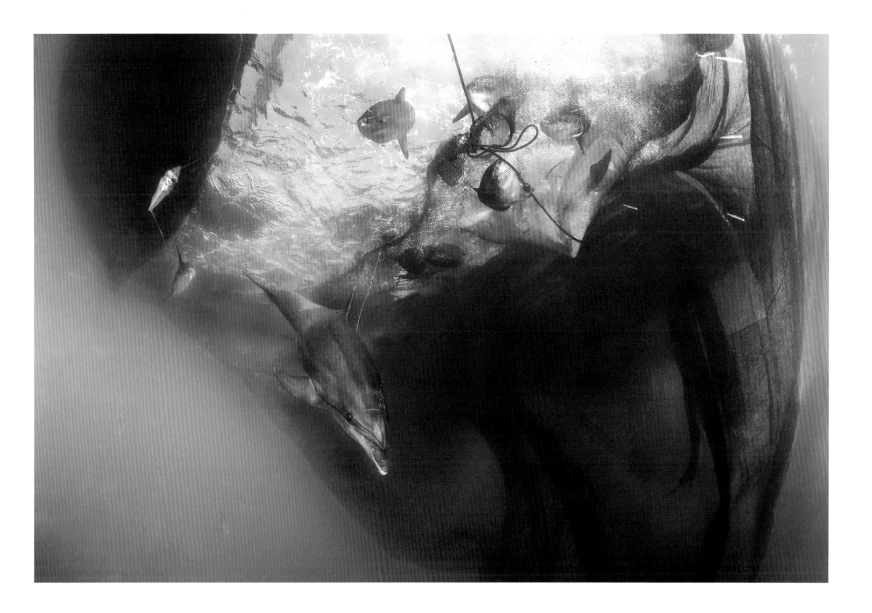

Jim Catlin (Cayman Islands)

Left: **Tulum, Yucatán, Mexico**. The light beams at The Pit cenote are some of the most extraordinary natural wonders to be seen when diving. Once you are inside the cenote, the sense of scale is hard to describe and I wanted to capture this feeling in an image. By asking my dive buddy to hover near the surface I was able to capture her and the entire 35m-long light beam coming from the cenote opening.

Olympus OMD-EM5II with Olympus 8mm FE lens, ISO 6400, 1/60sec at f/3.5, Nauticam NA-EM5II housing, in post-processing, other divers near the surface were removed from the original image to enhance the sense of awe and isolation in space

jimcatlinphotography.com

Isabella Maffei (Italy)

Ligurian Sea, Camogli, Italy. The 'Tonnarella' is a tuna fishing system located in Camogli. Sometimes non-commercial species come inside, usually moon fish. This was the first time that someone had documented dolphins inside too. Usually, two times a day, fishermen open the system to permit unmarketable species to leave. Nobody touched the mammals, they managed to free themselves.

Nikon D800E with Sigma 15mm f/2.8 lens, ISO 320, 1/250sec at f/10, Nauticam housing, two Sea&Sea YS-250PRO strobes

isabellamaffeiphoto.com

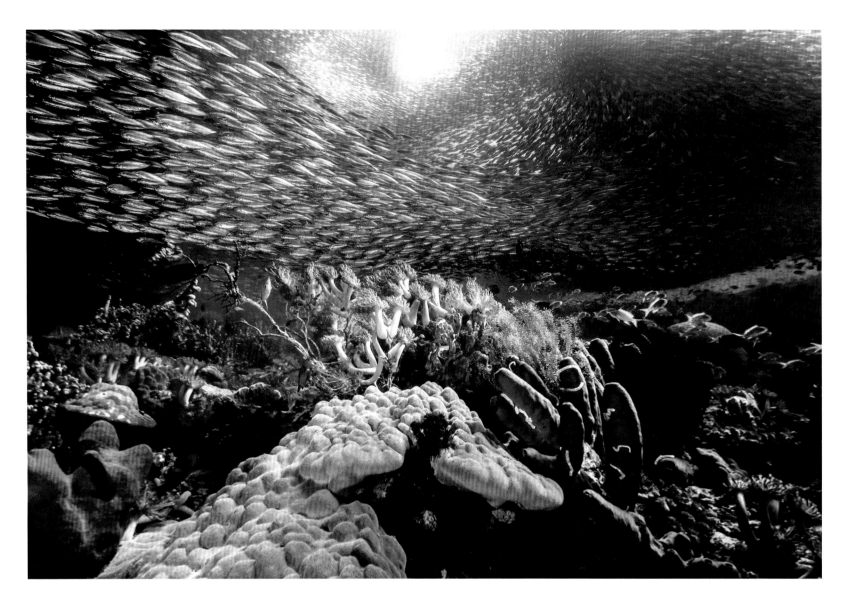

Isabella Maffei (Italy)

Pescador Island, Moalboal, Cebu, Philippines. It was an early morning dive, and what looked like a big black animal was moving under the boat. Underwater among the sardines it was like being in a typhoon of swirling motion. The problem was how to make the right exposure; the fish move so fast and sunlight was constantly flicking in and out of the scene. The movements of the school were quite predictable as there were no predators around, so I decided to stay and wait for the right scene and the right exposure to come together. I decided to use a slow shutter speed to emphasise the movement of the school; standing on the seabed to stabilise my body was crucial in allowing me to focus on the right point.

Nikon D5000 with Nikon 10-24mm f/3.5-4.5 lens at 10mm, ISO 200, 1/30sec at f/13, Ikelite housing, two Ikelite DS-51 strobes

isabellamaffeiphoto.com

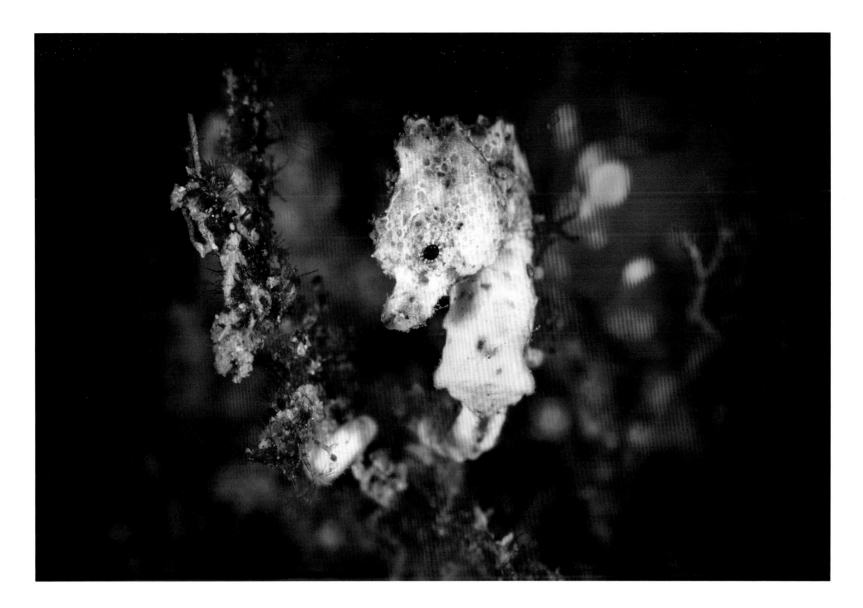

Massimo Giorgetta (Italy)

Lembeh strait, Sulawesi, Indonesia. This image was captured during a diving trip in Lembeh strait, on a mixed backdrop of black sand and coral reefs at a depth of about 8m. During the dive I met this beautiful pigmy sea horse, which was only about 2cm long, on a red coral.

Nikon D800E with Nikkor 105mm f/2.8 lens, ISO 100, 1/160sec at f/36, Seacam housing, SubSee +10 diopter, two Subtronic Pro 160 strobes

maxgiorgetta.it

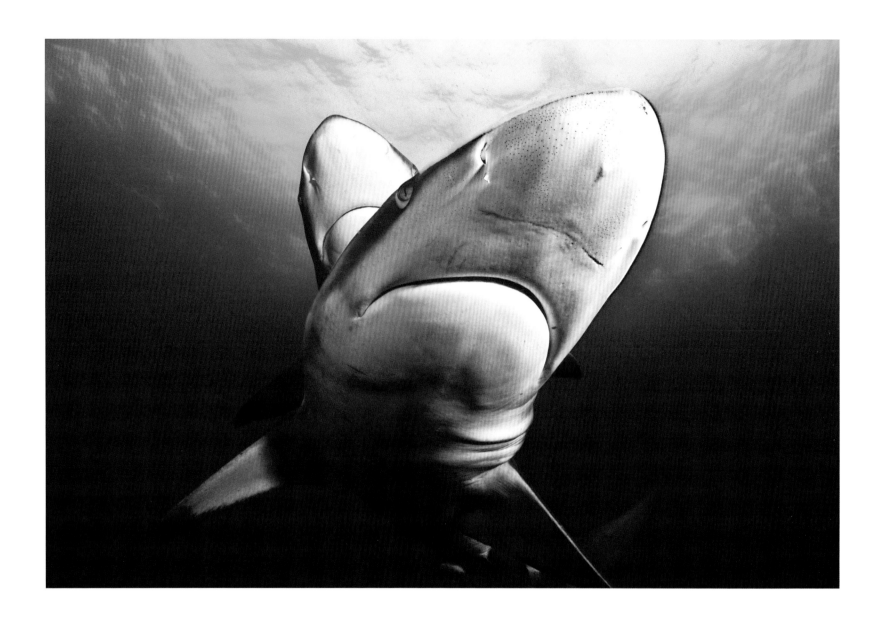

Nick Robertson-Brown (UK)

Aliwal Shoal, South Africa. This image reminds me
of David Bailey's 'The Kray Twins', with one brother
looking over the shoulder of the other. In fact, these
blacktip sharks are both female. I had to wait for
them to swim very close to my camera lens to get
this shot. I spent a couple of hours in the water with
30 to 40 of these beautiful sharks; it was an amazing
diving experience.

Nikon D700 with Nikon 16mm lens, ISO 1600, 1/250sec at f/18,
Sealux housing and dome port, twin INON Z-240 strobes

frogfishphotography.com

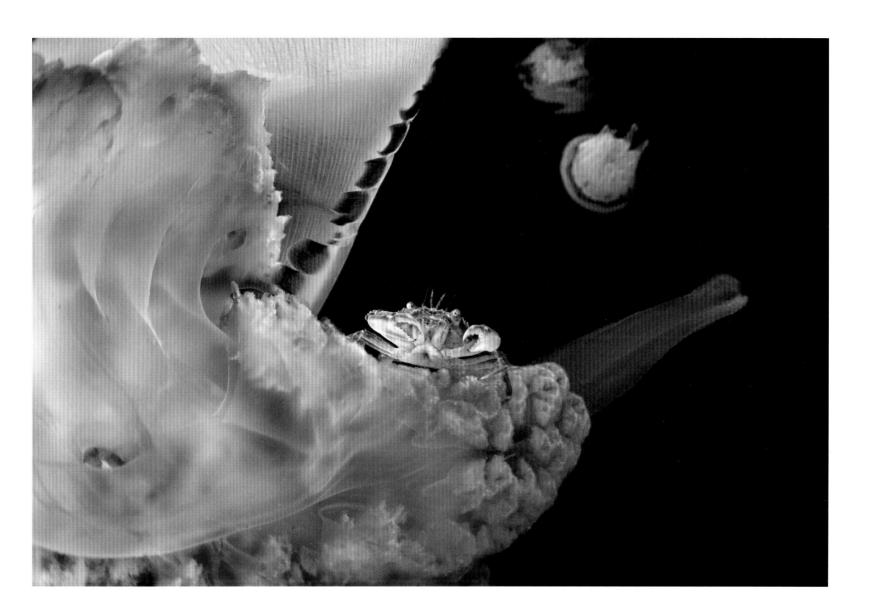

Pasquale Vassallo (Italy)

Capo Miseno, Napoli, Italy. This winter, the coast off the Gulf of Naples had a strong presence of Rhizostoma pulmo jellyfish. With a bit of luck and a good eye, it is possible to see a small guest, a *Liocarcinus vernalis* crab, on some of the jellyfish. They get carried away by the jellyfish to new destinations. After many days of diving I managed to find a crab in a comfortable enough position to be able to take a photograph.

Canon EOS 5DSR with 8-15mm lens at 14mm, ISO 200, 1/60sec at f/11,
Seacam housing with Fisheye Macro Port, two Inon Z-240 strobes

pasqualevassallo.com

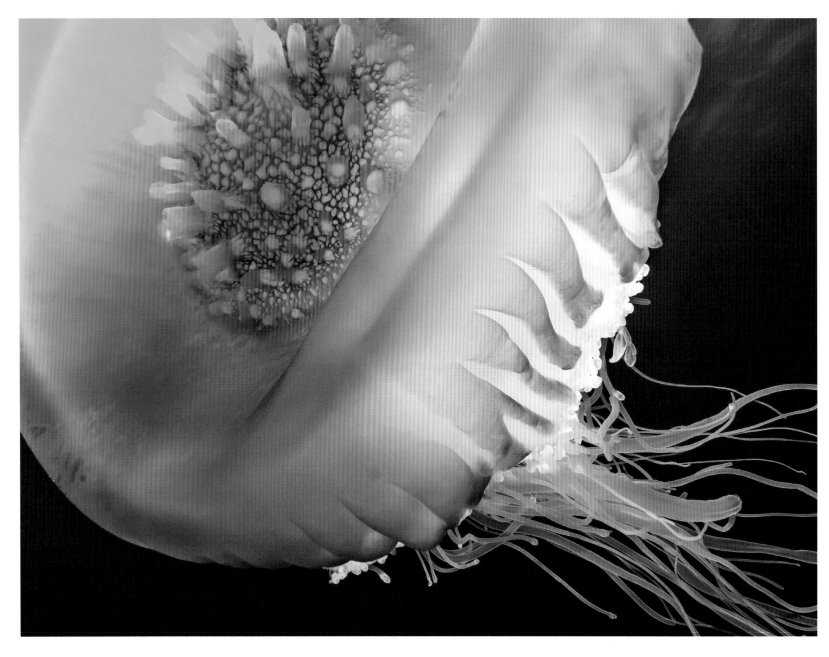

Pier A Mane (South Africa and Italy)

Protea Banks, South Africa. While open-water diving at Protea Banks searching for hammerhead schools, my eyes fell upon a sizeable and animated figure. Unable to identify it from afar, I slowly approached it and saw it was the largest crown jellyfish I have ever seen. With no background objects or diver present to provide perspective, and wishing to exalt this jellyfish in all its stunning colours, majestic size, and dancing elegance, I opted for a cropped head shot to magnify its presence.

Olympus E-M1 with lens at 9mm, ISO 400, 1/250sec at f/16

thevagabond.smugmug.com

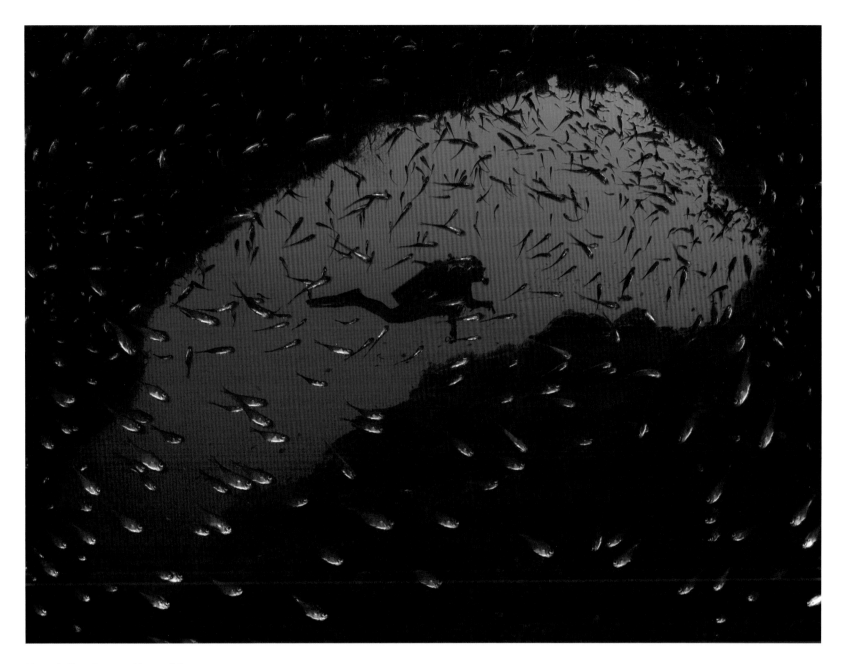

Tanasit Tancharoen (Australia)

Chapel Reef, Apo Island, Dauin, Negros Oriental, Philippines. After capturing a few ambient light images of the cavern opening, I noticed a school of sweeper fish circling around the roof above. As the fish became accustomed to my presence they began circling closer. I prepared my strobes to give just enough power to light the silvery fish while preserving the silhouette of the cavern. Then it was just a matter of waiting for both fish and diver to complete the picture.

Olympus OMD-EM5 with Panasonic Lumix G 8mm fisheye f/3.5 lens, ISO 100, 1/30sec at f/9,
Nauticam housing and acrylic dome port, two Sea&Sea YS-D1 strobes

instagram.com/tontancharoen

SPIRIT OF TRAVEL

Cultures, people, places and festivals of the world; we wanted
to see some of the most compelling and freshest images that
capture the spirit of experiences on journeys around the planet.

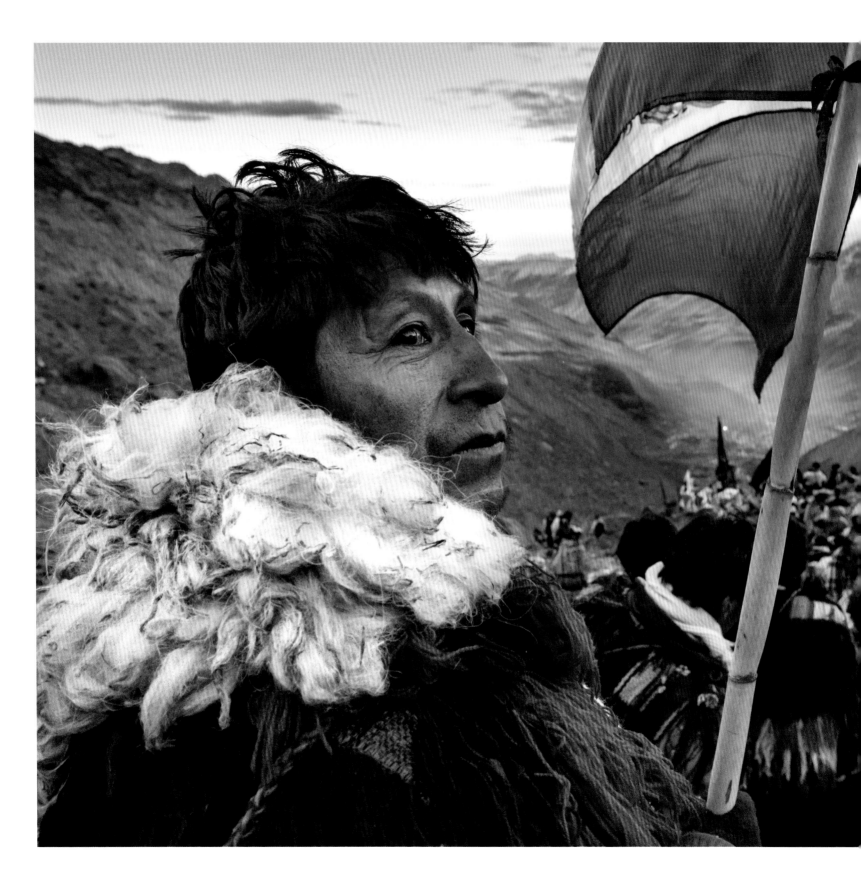

Christopher Roche (UK)

Sinakara, Peru. Around 80,000 pilgrims descend upon the Sinakara Valley in the Peruvian Andes to celebrate the festival of Qoyllur Rit'i – a mixture of Inca and Catholic traditions. During the final night, bands of Ukukus head up to the holy glaciers at an altitude of 5,600m to perform initiation rituals. At dawn they descend back into the valley, carrying large crosses on their backs.

Nikon D750 with Nikkor 24-70mm f/2.8 ED lens at 28mm, ISO 5000, 1/125sec at f/9

chrisrochephotographer.com

Tim Cornbill (UK)

Left: **Marie-Elisabeth-Lüders-Haus, Berlin, Germany**. Having just arrived in Berlin, I was greeted by a brilliant sunny morning, and decided to take a leisurely walk along the river from my hotel. I was drawn to the geometric form of this building, and waited for the perfect moment to capture it. As the cyclist came into the frame, the bicycle wheels complemented the vast concrete circle, while the walking couple served to emphasise the size of the structure.

Fujifilm X100T with 23mm lens, ISO 320, 1/800sec at f/2, handheld

timcornbillphotography.com

Yingting Shih (Taiwan)

Zuozhen, Tainan City, Taiwan. I visited this Buddhist temple with my family, and my little girls began to run around the giant Buddha. In the beginning, they ran together. A few minutes later, the elder sister ran faster and the younger sister had to chase her. The giant Buddha seemed to look at them calmly.

Canon EOS 7D MkII with Tamron 16-300mm lens at 16mm, ISO 250, 1/400sec at f/6.3, handheld

yingtingshih.com

Somenath Mukhopadhyay (India)

Birbhum, West Bengal, India. This image depicts the daily life of the wandering rural masqueraders of West Bengal, popularly known as 'bohurupee' (*bohu* means many; *rupee* means characters). I saw these artists walking back to their village by a dusty road at the end of a day. The father was carrying his son after they had been to a nearby village to collect alms, and another boy from the neighbourhood had joined them on a trail through the mustard fields.

Canon EOS 5D MkIII with Canon 70-200mm f/2.8 lens at 185mm, ISO 200, 1/640sec at f/4, handheld

flickr.com/photos/24874715@N03

Tim Bird (Finland)

Kunnar, Kerala, India. I visited this corner of northern Kerala especially to photograph the extraordinary Theyyam ritual. Performed only by lower caste males and only in this part of India, the ancient ritual involves hours of make-up and costume preparation. This character was performing in one of three Theyyams that I was lucky enough to witness. It was important not to be too intrusive, and a long, fast zoom lens helped me to get the full-face shot I wanted.

Fujifilm X-T1 with 50-140mm lens at 140mm, ISO 800, 1/75sec at f/2.8, handheld

timbirdphotography.com

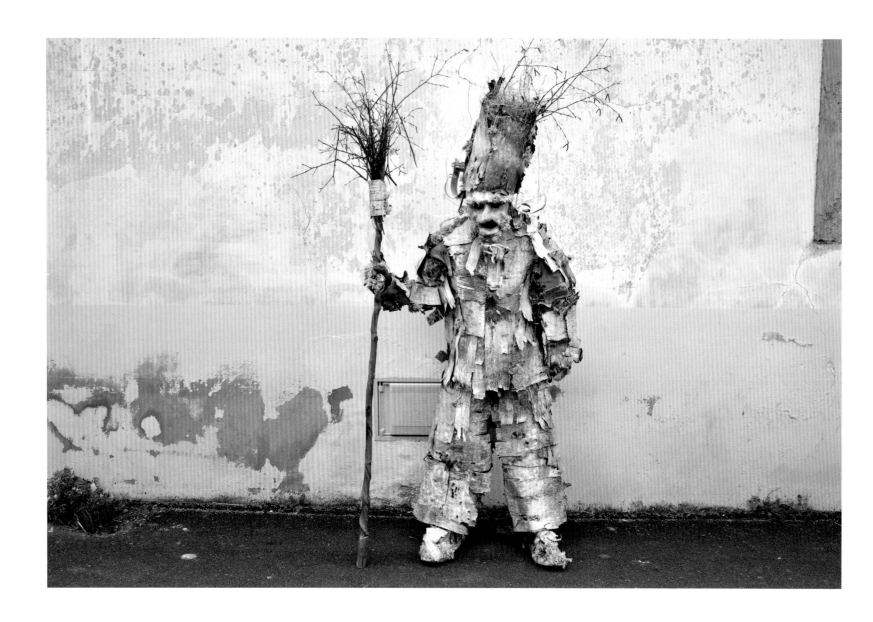

Adrián Domínguez (Spain)

Silió village, Cantabria, Spain. While working on my WeLAND project, on rural life and wild environments, I went to Silió village looking for subjects linked to the wild. In this old Cantabrian tradition there are several characters representing the forest, and this particular character is La Vijanera. Lots of people came to see this scene, so it was very difficult to get a clear picture of the character in isolation.

Nikon D750 with Carl Zeiss-Distagon 35mm f/2 lens, ISO 400, 1/160sec at f/8, handheld

adriandominguez.com

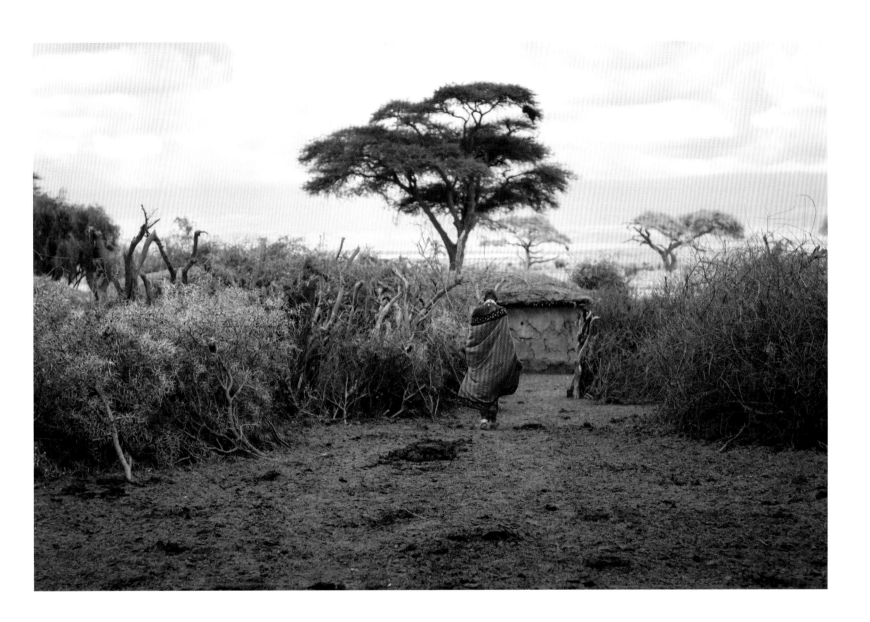

Catherine Bullen (UK)

Amboseli, Kenya. The centre of a Maasai village will house the livestock overnight, with thorny branches acting both as a fence and as protection from wild animals. Standing here as a member of the village walked past, the calm, colours and landscape came together, creating an image that to me portrays the fragility yet strength and spirit of people who live alongside nature.

Nikon D300 with Nikon 50mm lens, ISO 1000, 1/8000sec at f/3.2, handheld

catherinebullen.co.uk

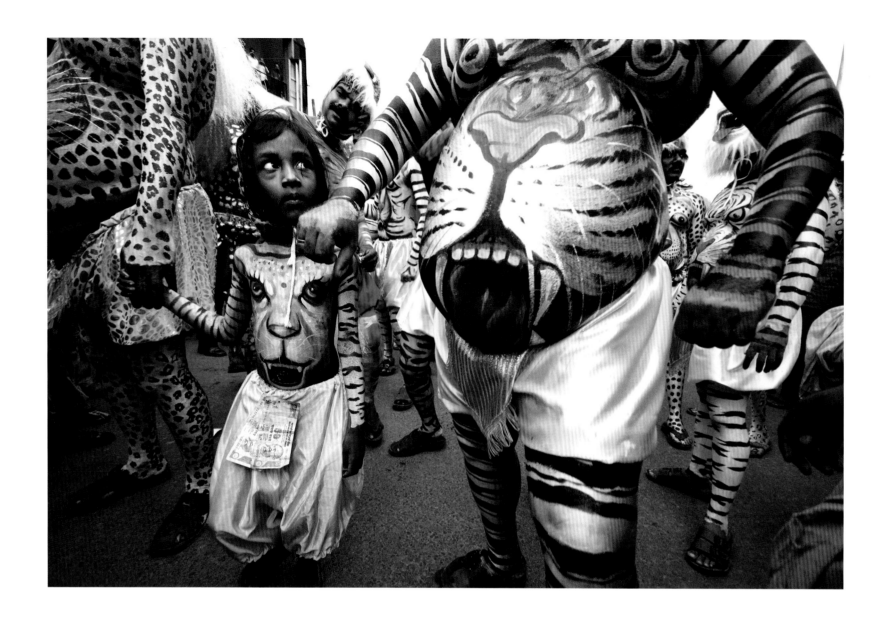

Indranil Sengupta (India)

Thrissur, Kerala, India. Pulikkali is a folk art in the state of Kerala; *Puli* means tiger and *Kali* means dance. In my photo tour during the annual Onam festival, I was amused to find this interesting event at Thrissur, where people are painted like tigers and dance wholeheartedly in the streets of the city to drive away evil spirits.

Nikon D300 with Sigma 10-20mm f/4-5.6 lens at 10mm, ISO 400, 1/200sec at f/4, handheld

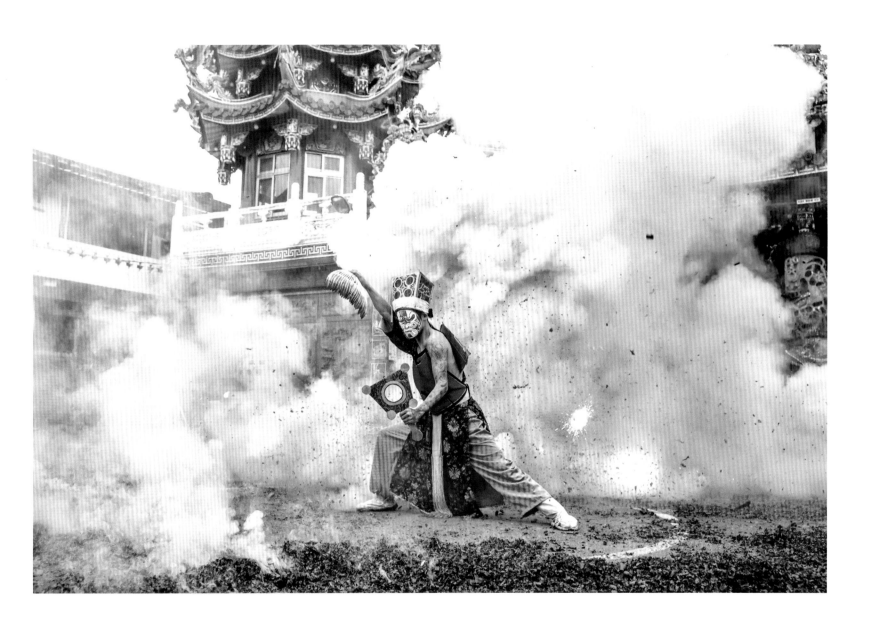

Rossi Fang (Taiwan)

Taiwan. This type of lively celebration with firecrackers around a temple is very representative of Taiwan's traditional culture. Face painting symbolises the gods possessing a person.

Sony Alpha 99 with Vario-Sonnar T 24-70mm lens at 30mm, ISO 200, 1/400sec at f/5*

Julian Elliott (France)

Notre Dame de Fourvière church, Lyon, Rhône, France. I was there to take images of the church itself but saw the young priest talking with parishioners. The way he had his hands coupled with the rosemary beads and his flowing robes, it struck me that it would make a great image. I asked if he minded me photographing him, and to my delight he said it was fine to go ahead and take the image.

Canon EOS 5D MkII with Canon 28-70mm L lens at 48mm, ISO 800, 1/30sec at f/2.8, handheld

ethereal-light.com

John White (UK)

Brighton, England. A cultural melting pot, the city of Brighton hosts visitors from around the globe and is a photographer's paradise. I often head out of an evening to watch the sun set behind the old pier and am regularly surprised to find some unusual activities taking place. On this balmy evening a small group of people had settled on a bandstand and were dancing together. They were so involved in the moment that I don't think they noticed me.

Nikon D750 with Sigma 24mm f/1.4 Art lens, ISO 2500, shutter speed not recorded, f/1.4, handheld

john.media

Tim Mannakee (France)

Nandgaon, Uttar Pradesh, India. Men sit on the floor of the Krishna temple to celebrate the Lath Mar Holi. While the devotees pray and sing, they are drenched with water and covered in coloured powder. I had to squeeze on to a ledge on the temple roof to capture this image. The man praying proved to be a strong focal point amid the chaos, and a telephoto lens was required to exclude the surrounding crowds from the composition.

Canon EOS 1DX with 70-200mm f/2.8 L IS II lens at 190mm, ISO 800, 1/320sec at f/5

timmannakee.com

Mark Boyd (UK)

Udaipur, India. My wife and I were having breakfast in the tiny and dark Queens Café in Udaipur. We were watching life pass by the only light source, the doorway. Suddenly this beautiful marmalade cow appeared. I grabbed my camera while the sacred beast paused to look in. I slowed my breathing and steadied my elbows on the table as I clicked the shutter. I love capturing images of India's street cows in strange places. For me, this image sums up India.

Canon EOS 40D with Canon 50mm f/1.8 lens, ISO 400, 1/60sec at f/4, handheld

mbimagery.co.uk

Howard Rankin (UK)

Marrakech, Morocco. I took this during a wander through the main souk in Marrakech. Photography opportunities very much required a candid and discrete approach, so a long focal length lens was essential. I liked the concentration this man was showing on his work. The shutter speed was chosen to blur the movement of the hammer.

Canon EOS 5D MkII with Canon EF 70-200mm f/2.8L IS II USM lens at 200mm, ISO 400, 1/15sec at f/5

500px.com/howierankin

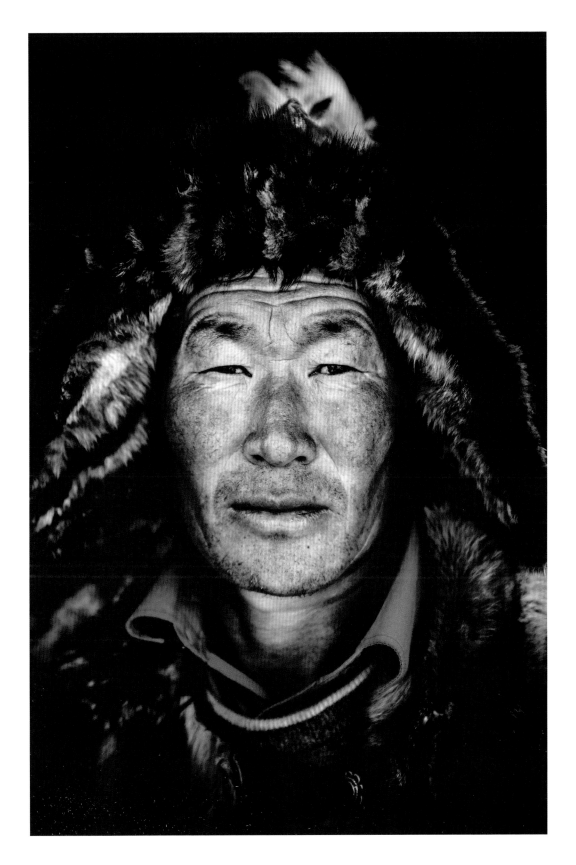

Rob Walbers (Japan)

Bayan-Olgii aimag, Mongolia. As part of the work for my series NoMa(n)d'sLand about the life of the Mongolian nomads, I visited the Golden Eagle festival in the Altai mountains in the west of Mongolia. The strength and life experience of these hunters can be strongly seen in their eyes. Shooting their portraits in front of a black backdrop takes away the distraction of the environment and makes you fully focus on their faces, eyes and the immense power coming from within.

Nikon D4 with Nikkor 28-70mm f/2.8D ED-IF AF-S lens at 50mm, ISO 200, 1/250sec at f/4, black backdrop

robwalbers.com

Chele Holt (UK)

Opposite page (top): **East Loch Tarbert, Isle of Scalpay, Inner Hebrides, Scotland**. On the road to Am Baile is this abandoned, melancholy reminder of spirited travel sheltering from the mercy of the wild Hebridean weather; empty though very much a part of the landscape. I was instantly struck by the contrast between the environment and the caravan.

Canon EOS 5D MkIII with EF 24-105mm f/4 L IS USM lens at 35mm, ISO 200, 1/60sec at f/9, handheld

cheleholt.com

Simon Byrne (UK)

Opposite page (bottom): **Hammer Hill, Kowloon, Hong Kong**. Hong Kong has the highest number of skyscrapers anywhere on Earth. It has more than New York, Tokyo, Shanghai and Dubai combined; all packed into a city the size of Berlin. Contrary to many other cities, however, people usually work at ground level and live in the vertiginous buildings. In the photo, I tried to encapsulate 'home' in Hong Kong, where you are packed in like city offices but see a neighbour's life instead of your colleague's desk through the windows opposite.

Canon EOS 6D with EF 70-300mm f/4-5.6 L IS USM lens at 170mm, ISO 400, 1/1000sec at f/11, handheld, four images stitched

simonbyrnephotography.com

Paul Christener (Switzerland)

N 66°58'19.52" W 52°10'11.56", West Greenland. This little shelter is located roughly in the middle between the ice cap and the west coast of Greenland. After two days of rain, the first rays of the sun were touching the landscape as we reached the shelter. We were on a two-week hiking tour from the ice to the ocean. It was one of those instants when you have to grab your camera and catch the moment.

Canon EOS 5D MkIII with EF 24-70mm f/1.4 L IS USM lens at 24mm, ISO 200, 1/60sec at f/18, ND soft grad, tripod

christener.ch

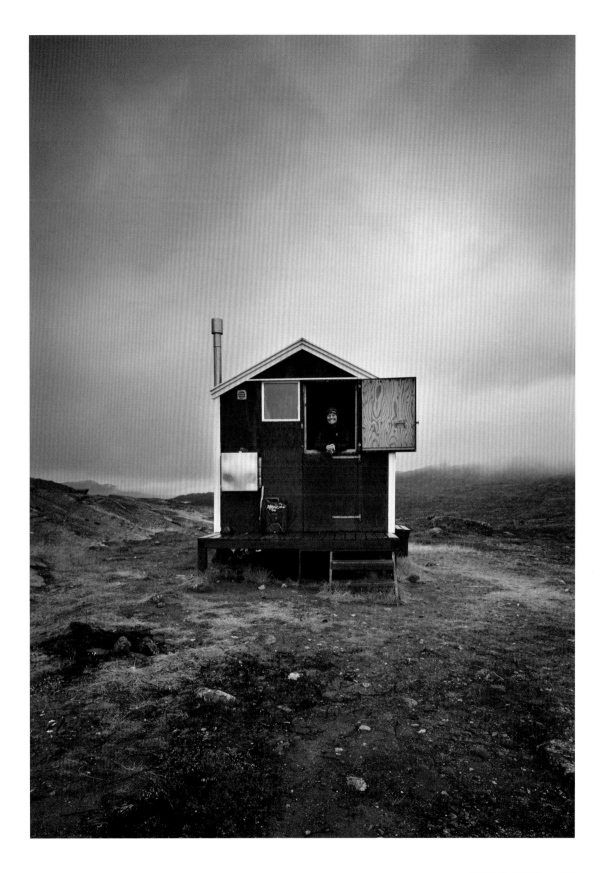

YOUNG OPOTY

Nature is my world: for outdoor photographers
aged 18 or under, to shoot landscapes, nature
or wildlife subjects that matter most to them.

David Rosenzweig (USA)

Timbavati Game Reserve, Mpumalanga, South Africa. The eternal bond between a mother and child is one that transcends the animal kingdom. One early morning in the Timbavati Game Reserve, we came across this female leopard. She was clearly searching for something and continued calling until she reached an open road. Just as she arrived, her cub came running out of the bushes. The ensuing interaction between the mother and cub proved the love that the two share for each other.

Canon EOS 70D with an EF 70-200mm f/2.8 L IS II USM lens at 180mm, ISO 100, 1/1000sec at f/2.8, handheld

davidrphotos.com

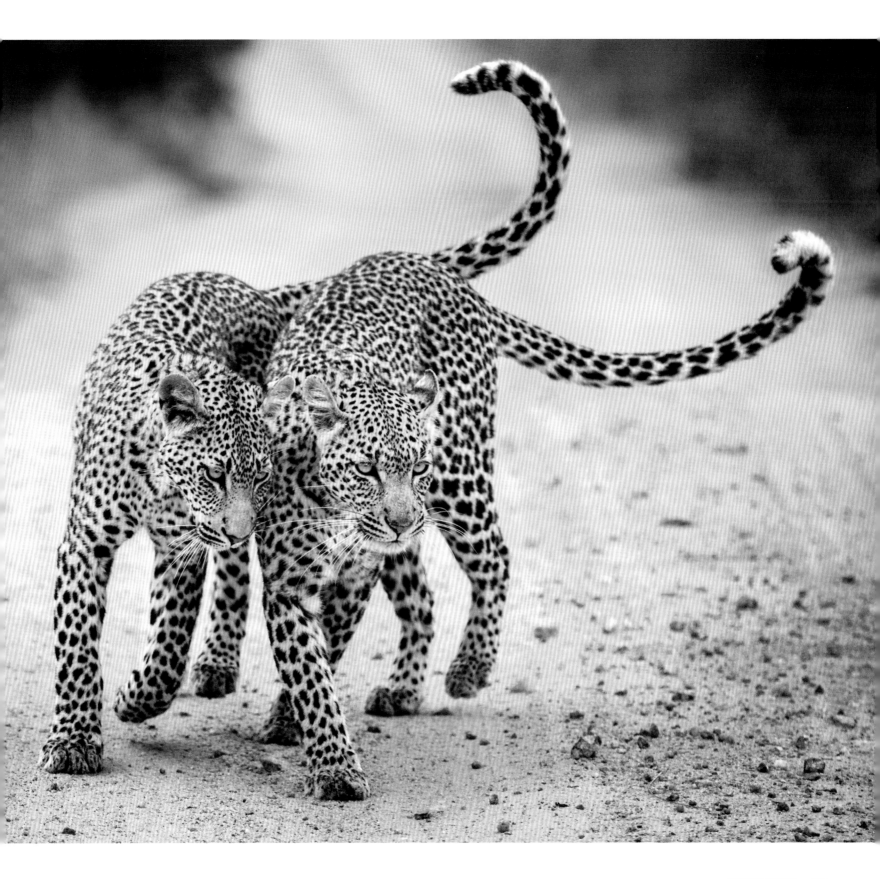

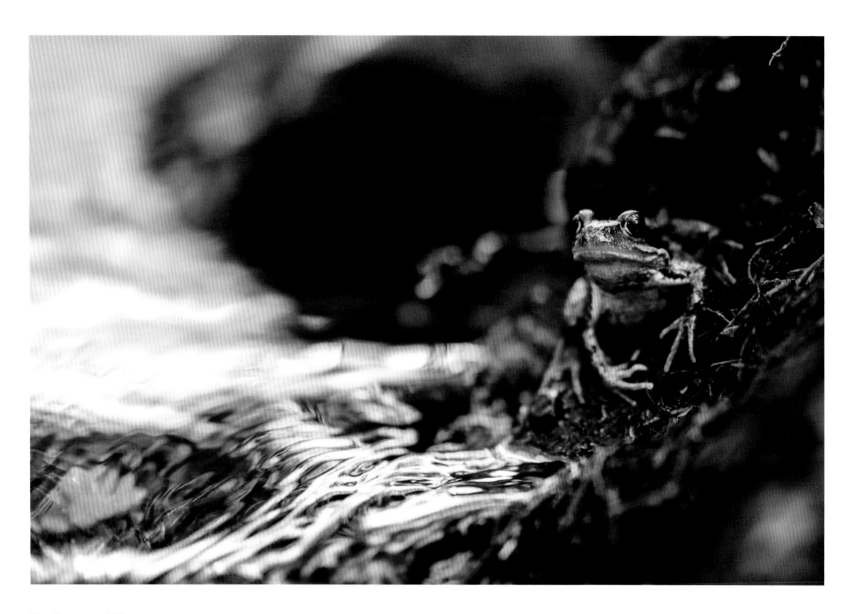

Ben Duursma (UK)

Skärsjön, Skinnskatteberg, Sweden. My main goal while visiting Sweden was to capture the small details of the wonderful natural landscape there. So when I came across this small moor frog jumping between rocks on a stream, I knew it was the perfect opportunity to show part of the ecosystem that is often forgotten about. To get the shot I had to get low in the stream, which resulted in wet elbows but an image I am really proud of.

Nikon D7000 with Sigma 105mm f/2.8 EX DG OS HSM lens, ISO 640, 1/125sec at f/3.5, handheld

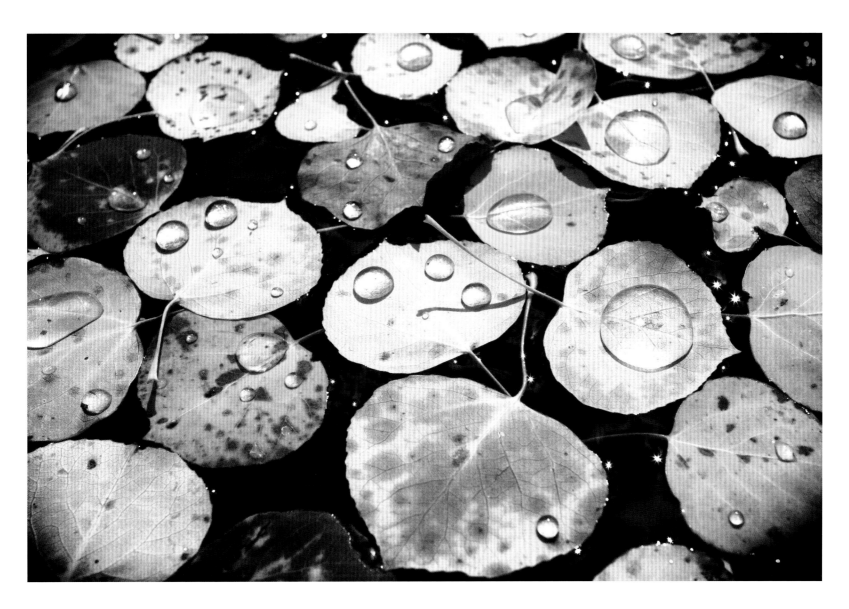

Morgan Wolfers (USA)

Kenosha Pass, Colorado, USA. I was trying to photograph the fall leaves up at 3,000m on Kenosha Pass, but the crowds were complicating all the shots. So instead I went with my family up an old jeep road and struck gold in the form of beautiful aspen leaves covering a quiet and isolated beaver pond. Snow had fallen recently, and had melted into large droplets on the leaves. I was excited to see all the little sunbursts on the dark water between the leaves.

Sony Alpha 6000 with Sony 30mm f/3.5 macro lens, ISO 100, 1/800sec at f/9, handheld

morganwolfers.com

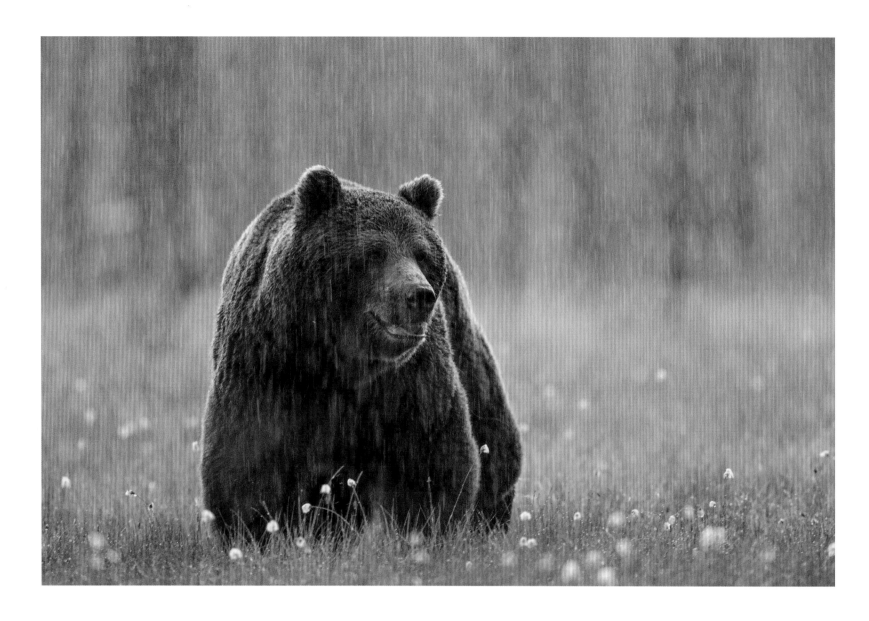

Kyle Moore (UK)

Wild Brown Bear Centre, Kuhmo, Finland. In the Kuhmo region of Finland, where it borders Russia, lies an area of land as wild and untouched as it gets in Europe, where you can find apex predators such as brown bear. This photograph was taken in the spring, when the bears had just emerged from their winter hibernation.

Canon EOS 1Dx with Canon EF 500mm f/4 L IS II USM lens with 1.4x teleconverter, ISO 1000, 1/125sec at f/5.6, Gimbal head attached to hide

kylemoorephotography.co.uk

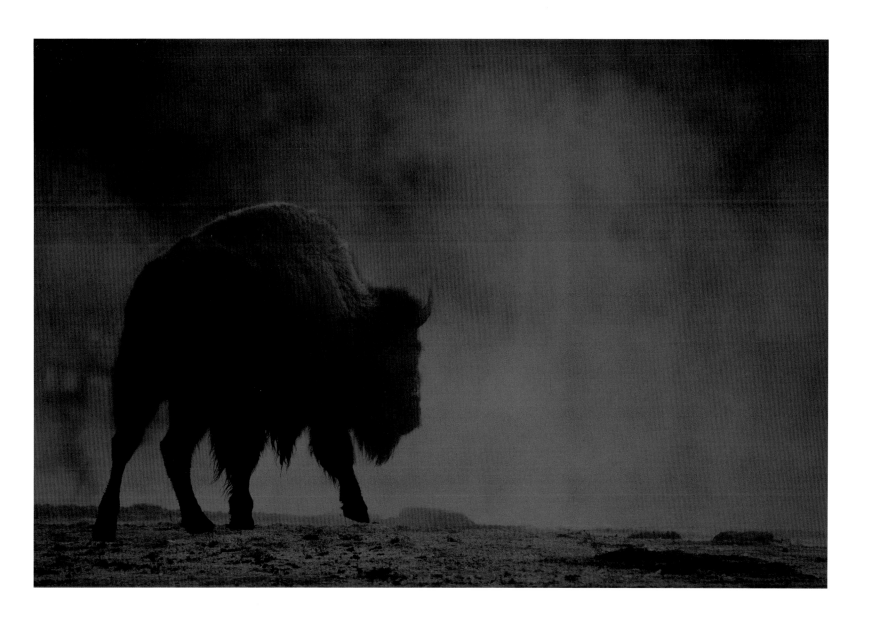

Laurent Dumas (France)

Yellowstone National Park, USA. On a cold winter
night I was hiking in Yellowstone, lost in my mind
and in the wild. It was that magical time of day, where
everything gets blue and mysterious and where the
forms are only clear in the imagination. Suddenly, I saw
a small group of bison slowly descending from the hills
to spend the night near the heat of the geothermal
features in the valley.

*Nikon D750 with Tamron 150-600mm f/5-6.3 lens at 420mm,
ISO 640, 1/500sec at f/6*

laurentdumasphotographe.com

Siddhant Sahu (India)

Rourkela, Odisha, India. Early one morning, when
I had just started exploring our garden with my
camera, I saw this butterfly. It was dark and at first
there wasn't much of interest in the scene, with
no colours. After shooting for about half an hour
I noticed how the sunlight was making the
translucent butterfly glow. After multiple attempts
I was able to shoot at the exact moment when it
opened its wings to fly, and I framed it against the
dark background to add contrast.

*Nikon D5200 with Venus 60mm f/2.8 lens, ISO 200,
1/1000sec at f/4, handheld*

siddhantsahu.com

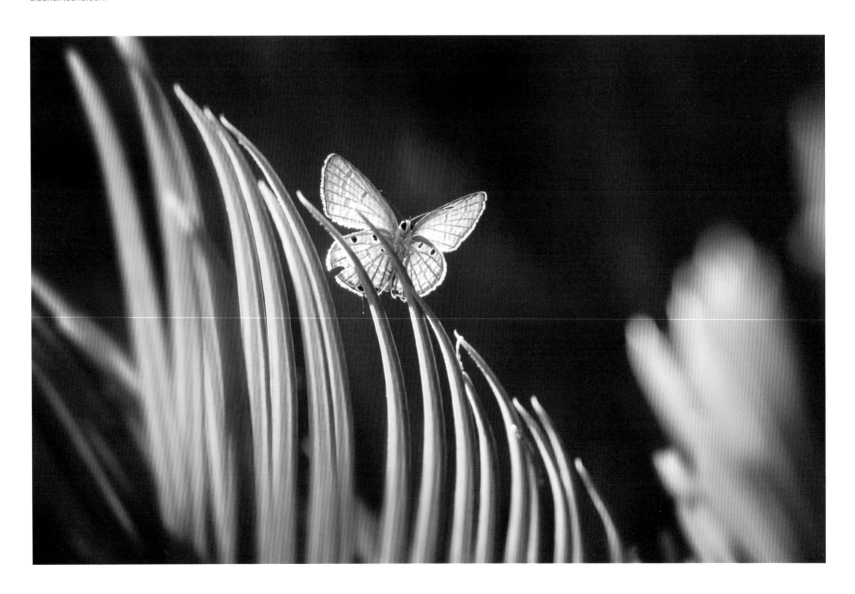

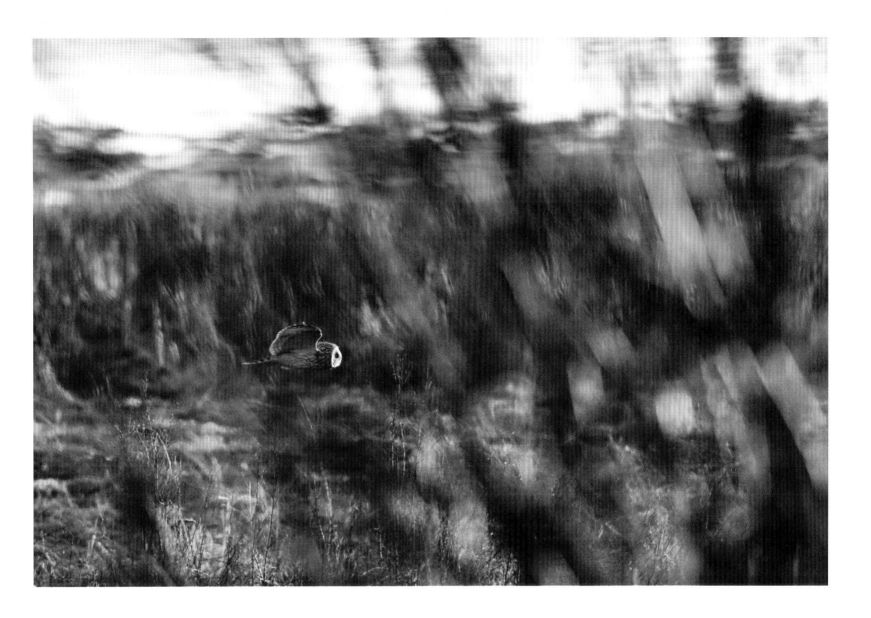

Josiah Launstein (Canada)

British Columbia, Canada. This short-eared owl hunted the bushes and grasses of a salt marsh at dusk looking for voles and mice for several hours while my dad, sister and I photographed it. I wanted to show the dense brush it was flying through so found a small hole in the branches to photograph through and hoped it would hunt past me. It took a while, but I finally caught it as it silently glided through the opening in the marsh in front of me. We were right on the coast in south-west British Columbia, and you can even see the ocean reflecting the sky at the top of the picture.

Nikon D7100 with Nikkor AF-S 300mm f/4 D IF-ED lens and Nikon TC-14E II 1.4x teleconverter, ISO 3200, 1/1250sec at f/6.3, monopod

launsteinimagery.com

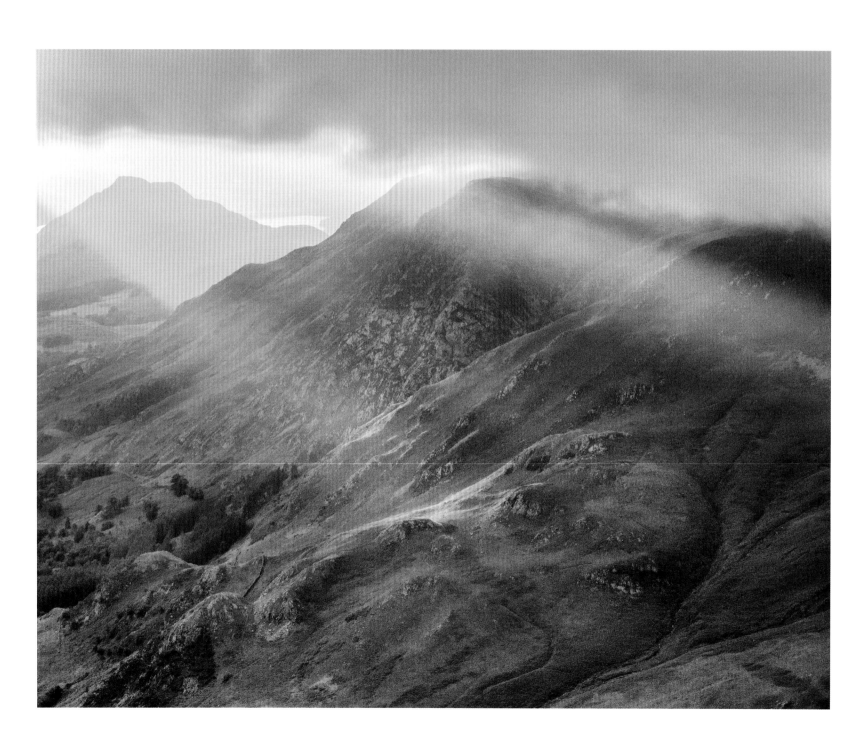

Fergus Brown (UK)

Left: **Rannerdale Knotts, near Buttermere, Cumbria, England**. I climbed Fleetwith Pike with my family and took my camera to photograph the sunset over Buttermere. The light started to turn a golden colour over the mountains, and it was one of the best sunsets I have seen.

Nikon D7000 with Sigma 17-50mm f/2.8 lens at 50mm, ISO 400, 1/40sec at f11, tripod

fergusbrown.photoshelter.com

Vasily Lakovlev (Russia)

Koh Kood Island, Andaman Sea, Trat Province, Thailand. On the beach near Hotel Chinnamon is a surprisingly long pier, which I decided to take an image of from the air using my drone.

DJI Phantom 3 Advanced drone with 20mm lens, ISO 100, 1/400sec at f/2.8

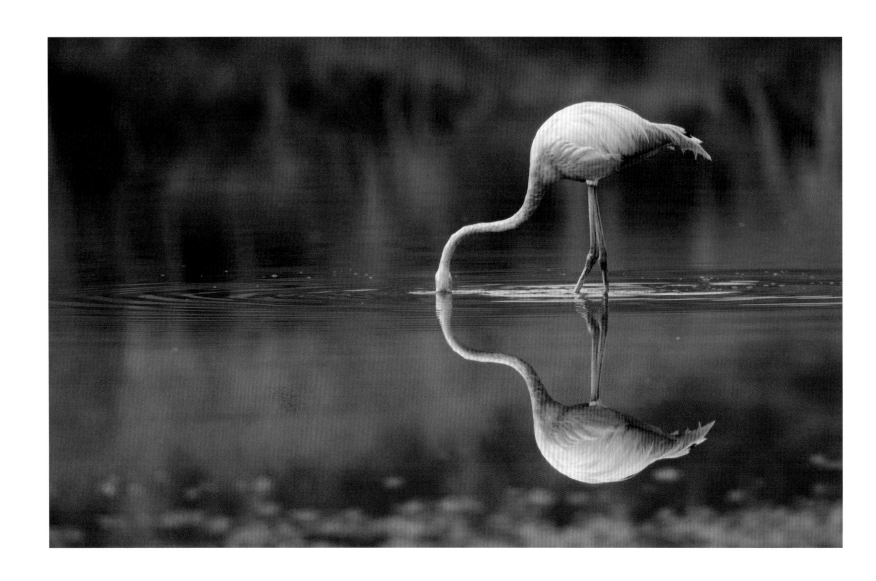

Carolina Fraser (USA)

Floreana, Galápagos Islands, Ecuador. While on
a trip to the Galápagos Islands with my family, we
saw flamingos early one morning. The water created
a beautiful reflection, and I took advantage of the
symmetry when creating this photograph. Flamingos
filter-feed, so this one kept its head under the water
for a while, making its way through the muddy
water searching for food.

*Nikon D7200 with Nikkor 70-200mm f/2.8 G ED VR II lens
with a 1.4x teleconverter at 340mm, ISO 400, 1/640sec at
f/4.8, handheld*

carolinafraserphotography.com

Riccardo Marchegiani (Italy)

Lake Clark National Park, Alaska, USA. It was a rainy day in the park and bears were all around us. Some were sleeping while others were busy fishing. The one in this photograph was running because other bears that wanted a salmon he had just caught were chasing him.

Nikon D500 with Sigma 150-600mm f/5-6.3 lens at 600mm, ISO 560, 1/2000sec at f/6.3

facebook.com/riccardo.marchegiani.75

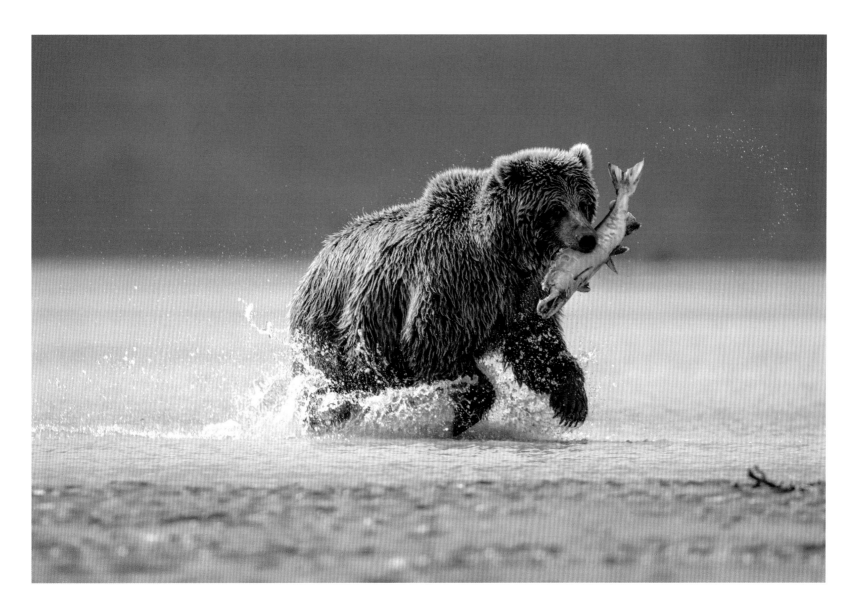

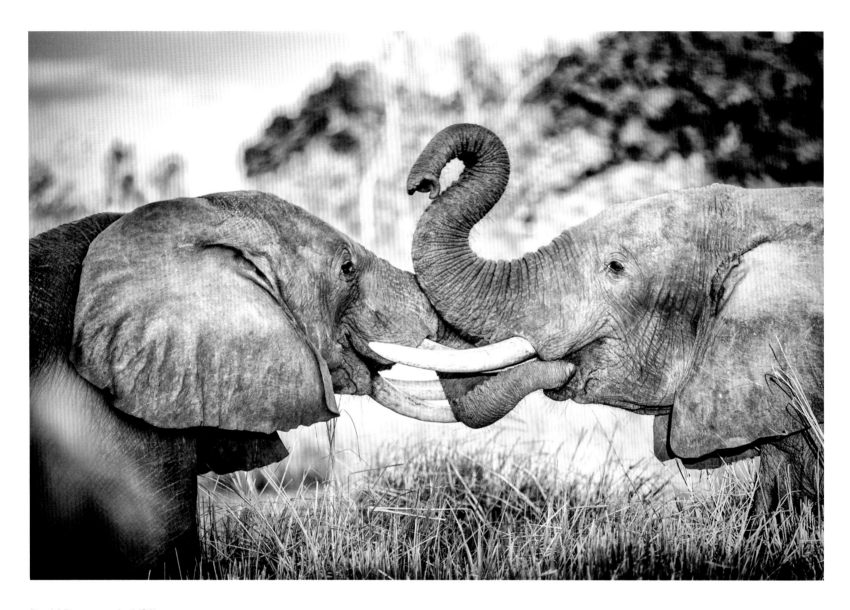

David Rosenzweig (USA)

Mana Pools National Park, Zimbabwe. From a very early age, elephant bulls establish dominance over one another. Despite travelling thousands of miles and sometimes being apart for ten or more years, this social structure is always maintained. When two or more bulls come together, dominance must be accepted so that one can breed. The way this is done is through their trunks. The bulls each put their trunks in the other's mouth, thus remembering their past encounters. Elephants truly are one of the planet's most intelligent animals.

Canon EOS 5D MkIII with EF 70-200mm f/2.8 L IS II USM lens at 200mm,
ISO 100, 1/250sec at f/2.8, handheld

davidrphotos.com

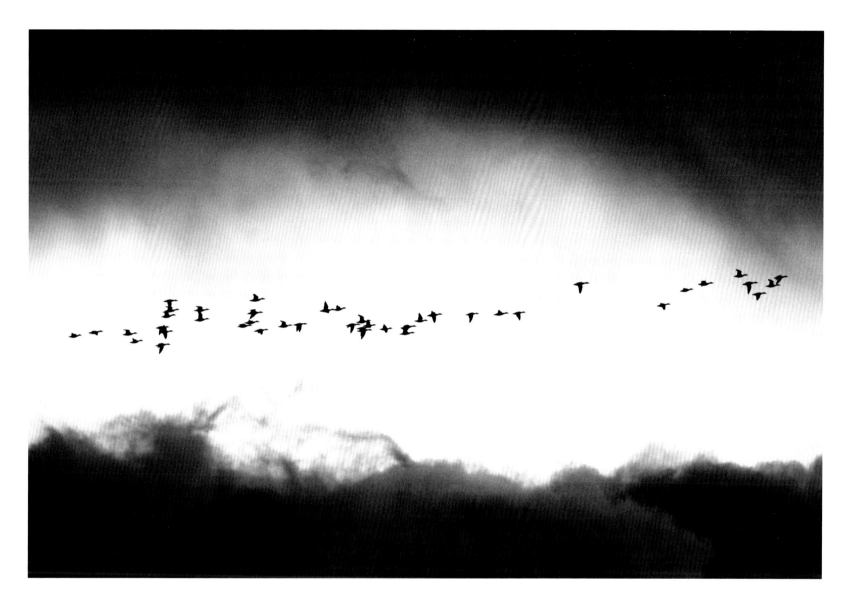

Josiah Launstein (Canada)

Pincher Creek, Alberta, Canada. My dad and I were photographing some great
horned owls when we noticed a starling murmuration. I had just started
photographing that when they disturbed a bunch of mallards that had settled
into a farmer's field for the night. The mallards looked really cool against the
mountains as they took off. I kept following them through my lens as they circled
round, and they made it all the way up above the first layer of storm clouds, which
were rolling in from the west. I was so surprised to get this shot; my dad and I had
been so focused on the owls that we hadn't noticed this sky until the mallards
made us turn around.

*Nikon D7100 with Nikkor AF-S 300mm f/4 D IF-ED lens and Nikon TC-14E II 1.4x teleconverter,
ISO 1600, 1/320sec at f/5.6, handheld*

launsteinimagery.com

OPOTY.CO.UK

To find out more about the competition, to see previous winners and to see information on how you can enter please visit our website.